Titian and Venetian Painting,
1450–1590

Titian

AND VENETIAN PAINTING,

1450–1590

Bruce Cole

Icon Editions
Westview Press
A Member of the Perseus Books Group

Published in 1999 in the United States of America by Westview Press, 5500
Central Avenue, Boulder, Colorado 80301-2877, and in the
United Kingdom by Westview Press, 12 Hid's Copse Road,
Cumnor Hill, Oxford OX2 9JJ

Library of Congress Cataloging-in-Publication Data
Cole, Bruce, 1938–
Titian and Venetian painting, 1450–1590 / Bruce Cole
p. cm.
Includes bibliographical references and index.
ISBN 0-8133-9043-5
1. Titian, ca. 1488–1576—Criticism and Interpretation. 2. Painting,
Italian—Italy—Venice. 3. Painting, Renaissance—Italy—Venice. I.
Title.
ND623.T7C66 1999
759.5'31—dc21 98-21705
CIP

The paper used in this publication meets the requirements of the American
National Standard for Permanence of Paper for Printed Library Materials
Z39.48-1984.

10 9 8 7 6 5 4 3 2 1

FOR MY CHILDREN–FELLOW ITALOPHILES

Contents

Illustrations

The numbers in italics refer to the
page on which the illustration appears

Color Plates

following page 110.

Preface and Acknowledgments

Surprisingly enough, there is no up-to-date introduction in English to Titian's art and its place in the Venetian painting of his time. This is rather remarkable when one considers the pivotal role his work has played in the development of Western art since the Renaissance. His unceasing importance as an artist has been universally acknowledged for more than four hundred years.

This book is written to provide a succinct survey of Titian's works and life. It is intended for the nonspecialist–that interested general reader or student of art history. The following pages provide an overview of Titian's artistic background; an account of the origins, development, and nature of his art; and a summary of the influence or afterlife of his work down to the nineteenth century.

Of course, a concise book like this can concentrate only on the essentials of its very large subject. Thus, it is possible that a reader's favorite painting will not appear in these pages. For this I must apologize; however, I hope that what I have written will encourage those who read my words to further explore the amazing range and depth of Titian's art. If it does, then I will feel that my goal in writing this book has been achieved.

At the end of each chapter is a section of notes. Most of these are intended to point the way toward specialized studies dealing with particular aspects or problems touched upon in

the text that the reader may wish to investigate further. I have, whenever possible, tried to confine the notes and the bibliography to sources in English in order to accommodate the greatest spectrum of readers. Above all, the reader should be referred to Crowe and Cavalcaselle's *Life of Titian,* published more than a century ago, but still, in its Victorian splendor, the magisterial foundation of all studies on the artist.

I have looked at and thought about Titian's art for a long time, yet still I find it, more than the work of any other artist, inexhaustibly fascinating. But no matter how well one knows Titian's paintings, their vast scope and titanic creativity instill a sense of transcendent wonder never wholly explicable. That is the ultimate mystery of this surpassing artist.

Many people have helped me with this book over the years of its gestation. My first debts are to my predecessors in the study of Titian, most especially to Joseph Archer Crowe and Giovanni Battista Cavalcaselle, those now nearly forgotten pioneers of the history of Italian Renaissance art. Without them, and Harold Wethey, the author of the three-volume catalogue of Titian's work, I would have been unable to write this book. I doubt we shall see their likes again.

I am also grateful to Jody Shiffman, the ever-vigilant and learned scholar/editor who improved what I wrote. Sheri Shaneyfelt gave the book a critical and very useful reading in one of its earlier incarnations. Nancy Thompson helped wrestle the manuscript out of the computer. Several generations of graduate students at Indiana University patiently bore with me in numerous seminars devoted to Titian; of course, I learned as much from them as they did from me. I am beholden to the Samuel H. Kress Foundation and its officers, Lisa M. Ackerman, vice-president, and Marilyn Perry, president, for help with the color illustrations in this book and for invaluable assistance over many decades.

As usual, my family and friends lent support of various kinds. My thanks to Doreen, Ryan, and Stephanie Cole, Peter and Julia Bondanella, Mort and Carol Lowengrub, Robert Barnes, and Andrew Ladis. Thies and Marion Knauf provided an unforgettable stay in Spain. My greatest debt is, however, to Cass Canfield, Jr., who has supported and edited my books for nearly a quarter century.

BRUCE COLE

Titian and Venetian Painting,
1450–1590

1

Venice, 1510

❧

The year 1510 constituted a fateful moment in the history of Venetian art. In that year, aged about thirty-four, the painter Giorgione died in Venice. His death, noted by some prescient contemporary observers, came at a time when Venetian art was undergoing a process of fundamental transformation, a process which he himself had helped to initiate. The year 1510 also saw the creation of seminal paintings by several of his talented contemporaries: Giovanni Bellini, Sebastiano del Piombo, and Titian. These paintings were to become the first in a long series of works which would, within less than a century, elevate the Venetians from a school of local importance to a major force in the history of Western art.

In 1510, an informed observer looking at Giorgione's *Tempest* [25], Titian's Santo frescoes [33, 34], or Sebastiano del Piombo's altarpiece in the church of San Giovanni Crisostomo [28] might have realized that these remarkable paintings both embodied and transformed the ancient traditions of Venetian painting upon which they so heavily depended. Their artists visualized the world, its inhabitants, and their beliefs and dreams in a way never before seen in the West.

Giorgione and his equally gifted near-contemporaries, Titian and Sebastiano del Piombo, had all studied with Giovanni Bellini (c. 1430–1516). Bellini and his painter brother Gentile (c. 1435–1507) had, in turn, learned their art in the family workshop headed by their father, Jacopo (c. 1400–1470). As a young man, Giovanni Bellini had painted a series of imaginative pictures based partially on the ancient traditions of Venetian picture-making that began in the Middle Ages and partially on some of the new developments that had lately come into northern Italy from Florence.

By 1510, the year of Giorgione's death, the old Giovanni Bellini himself had developed a personal style of great lyrical beauty, which, while it still embodied many of the venerable characteristics of Venetian art, was to become one of the foundations of Renaissance painting in the city. Bellini's late works, such as the *Madonna and Child* painted in 1510 [16], were to have a major impact not only on his pupils Giorgione and Titian, but on the subsequent development of Venetian Renaissance painting. Yet Bellini himself would be influenced by these two artists around 1510 when Venetian art was experiencing major new developments.

Bellini's influence was also felt by a number of more minor, but still highly talented artists whose conceptions of style and subject depended on his earlier works. For example, in paintings from 1510 by Vittore Carpaccio [23] and Marco Basaiti, one sees these men each responding in their own specific way to the new, broader horizons of the increasingly monumental figural style and expressive landscape favored by Bellini in his late work. Their responses, albeit limited, to the ferment occurring around 1510 graphically demonstrate the artistic dynamism and diversity of the time.

The year 1510 also saw the commissioning of Titian's frescoes for the Confraternity (Scuola) of Saint Anthony of Padua [33, 34]. These revolutionary works, the first which can be dated with certainty to the artist's hand, were a result of what Titian had learned from both Bellini and Giorgione. But more importantly, they embodied many of the elements of an idiom which was to become a cornerstone in the history of European art.

The prospects for Titian's future career improved around 1510 due to two events. The first was Giorgione's removal from

the Venetian scene by death in 1510; the second was the depar-
ture from Venice of a potential rival, Sebastiano del Piombo,
another remarkable artist trained in the Bellini shop. In 1511
Sebastiano moved to Rome, where he transformed himself into
a rather slavish follower of his idol Michelangelo. But before he
left, he painted a major altarpiece for the church of San
Giovanni Crisostomo [28], probably in 1510. A moving and
prophetic work, it reveals Sebastiano's not inconsiderable skill
and demonstrates just how talented an artist the Venetian
scene lost in that eventful year of 1510.

Sebastiano's change of residence in 1511 was motivated by
his desire to work in the city which was to become the only
serious rival of Venice for most of the sixteenth century:
Rome. Under the brilliant patronage of several popes who
wished to renew the luster of the Holy City and of the papacy
itself, artists from all over the Italian peninsula found work
there, including those two presiding figures of the Renaissance
in central Italy, Raphael and Michelangelo. In 1510 each of
these artists was engaged on a major Roman project:
Michelangelo on the Sistine Ceiling [35] and Raphael on the
School of Athens. Around 1510 Venetian artists were already
well aware of some of the major innovations of these two
artists through the reproductive mediums of prints and draw-
ings. Both Raphael and Michelangelo were interested in mon-
umental drama enacted by heroic protagonists within ratio-
nally planned, architectonic space. Order, balance, and gravity
were essential elements in their artistic visions. To achieve
these, they built their pictorial worlds through a rigorous study
of subject and setting, clarified and refined through drawing.
Careful, precise planning and the slow development of space
and form through a myriad of paper studies were used to make
a cartoon in which all the studied elements of the picture to be
painted were resolved. Such a process was the hallmark not
only of Raphael and Michelangelo, but of the entire tradition
of central Italian painting, a tradition upon which the
Venetians of the sixteenth century often reflected. Soon the
influence of the work created by the formidable figures of
Raphael and Michelangelo, and some of their lesser contempo-
raries working in Rome and Florence, was to become part of
the vibrant intellectual and formal world of Venetian painting.

Venetian art in 1510 was anchored in the past, but buffeted by strong winds of change, both from within and without. It was a time of intense artistic germination from which would arise the unbroken succession of painters destined to create an extraordinary epoch in the history of art. From the death of Giorgione in 1510 to that of Tintoretto in 1594, Venice was the crucible in which painting–in all its various characteristics of style, subject, and meaning–underwent a fundamental transformation destined to set the stage for every school of European art down to the present day.

The achievements of Venetian Renaissance painters provided an important base for the artists of Baroque Rome. Throughout the seventeenth century, the Venetians inspired not only Caravaggio, the Carracci family, and their contemporaries in Rome, but also constituted major sources of inspiration and motif for artists working outside the Italian peninsula. Rubens, Van Dyck, Rembrandt, and Velázquez derived much of their pictorial style and interpretation of subject from extensive study of the Venetian paintings, which were considered throughout the seventeenth century high points in the history of art.

Admiration for the famous Venetians continued unabated during the eighteenth century. In France the painting of mythological scenes and portraits, among other types, by Boucher, Watteau, and Fragonard strongly reflected Venetian influence. As in the previous century, French and other European artists made pilgrimages to Italy to study firsthand the famous Venetian works, many of which they knew partially through reproductive engravings and copies, both painted and drawn.

Venetian form, technique, and color entered the mainstream of nineteenth-century European painting where their example and influence remained undiminished. From Goya's work at the very beginning of the century, to Turner's around its midpoint, to the Impressionists at its end, Venetian painting played a seminal role in the history of Western art.

The city from which the remarkable school of Venetian painting of the sixteenth century arose had, like the school itself, a particular relationship with the rest of the Italian peninsula. By 1510 Venice already enjoyed a long and eventful history.[1] One of the most powerful city-states in the Italian penin-

sula, it could trace its foundation to the time when refugees from the Po Valley, fleeing the successive waves of barbarian invasions, escaped from the mainland to the comparative off-shore safety of the islands of mud flats, the location of present-day Venice.

By the sixth century, settlements on the small islands had been established, and by 741 the city had elected its first leader, the doge. The earliest settlers soon began to reclaim land from the lagoon by driving large timbers into the mud of the shallow waters to form foundations for their homes, churches, and commercial buildings. As the city grew in size, land was increasingly reclaimed and the various small islands which make up Venice were linked by the series of canals and bridges for which the city is still so famous. But the amount of land reclaimed always remained small compared to the holdings of the city-states of the mainland. For much of its history, Venice was forced to buy rather than raise its own agricultural products.

So it depended instead on the sea for its existence. To the Venetians the sea was both protectress and provider and, as such, it occupied a sacred place in the thoughts and beliefs of the city. All Venetian life was built and sustained, literally, on an aqueous foundation. The city's particular ties to the sea gave it a romantic uniqueness celebrated worldwide for centuries in both paint and prose.

Founded as part of the Eastern Empire of Rome and recog-nized as a semi-independent entity, the city soon began to estab-lish the strong commercial links that would eventually make it a formidable power both in the East and the West. Venice's physical and social divergence from the city-states of the rest of the Italian peninsula arose partially from its close spiritual and commercial connections with Constantinople and the Byzantine East. From its earliest history, Venice, led by its patri-cian oligarchy, looked to the East not only for its commercial livelihood in trade, but also for important elements of its sacred and secular culture.

The independence and power of Venice were symbolized by the Basilica of Saint Mark, the Doges' Chapel (named after the patron saint of the city), and the adjacent Palace of the Doges.[2] From the latter through a labyrinth of governing bodies and

committees, all designed to ensure that power could not be con-centrated in the hands of a single individual or family, the city built its considerable Eastern Empire stretching down the Dalmatian coast and into the Aegean Sea.[3] Venice's constitu-tion and government were widely admired throughout the West, especially during the Enlightenment. Despite, or perhaps because of, its ponderous governmental machinery, which kept power out of the hands of a dictator, the city preserved its inde-pendence longer than any other major European power, from about the sixth century to the end of the eighteenth century, when it was conquered by Napoleon.

By 1510 Venice's independence, wealth, and prestige had made the city the unique and beautiful place that it remains, largely unaltered, today. Already a distinguished center of painting in 1510, Venice was on the eve of a period of artistic creativity of astounding dimensions destined to last for nearly a century. Much of the impetus for this remarkable development was found in the mind and hand of Giovanni Bellini, the founder of Venetian Renaissance painting.

<div align="center">NOTES</div>

1. On the history of Venice, the most readable and informative introduc-tion is J. Norwich, *A History of Venice*, New York, 1989; see also F. Lane, *Venice: A Maritime Republic*, Baltimore, 1973. A detailed guide to Venice is G. Lorenzetti, *Venice and Its Lagoon*, Rome, 1961. Brilliant impressions of Venice are found in M. McCarthy, *Venice Observed*, London, 1956, and J. Morris, *The World of Venice*, New York, 1960.

2. Information on Venice's Basilica of Saint Mark and the Palace of the Doges is provided by D. Howard, *The Architectural History of Venice*, New York, 1981, and G. Lorenzetti, *Venice and Its Lagoon*, Rome, 1961.

3. For Venice's empire, see J. Morris, *The Venetian Empire*, London, 1980.

2

Precursors:

Giovanni Bellini and the Birth
of Venetian Renaissance
Painting

❧

In the Renaissance, art was a profession, an enterprise prac-
ticed in workshops frequently composed of artists related
to one another. Often the business was handed down from
father to son.[1] Giovanni Bellini (c. 1430–1516) was the son of a
painter, the brother of another painter (Gentile, c. 1435–1507),
and the brother-in-law of yet another painter. Giovanni's father,
Jacopo Bellini (c. 1400–1470), was himself an important figure
in the history of Venetian painting.[2] A pivotal and imaginative
artist, he was one of the first Venetians to incorporate substan-
tial elements of mainland art into his work. As a youth, he must
have marveled at a large fresco, the *Naval Battle between the
Venetians and Otto III* (c. 1410), by the central Italian painter
Gentile da Fabriano in the most important room of the Palace of
the Doges, the Sala del Maggior Consiglio.[3] Gentile's art, which
was deeply infused with the Florentine realism of Masaccio and
his contemporaries, came as a profound surprise to Venetian

eyes used to their own more stylized art of the day. That Jacopo Bellini was impressed by Gentile da Fabriano's work seems certain; less secure is the traditional identification of Jacopo Bellini with a Venetian Jacopo who was attested as a pupil of Gentile da Fabriano in Florence in 1423.

In any case, the style of Jacopo Bellini, known from the admittedly small evidence of a handful of authentic panel paintings and several drawing or pattern books, reveals the grafting of motifs and spatial conventions from mainland Italy onto a Venetian style. These outside influences come not only from contemporary central Italian examples, such as the works of Gentile da Fabriano, but also from older northern Italian sources, such as the highly complex painted narratives of Altichiero (c. 1325–1395), who worked in nearby Padua. Like so many Venetian artists who were to follow him, Jacopo Bellini borrowed selectively, with purpose and sophistication.

His most revealing works are the large drawings bound in two volumes now in London and Paris. These drawings, done over several decades (c. 1430–c. 1465), seem to have been used by the artist and members of his shop as models for a myriad of painting types: religious subjects, mythological scenes, and architectural fantasies, among others. There are also drawings of no recognizable subject which seem to be pure flights of imagination (scenes without subject will become an important part of later Venetian painting). Jacopo's drawings also demonstrate his fascination with one-point spatial construction, a hallmark of the Florentine Renaissance. He could have seen this construction in Venice, where the Florentines Paolo Uccello and Andrea del Castagno had left important examples of their art. Even when Jacopo's drawings are indebted to works by other painters, they are very far from simple copies; rather they are creative reinterpretations that transform the shape and spirit of the original into his own idiom. Unlike most Florentine artists, he was unwilling to use one-point perspective as an armature around which space, architecture, and figures were rationally organized. Instead he employed perspective to fashion effects of complexity and fantasy and, by so doing, became the first of a lengthy line of Venetian artists to use pictorial systems originally invented for rational, measurable representa-

tions to create an environment of unreality. In fact, throughout its long history, Venetian painting constantly eschewed the rationality so favored by central Italian art.

Many of the sacred subjects in Jacopo's sketchbooks are woven into fantastic architectural frameworks daunting in their enormousness and complexity. Sometimes the story is only an excuse for an intricate formal fantasy in which the artist's imagination is given full rein. These flights of inventiveness often center around mythological and classical subjects, revealing the interest in antiquity that he shared with his son-in-law, Andrea Mantegna (c. 1430–1506).

Andrea Mantegna, who married Jacopo's daughter Nicolosa probably in 1454, was born in Padua and studied there with a local master.[4] He worked in Padua, Ferrara, and Mantua, where he became court painter to the Gonzaga family. Strongly influenced by Florentine art, especially by Donatello's major Paduan sculptural projects of the 1440s and perhaps by the Venetian mosaics of the Florentine Andrea del Castagno, Mantegna's art parallels Jacopo's work in several ways. Both artists used one-point perspective for particular emotive and dramatic ends; both often employed a precise, wiry line to describe figures and architecture placed in milieus lacking any sense of real atmosphere; and both were interested in antiquity, although in Mantegna's case this interest occasionally approached obsession. Mantegna's first independent works, which date from the late 1440s, influenced the older Jacopo Bellini both in style and motif.

In turn, the art of Mantegna and Jacopo Bellini inspired Giovanni Bellini, an artist whose importance was eventually to eclipse them both.[5] Born around 1430, he was almost an exact contemporary of Andrea Mantegna. Giovanni was trained in the workshop of his father along with his brother Gentile, who was himself to become a well-known Venetian painter.

One of Giovanni's first major works is an altarpiece depicting the Transfiguration [1], painted around 1450, when the artist was about twenty. Originally arched, the picture is indeed close to the style of Andrea Mantegna, to whom it was attributed until the last century. The restricted, rather somber palette and the figures, whose drapery seems made of metal, are very close to elements

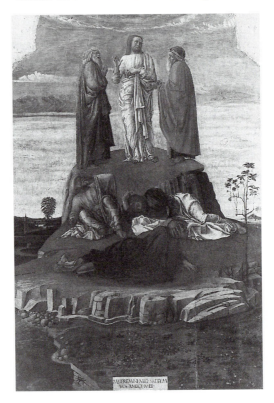

1. Giovanni Bellini,
Transfiguration, Venice,
Museo Correr

Originally arched in
form, the painting has been
truncated just above the
head of Christ. An image of
God the Father surrounded
by cherubim probably
appeared in the now-lost
upper section. A fragment
of a cherub can still be
seen at the very top of the
painting.

employed in contemporary works by Mantegna. Yet the meticu-
lously planned and calibrated structure of the painting depends
in part on the compositional principles articulated in the drawing
books of Jacopo Bellini, which the young Giovanni must have
studied with care. The tiered mountain neatly accommodating
each of the groups of three figures, the rough circle formed by the
sprawled bodies of the apostles, and the archlike configuration
of Christ, Moses, and Elijah (which echoed the now-removed
original arch of the painting): all fit one another with remarkable
sensitivity. Such a composition is the result of much cogitation
and meticulous planning, planning which, again, reminds one of
many pages in Jacopo Bellini's drawing books.

Giovanni Bellini's development into an independent artist
can be observed in his famous *Agony in the Garden* [2] of
around 1460, painted about a decade after the *Transfiguration.*
It is a commonplace in Venetian art history to compare
Bellini's *Agony in the Garden* with the painting of the same sub-
ject by Mantegna [3]; nonetheless, this comparison remains

2. Giovanni Bellini, *Agony in the Garden*, London, National Gallery

The long cloud formation set in the dawning sky is brilliantly observed and painted. Titian was an avid student of this type of dramatic cloudscape.

instructive. Mantegna's painting is a meticulously drawn, hard-edged composition. Lit by an even, overall illumination, its forms seem to exist in a vacuum bereft of any atmosphere surrounding the objects or existing between them and the observer. All forms are seen with equal clarity and intensity. In many ways, this constitutes the classical fifteenth-century presentation of narrative found throughout the Italian peninsula.

But Bellini's *Agony in the Garden* moves decisively away from the traditional idiom by making a number of modifications that both document the artist's considerable originality and manifest, in an early form, some of the most salient charac-

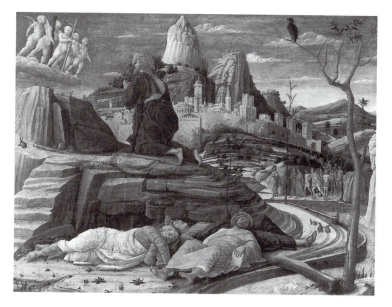

3. Andrea Mantegna, *Agony in the Garden,* London, National Gallery

Like Bellini's picture of the same subject, Mantegna's *Agony in the Garden* is painted in tempera. However, while Bellini's handling of the material presages the luminous effects he will later achieve in oil, Mantegna's use of tempera remains firmly traditional.

teristics of all subsequent Venetian Renaissance art. The prin-
cipal modification–and by far the most important and
prophetic one–is the introduction of time and atmosphere into
the narrative. Our knowledge of time in Mantegna's *Agony in
the Garden* comes not from the painting, but from the Bible,
which states that Christ was betrayed at dawn (a file of
advancing soldiers coming to capture Him is seen in the val-
ley). Yet no such previous information is required to appreciate
Bellini's painting, where the landscape is bathed in the long
rays of the rising sun, which lights the horizon and illuminates
the clouds from behind the line of hills in the far background.
Parts of the valley are still cast in shadow, but the area around
Christ is irradiated by a supernatural aura which seems to
emanate from His presence. Although still fantastic in places,
Bellini's landscape is temporal, realistic, and dramatic in its vast
panoramic sweep.

In Mantegna's picture, meaning arises from objects, moun-
tains, holy figures, and the like. In Bellini's work, form and
atmosphere, no less than objects, generate meaning. Christ's
sacrifice was, like the dawning day, a new beginning, making
mankind's salvation possible. Bellini understood this on a visual
level. In his *Agony in the Garden*, therefore, the natural world
and the spiritual world unite to form an inseparable, expressive
whole charged with the spiritual meaning of the momentous
event. His painting is infused with a sacred resonance far
removed from that of Mantegna or, for that matter, any of
Bellini's contemporaries.

In two other paintings with equally extensive panoramas,
Saint Francis in Ecstasy [4] and the so-called *Sacred Allegory* [5],
Giovanni Bellini was to find nearly perfect expression for his
maturing style, especially in his use of landscape and light as a
vehicle of spiritual meaning. The *Saint Francis in Ecstasy* is one
of Bellini's most moving and enigmatic works. There has been
much inconclusive debate about the subject and date (c.
1475?) of this beautiful painting. It has been called the
Stigmatization of Saint Francis, *Saint Francis in Ecstasy*, or simply
Saint Francis. One reason for the uncertainty surrounding the
subject is that the vision of Christ crucified, which appeared
to Francis during the Stigmatization, is absent. However,

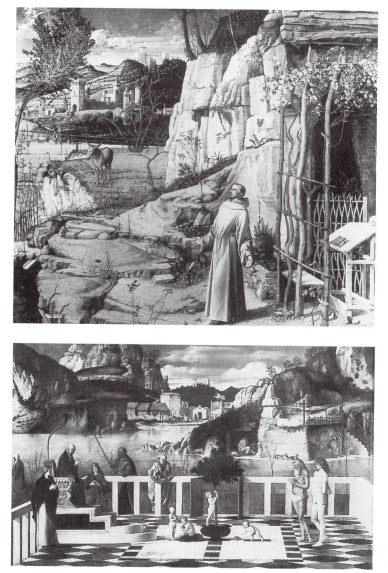

4. Giovanni Bellini, *Saint Francis in Ecstasy,* New York, The Frick Collection

This painting has a long pedigree. In 1525, Marcantonio Michiel saw it in the Venetian palazzo of Taddeo Contarini and described it as "The panel of Saint Francis in the wilderness, a work begun by Giovanni Bellini for Messer Zuan Michel, with a marvelously realized landscape."

5. Giovanni Bellini, *Sacred Allegory*, Florence, Galleria degli Uffizi

because the painting appears to have been cut down at the top, the vision may have originally been painted in the sky. In any case, none of the traditional rays from Christ's wounds that stigmatized Francis are present; these rays would have remained even if the image of Christ had been removed from the sky. Nor can one be sure whether Francis is depicted in an ecstasy of religious contemplation or in meditation. In contrast to the *Agony in the Garden*, few, if any, narrative or

sequential guideposts are provided. Indeed, Bellini's emphasis here is focused not on temporal sequence, but on a state of timelessness and stasis.

As in the *Agony in the Garden*, the figure of the protagonist occupies only a small portion of the picture. It is, in fact, correct to say that the major carrier of meaning in the *Saint Francis in Ecstasy* is not the saint, but the light-filled, late-afternoon landscape into which he is subsumed. This rocky world, with its distant view of towns and mountains, is elevated by Bellini's use of light from a mere depiction of place to a sacred state of being. All is still and expectant in the pure, unwavering illumination that bathes the scene with holy radiance. Earth, sky, landscape, animals, and humans all seem to exist within a benevolent, welcoming world infused with divine spirit. Bellini's theistic view of nature, which was to appear increasingly in his paintings, embodies perfectly the nature and teaching of Saint Francis, for whom God and His creations were inseparable. The peaceful, uplifting, and optimistic world upon which Francis and the spectator meditate is itself the real subject of the painting. Bellini has eschewed a traditional, easily recognizable subject type or composition; instead he has created an original entity in which all the elements of the picture combine to convey the profundity of both Francis' and the artist's faith in God's omnipresence.

This theistic view, expressed by a radiant landscape of great beauty and tranquility, is seen again in another puzzling painting by Giovanni Bellini. Like the *Saint Francis in Ecstasy*, the so-called *Sacred Allegory* (c. 1475) has been the subject of much scholarly debate about its meaning. The picture has no artistic precedent and offers no obvious clues to its subject, something quite remarkable in a period in which almost all painting followed standard, clearly identifiable types which had been set down long before.

Many of the explanations proposed for the picture's meanings have been highly arcane and would have been recognizable, if at all, only to the very learned. All this uncertainty about what the painting depicts suggests that it does not, in fact, have a unique subject and that its real meaning may, like that of the *Saint Francis in Ecstasy*, reside more in the evocation of a mood

than in a specific temporal narrative. It may, in other words, not have a subject in the conventional sense.

Several of the figures in the *Sacred Allegory* are recognizable. Four saints–Paul, Peter, Job, and Sebastian–are seen in the foreground; the enthroned figure may be Mary, and in the background, a satyr appears next to the flight of steps. But the composition, with its foreground of geometrically shaped pavement tiles and surrounding stone balcony fronting a large lake set in a vast, panoramic landscape, creates a setting of unreality. There is a strong sense of isolation. The various figures appear to be almost randomly disposed and make little physical or emotional contact among themselves. A sense of meditative tranquility is produced, which, with the emotional associations provoked by the placid, shimmering water and luminous landscape, seems to be the picture's real subject.

Discussion of the subject of the *Sacred Allegory* leads to speculation about its function. Its ambiguity of subject seems to preclude its use as an altarpiece, for an altarpiece would have a recognizable subject with clear, traditional iconographic connections to liturgical doctrine and function. Could the *Sacred Allegory* have been commissioned for display in a private house by a patron who wanted neither narrative illustration nor an altarpiece, but rather a work of beauty and subtle emotional complexity–a sort of visual poem? The answer to this question will probably never be known, but the fact remains that the *Sacred Allegory*, like the *Saint Francis in Ecstasy*, is one of the first Venetian, and, for that matter, Renaissance paintings which has no easily recognizable subject matter. In Venetian painting of the sixteenth century, such works will be rightly termed *poesie* ("poems" is a rough translation) and will constitute one of Venice's unique contributions to the history of Western art.

Bellini's role in the history of the Venetian altarpiece is also significant. His development as an artist and thinker, from his early essays in the type, such as the *Transfiguration*, to his mature and late works, is remarkable. For instance, substantial changes may be perceived from a comparison of the early (c. 1450) *Transfiguration* [1] and a later altarpiece of the same subject painted around 1480 [6].

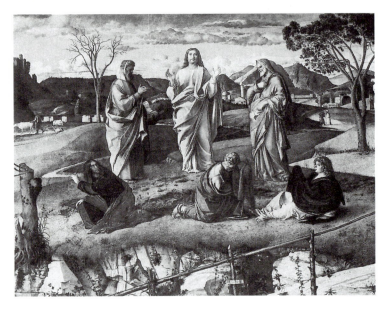

6. Giovanni Bellini, *Transfiguration,* Naples, Museo Nazionale di Capodimonte

The preternatural clarity of vision, as though the figures existed in a vacuum, has been replaced by the depiction of the ambient atmosphere and sacred radiation that so characterized the *Saint Francis in Ecstasy* and the *Sacred Allegory*. The form-bounding lines of the earlier altarpiece are gone, and objects are given substance by light and shadow only. Moreover, the later painting is saturated with color and light and graced by a subtlety of tone absent from the youthful *Transfiguration* [1]. Bellini was able to realize his new vision of the event only through the use of oil paint, a medium in which he was a pioneer. Oil paint, unlike the tempera medium which it replaced, has linseed or other oils as a vehicle to apply the pigment to the surface of the painting (usually gessoed wood in the tempera medium, but primed canvas in oil).[6] Oil, unlike tempera, dries slowly and thus allows the artist to glaze, a process in which translucent layers of pigment are worked into and over eachother. Glazing creates the effects of surface, atmosphere, and depth so clearly seen in Bellini's later *Transfiguration*. Such effects are impossible to achieve in tempera painting. Moreover, oil paint allows a wide spectrum of tone, from the deepest blacks to brilliant white, something also impossible to create with the tempera technique. This range of tones allows an artist to create highly realistic shading and spatial depth. Bellini had sought these effects in his

earliest paintings and had attempted to render them in tempera—
for example, in the *Agony in the Garden*. This he did rather suc-
cessfully, but his employment of oil furnished him with an
almost limitless range of possibilities for the depiction of the
material world.

Along with a new emphasis on atmosphere, Bellini's later
Transfiguration displays an increased monumentality of form
and a surer sense for the integration of landscape and figures.
The formal relation between the figures remains as finely cal-
culated as it did in the earlier *Transfiguration*, a demonstration
of Giovanni Bellini's enduring debt to his father. There are also
some eccentric passages in the painting, typical of Giovanni
Bellini's work, such as the foreground declivity, across which
the eye must leap to focus on the six figures in the landscape.

Giovanni Bellini's later *Transfiguration* focuses on the figure
of Christ. The shining white center of a composition other-
wise constructed almost entirely of browns, greens, and yel-
lows, Christ's form is bracketed by the standing figures of
Moses and Elijah, whose whitish-pink and red robes frame and
direct attention toward Him. The only figure in the painting to
directly confront the viewer, Christ is a bright, shining beacon
of hope and of physical and spiritual renewal in the panoramic,
barren, autumnal landscape (the leaves on the tree at the right
seem to be a later addition).

Christ's levitating body and the strong, pure light in which
it is bathed are also present in another altarpiece by Giovanni
Bellini, whose maturing imagination is again engaged in empha-
sizing the regenerative power of Christ. In this *Resurrection* [7],
which Bellini painted around 1475 for a church on Murano,
one of the islands in the Venetian lagoon, nature and light con-
tinue to convey the spiritual significance of the image. The
light of dawn breaks upon a hilly landscape on a late winter
day; both the earth and most of its inhabitants are still sleep-
ing. The sun is just appearing behind the hills, and its first rays
have turned the underside of the clouds a delicate pink. Much
of the valley is still dark. Yet this is not the start of an ordinary
day, for as the soldiers guarding the dark tomb doze or stare
with astonishment into the sky, Christ levitates, reborn and
pure. The hope for rebirth and salvation embodied in the

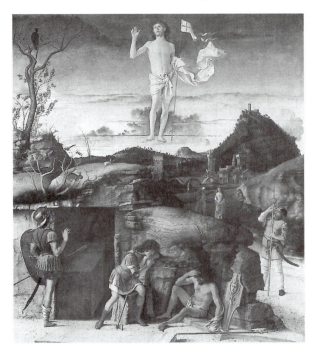

7. Giovanni Bellini,
Resurrection, Berlin,
Gemäldegalerie,
Staatliche Museen

This *Resurrection,* com-
missioned by Marino Zorzi,
was originally the altarpiece
for his chapel in the church
of San Michele on the
Venetian island of Murano

Resurrection is mirrored and made manifest by the dawning of
a new day and by the earth, which seems fecund and alive
beneath the crust of its winter landscape. Bellini highlights this
by placing scampering rabbits above Christ's tomb. In very
few scenes of the Resurrection have light, landscape, color,
and figures been so masterfully composed and interwoven to
convey the central spiritual message of the narrative. There is
but one other fifteenth-century *Resurrection* that rises to the
level of Bellini's work–Piero della Francesca's fresco in San
Sepolcro. It is possible that Bellini saw this work, or one like
it, somewhere in northern Italy where Piero had worked, and
remembered it when he painted his own version of the story.[7]

Bellini's altarpiece, like most other altarpieces of the
Renaissance, was made for a specific chapel. Here the patron
and his or her heirs were to be buried. When it stood upon the
altar at which the Mass, with its mystic elements of birth,
rebirth, sacrifice, and the promises of salvation and eternal life
was said, the remarkable imagery of the *Resurrection* must have
intensified the rite with its vivid presentation of Christ reborn
among the communicants.

Around the time (c. 1475) when the *Resurrection* was completed, Giovanni Bellini was commissioned to paint the first in a series of large altarpieces. These vertical, rectangular forms featured a central image flanked by standing saints. The *Coronation of the Virgin* [8] is often called the *Pesaro Altarpiece,* after the town for which it was commissioned. It, together with several of Bellini's later altarpieces of roughly the same type, constitutes a crucial chapter in the development of Venetian Renaissance painting.

The Pesaro *Coronation* is one of Bellini's best-preserved altarpieces. It still possesses its handsome Renaissance frame, complete with a predella (a storied base), small painted pilaster saints, and an elaborately decorated cornice. A *Pietà*, now in the Vatican Museum, originally crowned the altarpiece. Painted in oil, the *Coronation* once again demonstrates Bellini's meticulous planning. The overall shape of the altarpiece is mirrored in the unusual throne, whose back has been opened to reveal one of Bellini's lovely landscapes. Standing around the throne like columns, the four saints (Francis, Jerome, Peter, and Paul) underscore and echo the verticality of the rectangle. The reced-

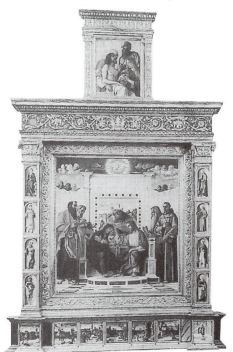

8. Giovanni Bellini, *Coronation of the Virgin*, Pesaro, Museo Civico

The *Coronation of the Virgin* was one of Bellini's most important altarpieces. In addition to the *Coronation* and the *Pietà*, the altarpiece includes seven predella panels and eight saints in tabernacles flanking the *Coronation*.

ing orthogonals created by their bodies guide the eye toward the throne, while their overlapping forms further delineate the space within the picture.

Figures play a crucial role in the *Coronation*. Although landscape is of considerable importance, the composition is built around the human body. This is quite different from other works by Bellini, such as the *Saint Francis in Ecstasy* or the later *Transfiguration,* where the figure is subsumed in the landscape. This tendency to make figures the structural armature of his paintings will henceforth characterize Bellini's altarpieces and give them a new, monumental character that will prove important in the later development of Venetian art.

Part of this increased emphasis on the figure may be due to Bellini's reacquaintance with central Italian art. He already knew and was influenced by Donatello's seminal sculptures in Padua of the 1440s, either through Mantegna or direct contact. Yet in the 1470s, and specifically around the time of the Pesaro *Coronation,* he seems once again to have studied central Italian art, especially that of Florence, incorporating some of what he had recently learned into his own painting. He was, it appears, looking for a new sense of architectonic structure to help order and monumentalize his paintings.

It is usually suggested that the Pesaro *Coronation* demonstrates Giovanni Bellini's knowledge of the painting of Piero della Francesca (c. 1420–1492). In fact, the perspectival construction, the geometric forms of the pavement and throne, the grave, monumental figures, and the walled hillside do resemble the features in several of Piero's works. It is possible that if Giovanni executed the *Coronation* in Pesaro, which seems likely because of the size of the altarpiece, he may have seen Piero's works in Rimini or perhaps even in Urbino. Piero also seems to have worked in Ferrara, a northern Italian city with many ties to Venice, and it may be that Giovanni saw some of Piero's works there or even in Venice itself.[8]

But it is not necessary to postulate only Piero's influence on the Pesaro *Coronation*. By the 1470s, a new generation of Tuscan artists was working throughout the Italian peninsula. Their carefully organized pictures are constructed around a one-point perspective spatial frame and are inhabited by monumental

figures whose forms intermesh with and complement the overall construction of the painting. These designs seem to have especially interested Bellini at this period and may have appealed to him because they recalled his earliest training with his father.

Perhaps more than any other of his mature works, Bellini's Pesaro *Coronation* recalls the austere, intellectual quality of central Italian painting, where every aspect is finely cogitated, planned, studied, refined, and then, and only then, set down in paint.

Yet, the austere, cerebral foundation of the *Coronation* is softened by Bellini's unique light, color, and subtlety of tone. The absolute stillness of the scene and the softly glowing landscape behind it, crowned by the lustrous sky, are all Bellini's own. Late-fifteenth-century painting, throughout the entire Italian peninsula, witnessed an increasing glorification of the natural world. As in Bellini's *Saint Francis in Ecstasy*, a theistic view of nature frequently prevailed. Moreover, the painted landscape of Italy was often elevated by the presence of miraculous events occurring on familiar soil. The Coronation of the Virgin was a miraculous event that took place in heaven, but Bellini has depicted it in a hilly landscape embellished with Renaissance architecture. Here the sacred event occurs in the particular, recognizable environment of the fifteenth-century spectator. In Bellini's vision, the world of the viewer has become heaven itself.

But Bellini completely excluded nature in a large altarpiece finished just slightly later than the Pesaro *Coronation*, restricting his imagery solely to figures in an architectural setting. Painted around 1480 for the Venetian church of San Giobbe (Job was venerated by the Venetians as a saint), the altarpiece [9], like the Pesaro *Coronation*, is a vertical rectangle. The viewpoint, however, has been substantially raised so that the large figures (Virgin, Child, and Saints Francis, John the Baptist, Job, Dominic, Sebastian, and Louis of Toulouse) seem to tower above the spectator, thereby assuming a greater presence than their counterparts in the Pesaro *Coronation*. This new sense of dimension is furthered by the tall, imposing structure in which the figures are placed. Resembling the apse of a church in which the figures are arranged like a living altarpiece, this large and somber structure is a monumental stage setting for the holy personages.

9. Giovanni Bellini, *San Giobbe Altarpiece,* Venice, Galleria dell'Accademia

The apse of the church in this painting displays a mosaic of glittering gold tesserae decorated with a band of cherubim. Bellini has abandoned his own style here to recreate the iconography and look of a medieval mosaic.

These sacred figures are more volumetric and grandly conceived, both in their physical and psychological nature, than the saints of the Pesaro *Coronation.* They are also painted more broadly, so their forms now have a real presence. Volume is created almost entirely by light and shadow, not by line. There is an increased softness and subtlety of tone and ambient atmosphere, which is probably the result of Bellini's increasing skill in the use of oil paint.

Some of the characteristics of the *San Giobbe Altarpiece* seem to have appeared in another, perhaps slightly earlier, altarpiece painted by Bellini, for the Venetian church of SS. Giovanni e Paolo. Because this painting was destroyed in a

nineteenth-century fire, much caution must be exercised when discussing it. It is, in fact, known only through several crude (and possibly inexact) prints [10] and, moreover, no written documents exist that might establish its date.

The lost painting praised by Giorgio Vasari, the important six-teenth-century biographer of Italian artists, has assumed a role of considerable importance in the study of Giovanni Bellini's art.[9] Scholars have seen in this work influences of an altarpiece for the Venetian church of San Cassiano by Antonello da Messina (c. 1430–1479), an artist known to have been in Venice in 1475–1476. Antonello's painting, it has been suggested, fundamentally affected and redirected the art of Giovanni Bellini.

Antonello da Messina is an enigmatic figure. He was born in Sicily probably around 1430, and trained in southern Italy, possibly in Naples.[10] There he would have encountered dis-parate styles from various areas of the Italian peninsula as well

10. Giovanni Bellini, SS. *Giovanni e Paolo Altarpiece,* Venice, SS. Giovanni e Paolo

The loss of this major altarpiece by Bellini is espe-cially regrettable. Vasari already recognized its impor-tance, praising it as one of the great works of Venetian painting. Unfortunately, the painting burned just before the widespread use of pho-tography to document works of art.

as a number of paintings by artists from Flanders who were much admired in the south. These transalpine painters strongly influenced the development of the youthful Antonello, whose early work done for southern Italian patrons can be characterized as eclectic, derivative, and of only mediocre quality.

In the 1470s, Antonello seems to have been working in some of the courts in northern Italy. One of his contacts there may have led to his commission for the altarpiece in Venice. This work was painted for the church of San Cassiano, probably during his stay in the city in 1475–1476. In the seventeenth century, this altarpiece was removed from the church, and it disappeared. Only in this century were fragments of the painting, a Madonna and Child enthroned and four surrounding saints, identified in the Kunsthistorisches Museum in Vienna [11]. Two additional standing saints are known from early drawings.

Writing in the middle of the sixteenth century, Vasari claimed that Antonello da Messina had introduced the technique of painting in oil to Italy and, in fact, the fragments of the San Cassiano altarpiece are indeed painted in the oil medium. Antonello may have learned how to paint in oil from Flemish artists in the south, but he certainly did not introduce the medium to Italy. On the contrary, the medium of oil paint, in which the pigment is applied to the surface of the painting in a slow-drying oil vehicle, had been known there for centuries and had already been employed by Bellini. Around the last quarter of the fifteenth century, oil gradually began to replace the traditional and popular tempera technique in many locations throughout the peninsula.

The original configuration of Antonello's *San Cassiano Altarpiece* has been postulated through various reconstructions made by scholars. These reconstructions look very much like Bellini compositions. This fact, together with Antonello's use of the oil medium, has been adduced as proof that the *San Cassiano Altarpiece* influenced both Giovanni Bellini's lost work for the church of SS. Giovanni e Paolo and his *San Giobbe Altarpiece*. In fact, there are a number of striking similarities among these works.

The questions posed by these similarities are varied and important. Did Antonello da Messina's altarpiece influence

11. Antonello da Messina,
San Cassiano Altarpiece,
Vienna, Kunsthistorisches
Museum

Giovanni Bellini, or was it the other way around? Or could both artists have been influenced by another, as yet unidentified, source? One way of answering these questions is to think about the type of art Antonello made before he appeared in northern Italy in the 1470s. His earlier works were derivative and quite unlike the surviving fragments of the *San Cassiano Altarpiece.* As late as 1474, just one year before he arrived in Venice, Antonello painted an *Annunciation* [12] in Sicily that is provincial in nature and eclectic in its borrowings, both from Flemish art of the first half of the fifteenth century and from contemporary central Italian painting, including perhaps works by Piero della Francesca. The *Annunciation* lacks the monumental, coherent quality of Antonello's *San Cassiano Altarpiece* fragments; its composition is not strongly unified, but rather episodic and anecdotal. These characteristics call to mind the eclectic nature of all the known works produced by Antonello before he arrived in Venice. In the light of Antonello's previous work, one would, therefore, have to postulate either that he reinvented his style single-handedly in the *San Cassiano Altarpiece* or that he borrowed heavily from Giovanni Bellini, the most famous contemporary artist in

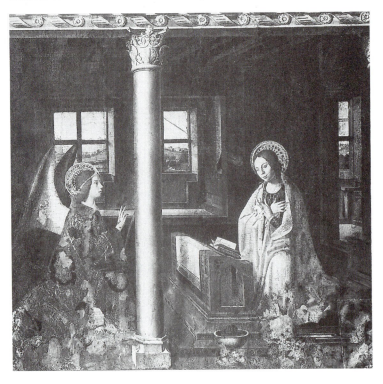

12. Antonello da Messina,
Annunciation, Syracuse,
Museo Regionale del
Palazzo Bellomo

Venice. Given Antonello's highly eclectic nature, the latter
seems most probable.

It is possible that Antonello's use of oil further encouraged
Bellini's employment of the medium, which he used almost
exclusively from the *San Giobbe Altarpiece* onward. Bellini, as
we know from the Naples *Transfiguration* [6], must have been
attracted to oil because it allowed a wide range of tonality and
lights and a subtlety of volumetric modeling with color and
tone, qualities impossible to achieve with the older tempera
technique. These characteristics of oil painting would have
aided Bellini in his search for the monumental, subtle, and
increasingly atmospheric effects which one sees in their mature
form in the *San Giobbe Altarpiece.*

In 1505 Giovanni signed and dated an altarpiece, the
*Madonna and Child Enthroned with Saints Peter, Catherine of
Alexandria, Lucy, and Jerome* [13], still in the Venetian church of
San Zaccaria for which it was painted. Like the *San Giobbe
Altarpiece,* this large work is constructed around a towering

architectural armature. The painting's extensive range and nuance of tone, color, and surface combine to create an atmosphere of luminosity and stillness, a contemplative, sacred world now realized in the fullness of Bellini's late style. Even more than in the *San Giobbe Altarpiece,* Bellini's softly glowing fields of color construct figural form while acting as independent decorative units. The brightest colors, the red and blue of the Madonna's robe and the orange of the angel below, are flanked by the darker colors of the surrounding saints. As in all of Bellini's paintings, color is used to order and articulate form and space.

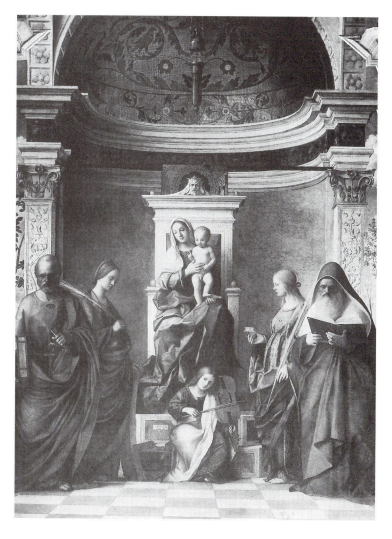

13. Giovanni Bellini, *San Zaccaria Altarpiece,* Venice, San Zaccaria

The four saints are placed beneath a mosaic-covered apse which, in its medieval style, resembles the mosaic of Bellini's *San Giobbe Altarpiece* (fig. 9).

The painted architecture of the *San Zaccaria Altarpiece* was carefully calculated to be a continuation of the architecture of the stone frame surrounding the altarpiece: its painted vault appears supported by the decorated piers of the stone frame, each equipped with capitals and impost blocks. In the painting's background, almost identical piers support the opposite end of the vault. There is, in other words, a sort of merging of the real world of the spectator and the painted world of the altarpiece. The actual space of the church appears to continue into the sacred realm of the holy figures. A similar relation between painting and frame was also an important part of the *San Giobbe Altarpiece,* which, unfortunately, has been separated from its original stone frame.

Yet Bellini, like most other Venetian artists, never allows his paintings to become too real, even when they are so spatially sophisticated. Instead, he restricts their spatial recession by placing the figures within a shallow, constructed environment. This environment, as in the *San Zaccaria Altarpiece* and a number of Bellini's other works, is not always entirely logical. The structure depicted in the *San Zaccaria Altarpiece* is not a church or a tabernacle, but really a huge stage set. Moreover, the bulk of the figures is modified by the breaking of their surfaces into patterns of color. This is best seen in the Madonna's robes, which comprise fields of four different colors that fragment the figure and keep it close to the picture plane. The pattern of the salmon and white floor tiles further splinters the foreground space. This use of color as space-denying pattern recurs throughout the entire span of Venetian painting and will be especially important in the work of Bellini's followers.

Bellini's religious paintings were not limited to altarpieces, but encompass a wide variety of other sacred formats, including the important Madonna and Child composition. The Madonna and Child was one of the most popular of all Renaissance images. Every artist's shop was responsible for painting or carving many of these, which were destined for both churches and private homes. The type had a long history, during which the various possible arrangements of the two figures became codified. Most artists of the Renaissance developed a small stock of these types, which they were content to repeat for the many commissions they regularly received for the image.[12]

Giovanni Bellini's many Madonna and Child pictures are an exception to this tendency. Throughout his long career, even in his very early works of the type, he rethought and reinvented the traditional format; like his altarpieces, the series of Bellini's Madonna and Child compositions demonstrated his highly original approach to painting. Moreover, he never lost sight of the meaning of the image; he continually reinvested it with a subtle sense of tenderness and pathos while always demonstrating his unceasing interest in the most formal properties of painting.

Bellini's earliest Madonna and Child paintings are done in the hard, wiry style of his first altarpieces. They, and all his subsequent Madonna and Child pictures, are indebted to the tradition of Byzantine and Byzantine-influenced examples of the type that were so popular in Venice during the thirteenth and fourteenth centuries. The abstract, pictographic, and geometric structure of these works continually exercised a subtle but persuasive influence on the way Bellini approached the subject.

An early *Madonna and Child* (c. 1460?) [14] is notable for the meticulous adjustment and interweaving of the diagonal and horizontal shapes of the two bodies. The forms of the figures are woven into a complex, sophisticated fugue of echoing and contrasting shapes and patterns. As in many of Bellini's examples of the type, the figures fill much of the picture's space and are placed close to and just above the sight level of the observer. Only at the sides of the picture is there open space, the rest of the painting being occupied by the expansive bodies; nothing is allowed to intrude upon the concentrated physical and psychological presence of the figures. Yet these bodies are never allowed to attain much volume; they are patternlike and flat, much like the abstract Byzantinizing examples so frequently found in earlier Venetian painting. The figures in Bellini's later versions of the subject will become more volumetric, but the artist's need to emphasize the formal properties of the bodies and their patterned, space-denying nature remains strong. The protective embrace of the Madonna and the preoccupied faces create a sense of foreboding that presages the sacrifice of Christ and the Virgin's loss, a sense made immediate and poignant by the reductive nature of Bellini's painting.

14. Giovanni Bellini, *Madonna and Child*, Milan, Pinacoteca di Brera

This painting was originally placed in an office in the Ducal Palace of Venice.

15. Giovanni Bellini, *Madonna and Child*, Venice, Galleria dell'Accademia

This painting, like several Bellini Madonna and Child images, is signed. The name IOANNES BELLINVS appears on the small piece of paper attached to the stone ledge. Christ's position on the ledge, his blessing, and frontal posture would have reminded the Renaissance viewer of scenes of the Resurrection, where a blessing Christ either stood or hovered above his tomb.

In another example of the type (c. 1480?) [15], Bellini rearranges both figures and meaning. Now placed before an extensive landscape (landscapes occur with increasing frequency in Bellini's Madonna and Child paintings), the Virgin seems almost seated while her Son stands on a marble balustrade. Still present is the careful adjustment of patterned form, but now the mood has shifted from the tragic to the triumphant as both Christ and the Virgin look out into the spectator's world. Held and protected by His mother (all Bellini's examples of the type dwell on the human, maternal nature of the young, beautiful mother), Christ blesses the onlooker. Many of these Madonna and Child pictures served as altarpieces, making manifest and visual the presence of the living Christ who miraculously appeared among the priest and communicants during the Mass. Intimate, tangible, yet divine, the Madonna and Child paintings by Bellini remain not only highly sophisticated works of art, but also images that still furnish spiritual enlightenment and nourishment in a most human way.

The landscape in this particular *Madonna and Child* is especially appealing. Kept down to just about the level of the Madonna's shoulders, it is light-filled and welcoming, its mood

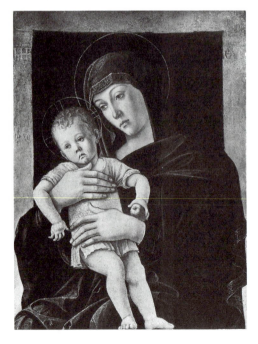

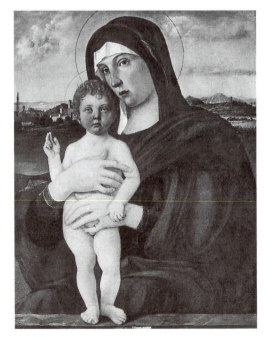

expressive of the triumphant, clear-eyed figure of the blessing Christ. Once again Bellini uses the natural world to express the spiritual meaning of the holy figures.

In one of Bellini's latest (dated 1510) Madonna and Child paintings [16], the landscape has become even more important. In the center of the composition the Madonna, whose robes form a vast lateral expanse, supports the blessing Child. To keep the Madonna's form from becoming too volumetric, Bellini has fragmented it by separating its surface into several hues: passages of reddish-pink, brown, white, and blue turn the large area of the Madonna into a space-denying mosaic of pattern, while the olive green, watered-silk cloth of honor prevents spatial recession behind the Madonna and Child. Moreover, the carefully defined edges of the figures clearly separate them from the surrounding landscape.

Because of this denial of volume and spatial recession, the figures remain close to the picture plane, almost in the observer's space; they seem placed in front of the landscape rather than in

16. Giovanni Bellini, *Madonna and Child*, Milan, Pinacoteca di Brera

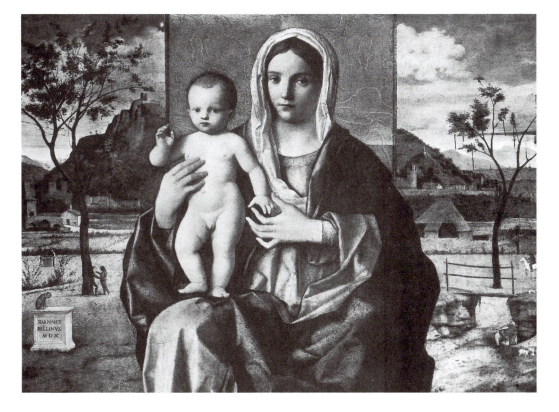

it. The landscape itself, although realistic, appears to belong to another realm, almost as though it were a painting before which the figures sit. The influence of the traditional Byzantinizing Madonna and Child image must, at least partially, account for this tendency to limit volume and spatial recession, and to frag-ment form into patterns of color, even in Giovanni Bellini's most mature examples of the type.[13] That Bellini was respecting the artistic traditions of a venerable type is proven by how very dif-ferent these Madonna and Child images are from his much more spatial and volumetric altarpieces. Yet the dichotomy between figures and landscape is bridged by a unity of mood. The beck-oning late-afternoon landscape, filled with a soft, golden light, seems the exact visual metaphor for the blessing Child and youthful mother who regard the spectator with tender, benevo-lent glances.

The abundant originality and variety that mark Bellini's images of the Madonna and Child also characterize his many paintings of the Dead Christ. In these, Christ appears in several contexts: surrounded by angels, with His mother and other holy figures, or with His mother alone. These several variants on the Pietà image demonstrate the artist's ability to rethink and refor-mulate traditional types to create works of striking invention.

One of these is the arresting *Dead Christ and Four Angels* from c. 1475 [17], which still contains lingering echoes of the influence of Donatello's Paduan reliefs.[14] This painting is a frozen ballet of restrained grief. In fact, it is often the restraint of Bellini's pic-tures that gives them their emotional power. Pushed up close to the picture plane, the echoing, mirroring, or opposing limbs, out-lined against the stark black background, weave an adagio of form that perfectly establishes the meditative quality of this image, which is not a historical narrative, but an icon meant for the contemplation and edification of the communicant.

Bellini has humanized the image, however, by turning the angels into boys whose sadness is both genuine and touching. Especially noteworthy and daring is the supporting figure whose head is hidden behind Christ. Each clad in a different sober hue, these alert little figures form a strong contrast with the large Christ set diagonally across the surface of the picture. Much attention has been given to the blood of Christ: it is seen

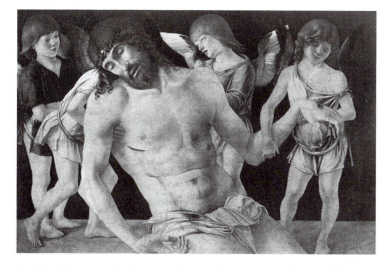

17. Giovanni Bellini, *Dead Christ and Four Angels,* Rimini, Pinacoteca Comunale

This painting, originally placed in the church of San Francesco in Rimini, was probably commissioned by a member of the city's ruling family, the Malatesta. Bellini's asymmetrical placement of the figures is notable.

in the side wound, dripping down the torso, pooling in the loincloth, and dripping down His left elbow; its color is also echoed in the red notes of the angels' clothes. This emphasis on Christ's blood, like the prominent display of His body, would have made manifest the invisible miracle of the Mass, where the wafer and wine of the liturgical service miraculously become the body and blood of Christ.

Christ's body is also the focal point of an ineffably moving *Pietà* (c. 1475?), one of Bellini's masterpieces [18]. Flanked and held by the Virgin and Saint John the Evangelist, Christ is set before a landscape (the format of the painting recalls happier scenes by Bellini of the infant Christ among the Virgin and other saints). The amassing of the three bodies and the complex, sophisticated relation between their heads and hands (each of which is a different expressive entity) create a subtle network of physical and psychological connections.

The starkness of the human tragedy in the foreground is echoed by the background, which rather than receding horizontally, rises vertically like many of Bellini's landscapes so as to keep all forms near the picture plane. Above the dark hills and scattered trees is a leaden, cloud-streaked sky illuminated only at the horizon by a pale band of light. In this *Pietà,* Bellini dwells neither on the redemptive nature of Christ's sacrifice nor on the regenerative potential of nature. Instead the work functions as an essay in unalloyed grief and suffering, which, in its brilliant and

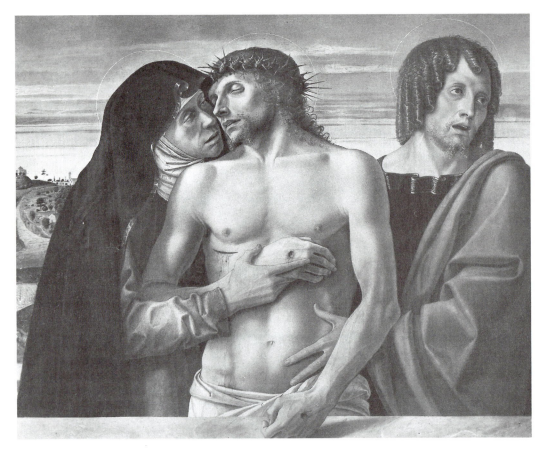

18. Giovanni Bellini, *Pietà*, Milan, Pinacoteca di Brera
 The background of this painting contains one of Bellini's most impressive cloudscapes.

restrained depiction of these emotions, rises to a level of expressiveness seldom matched in the long history of the image.

Bellini's ability to create emotion also extended to his treatment of allegorical and mythological subjects. The representation of such subjects in paint was just gaining popularity, and his several depictions of these nonreligious themes seem to have had a great influence upon this type of painting, which was to become increasingly important in Venetian art. Bellini's major work in the mythological genre is the famous *Feast of the Gods* [19], which he signed and dated in 1514, two years before his death. This painting, commissioned by Alfonso d'Este, duke of the northern Italian city of Ferrara, for a room called the Camerino d'Alabastro (after its alabaster carvings), was probably located in a passageway connecting the palace and castle of the city. Bellini's picture was the first of a series of

painted decorations that was eventually to include three other
pictures by his pupil, Titian. Other, non-Venetian artists also
contributed to the decoration of this room, but only a few of
their paintings and sculptures survive. The exact location and
dates of the decorations made for the Camerino d'Alabastro
are not known with certainty.

The history of the Camerino, which seems to have been a pri-
vate rather than a public room, is complicated, but it does appear
that Duke Alfonso wished to commission a series of canvases
based on descriptions of paintings found in the writings of Greek
and Roman authors.[15] This desire to emulate antiquity was very

19. Giovanni Bellini, *Feast of
the Gods*, Washington, D.C.,
National Gallery of Art

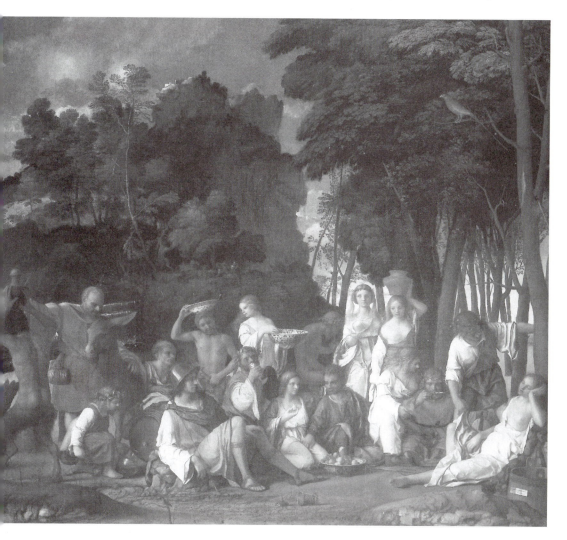

much part of the general revival and even adoration of the classi-
cal past inspired by the humanist historians and philosophers
whose writings had a considerable impact on many of the ruling
courts of Italy. Alfonso, who was first and foremost a soldier,
could demonstrate his learning and taste by commissioning a
series of antique-inspired works from famous artists. He may also
have been trying to rival his famous sister, Isabella d'Este, who
had commissioned a group of well-known artists to decorate her
studiolo with pictures of antique subjects. She had, in fact,
attempted to enroll Giovanni Bellini in her endeavor, but he man-
aged to escape her demanding commission.

Alfonso had initially enlisted Raphael and the well-known
Florentine painter Fra Bartolommeo for his scheme, but these
artists never seem to have progressed beyond the stage of
preparing preliminary sketches. He was, however, successful
with Bellini, whose painting is derived from the Roman author
Ovid's *Metamorphoses,* the most popular source of mythological
tales in the Renaissance.[16] The story Bellini depicted takes place
during a feast of Bacchus. The assembly of gods, pans, satyrs,
and naiads was sleeping after an evening of drinking and
carousing when Priapus, a god of fertility renowned for his
enormous penis, furtively attempted to sexually attack the
sleeping nymph Lotis. His efforts were foiled by the braying of
an ass. This noise awoke Lotis and the rest of the celebrants,
who then laughed at the embarrassed Priapus. It is a tale of lit-
tle action, requiring a painter with real narrative skill to make it
come alive. Exactly why this rather obscure tale from Ovid
should have been chosen for Alfonso d'Este's Camerino
remains uncertain, but, like several other stories depicted in the
room, it revolves, in part, around wine and wine drinking.
Perhaps they allude to Alfonso's vineyards or some other
aspect of viticulture in Ferrara and its territories, which were,
and remain, important producers of agricultural products.

The importance of Bellini's work is, nevertheless, clear; the
Feast of the Gods is among the earliest large-scale Venetian
depictions of mythology. His position as the grand old man of
Venetian art in the first years of the sixteenth century ensured
that such a prestigious, princely commission would exert vast
influence on other artists. Moreover, Bellini's ability to create

a believable and appealing world invested with the spirit of the ancient gods was revolutionary. The carnality and sensuousness of both body and atmosphere, a kind of pagan analogue to Bellini's religious scenes, elevated the depiction of mythology to a new, more sensory realm that was to inspire scores of mythological paintings throughout the subsequent history of Venetian art. This painting was to have a major influence on Titian who, in fact, repainted the background to make it harmonize with his own contributions to the Camerino d'Alabastro. Originally the trees silhouetted against the sky in the right background continued across the picture. These were painted over by Titian, who put in the large mountain at the left to make the background conform to the three paintings he executed for the room.

Bellini's mythological and religious paintings were less rooted in the past than were his traditional and conservative portraits. Consequently, his influence on portraiture waned with the appearance of Titian's newly invented methods of recording the human face, which first started to appear around 1515. But, up until that date, Bellini and his shop had been the major supplier of Venetian portraits, which they produced in increasing numbers. The portrait was to become an important, highly developed painting type in Venice, and its influence on artists from outside the city was to change the course of portraiture throughout Europe.[17]

Most of Bellini's portraits show only the face, usually seen in three-quarter view, and the torso of the sitter. This arrangement of the sitter, which replaced the earlier view of the face in strict profile, developed in Florentine painting during the last quarter of the fifteenth century. Bellini's portraits depict the Venetian male patriciate, but there is little in them, aside from the style in which they are painted, which can be classified as particularly Venetian–Bellini seems to have depended upon Florentine models. As is the case with almost all portraits produced before 1500, Bellini's portraits are not essays or interpretations of the sitter's character. Rather, they are superbly designed and painted images meant principally to provide, in brilliantly concentrated form, the outward appearance and station of their sitters.

The lapidary *Doge Leonardo Loredan* (c. 1505) is an icon of authority and power [20]. Every aspect of the face, torso, and costume is rendered with a fidelity which must have made this portrait startlingly realistic to the doge's contemporaries. There is much in Bellini's portrayal of the doge–the crispness and hardness of detail, the frozen quality of the face, the way the torso seems almost to sit upon the stone ledge rather than stand behind it–that reminds one of contemporary carved portrait busts. But this stony quality is mitigated by the living eyes and delicate, almost transparent, flesh that gives the face a subtle vivacity achievable only in the oil medium. It is the tension between the desire to record the topography of the face and the wish to exhibit status that makes the portrait compelling.

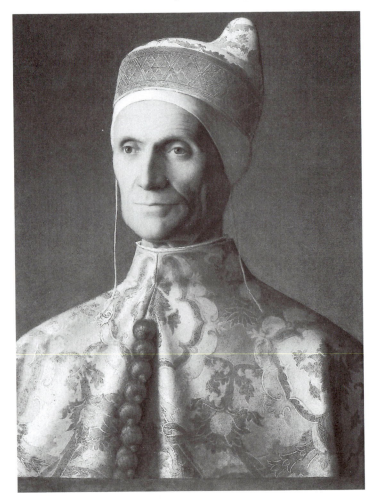

20. Giovanni Bellini, *Doge Leonardo Loredan*, London, National Gallery

Born in 1436, Leonardo Loredan was Doge of Venice during the decades that witnessed Titian's early work and first major commissions (1501-1521).

Bellini also painted portraits of men of less exalted station. Many of these present the same delicate balance between the display of face, social position, and the tentative exploration of the sitter's psyche seen in the *Doge Leonardo Loredan*. An especially felicitous example of this type is the *Portrait of a Man* (c. 1505, sometimes mistakenly called Pietro Bembo) [21], which is complemented by the extensive landscape with towers and a range of mountains seen in the distant blue haze. As in Bellini's mythological and religious paintings, the landscape adds an expressive dimension. The gently rolling green hills and bright sky evoke a sense of serenity that envelops the sitter. The man's body and face are, at one and the same time, both a highly abstract series of forms and a convincing description of an individual human being whose character is hinted at, but never revealed. Everything in the painting is seen through an atmosphere laden with light and moisture that caresses and softens the forms, performing exactly the same function as it does in many of Bellini's religious and mythological paintings. The particular softness and luminosity of this *Portrait of a Man* may owe something to the fertile art of Bellini's pupil Giorgione, whose few securely attributable paintings are filled with a similar atmosphere.

21. Giovanni Bellini, *Portrait of a Man*, Hampton Court, Royal Collection

Giovanni Bellini painted a number of portraits, all bust-length and framed in front by a stone ledge. Many of the sitters, most of whom have not been identified, are depicted sporting similar hair styles, dark tunics, and hats. The quality of these portraits varies, suggesting that Bellini's shop may have had a hand in them.

In his recasting of traditional types that he imbued with new meaning, Giovanni Bellini reshaped Venetian painting. In many ways, he defined that painting by his handling of form, color, and surface. He popularized the use of oil painting and exploited its illusionistic properties. Bellini also marked out the boundaries of representation within which all subsequent Venetian artists were to work until the dissolution of the school in the early nineteenth century.

Giovanni Bellini was the most famous and influential painter of the last half of the fifteenth century in Venice and he maintained a large workshop that trained artists for their own careers. Not surprisingly, his innovations were built upon by a series of Venetian painters of considerable talent. The artist most closely related to Giovanni was his brother Gentile, who had also been trained by their father, Jacopo. Gentile was a less gifted and innovative artist than his brother, but his paintings for several Venetian *scuole*, the confraternities of the city, are, nonetheless, remarkable.[18]

Throughout the Italian peninsula, such confraternities, often composed of members with similar occupations or rank, played an important role in society by performing many of the social and charitable services otherwise unavailable in a society without a governmental social welfare system. They tended the sick, buried the dead, dispensed large amounts of money to the poor, and furnished numerous other social benefits. In Venice these *scuole* were especially notable for the number and importance of the works of art they commissioned to decorate their meeting halls. From the late fifteenth until the eighteenth century, paintings for the *scuole* were furnished by the major Venetian artists, who continually developed and enriched this site-specific type.

Gentile Bellini's paintings (1496–1501) for the *scuola* of Saint John the Evangelist, one of Venice's most important confraternities, employ many of the elements that distinguish the early examples of the Venetian *scuole*. Foremost among these is a particular attention to the minute details of everyday life. The works display a remarkable, loving veracity in rendering the physical and atmospheric environment, especially when the scene is set in Venice. But even when the location is suppos-

edly foreign, the setting is often Venetian-like. Part of the rea-
son for this must lie with the commissioners who, inordinately
proud of their city and their elevated social position in it,
insisted that it be portrayed with a high degree of fidelity and
detail in the pictures for which they paid. Such interest in the
representation of the real world was also characteristic of
Venice as a whole, a city whose painters were increasingly fas-
cinated with depicting appearances.

Gentile Bellini's *Miracle of the Relic of the True Cross Recovered
from the Canal of San Lorenzo* from 1500 [22], one of his several
paintings for the *scuola* of Saint John the Evangelist, is a classic
example of the type. The subject is the miraculous recovery of
the confraternity's major treasure, a fragment of the True
Cross. This had fallen into the Canal of San Lorenzo during a
procession of the members of the *scuola* in the late fourteenth
century. The relic skidded across the surface of the water,
frustrating all attempts at rescue until the pious Andrea
Vendramin, the Grand Guardian of the *scuola*, brought it safely
to land.

The story is told by Bellini with precision and detail.
Witnessed by a large crowd, which includes portraits of the
most important members of the confraternity, kneeling at the
right, the narrative unfolds in a setting of almost photographic
realism. The buildings that flank the canal, the bridge, and the
dress of the spectators faithfully reproduce the world of early
sixteenth-century Venice. Even the miracle of the animate relic
and its discovery by Andrea Vendramin are treated quite pro-
saically. But the particular talent—genius, one might say—of
Gentile Bellini and several other Venetian painters engaged
upon similar commissions for the Venetian *scuole* is their ability
to elevate the quotidian reality of the stories into an altogether
different, higher realm. The aqueous, luminous world of Venice
has been frozen in time, its buildings and inhabitants magically
fixed forever. Venice and its citizens have been both ennobled
and sanctified.

Vittore Carpaccio (c. 1465–1526) was the foremost fifteenth-
century painter of the *scuole*.[19] During the years between 1490 and
1526, he brought the type to a very high level of formal and nar-
rative sophistication. Several series of large canvas paintings com-

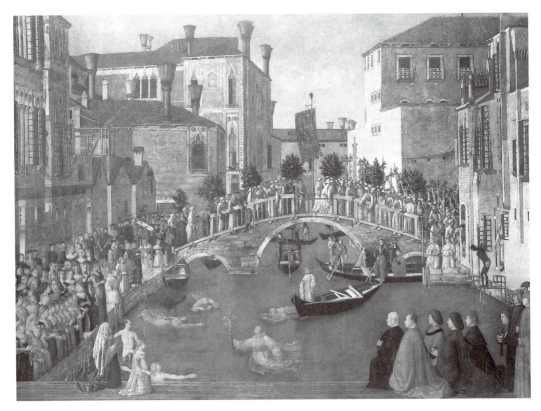

22. Gentile Bellini, *Miracle of the Relic of the True Cross Recovered from the Canal of San Lorenzo,* Venice, Galleria dell'Accademia

Gentile's first independent works date from the early 1460s. In 1479, he joined a Venetian diplomatic mission to Constantinople, where the following year he painted a portrait of the reigning sultan, Mehmet II (1423–1481), now in the National Gallery, London. Gentile spent much of his career painting in the Palazzo Ducale, Venice. Unfortunately, his works were destroyed in 1577 during the great fire, an event that furnished many artists with commissions to replace the lost paintings.

missioned to decorate the meeting halls of the Venetian *scuole* constitute his most notable contributions to the history of Venetian art. Among these are the paintings for the *scuola* of Saint Ursula, his largest and most ambitious enterprise. Like Gentile Bellini's *Miracle of the Relic of the True Cross Recovered from the Canal of San Lorenzo,* Carpaccio's paintings elevate a minute description of everyday reality into a sacred fantasy. In his *Departure of Saint Ursula and the Prince* of around 1496 [23], Carpaccio transforms the French port, from which the heroes of the Ursula legend set sail, into a Venetian fantasy of glistening water, moisture-laden air, imposing castles, and marble-clad palaces. Like many Venetian painters, he dwells on the sensual nature of the world he illustrates. This painting encourages undisguised delight in the texture and color of heavy fabric, smooth stone, and still water, all of which please the eye and stimulate the senses.

Many of the *scuole* paintings, and especially the *Departure of Saint Ursula and the Prince,* are visual chronicles of their time. In

them, myriad facets of Venetian life at the beginning of the six-
teenth century are described with remarkable accuracy.
Fascinating glimpses into the daily life of the Venetians–from
the many types of houses that they inhabited to the ships that
ensured the city's economic livelihood–are reproduced with
amazing and loving fidelity. Inhabiting this world one sees
dozens of portraits (recognizable by the individualism of their
unidealized faces) of the leading members of the *scuola* who
helped finance the painting and wished to be immortalized by
their presence in it. Such portraiture, which appears often in
paintings for the Venetian *scuole* (and which may be one of the
reasons why the type was so popular), is an early example of
large-scale group portraiture in Europe, and an important pre-
cursor of the development of the portrait in later Venetian
painting.

By 1500, the foundations of much of the later history of
Venetian painting had been laid. The major architect was
Giovanni Bellini, the artist whose own work blazed many of the
paths to be followed by generations of Venetian artists. His
early work took shape against the background of the highly con-
servative Byzantine-Venetian tradition and the subsequent
waves of influence then emanating from Tuscany and Padua.
Working under the sway of his father Jacopo and his brother-in-
law, Andrea Mantegna, Giovanni Bellini developed a personal
style that went far beyond the basically fifteenth-century idiom

23. Vittore Carpaccio,
*Departure of Saint Ursula and
the Prince,* Venice, Galleria
dell'Accademia

Vittore Carpaccio seems
to have trained with Gentile
Bellini. Carpaccio's earliest
dated work is one of the
canvases of the Saint Ursula
legend. Carpaccio and his
teacher were the outstand-
ing painters of historical nar-
ratives such as the Ursula
scenes.

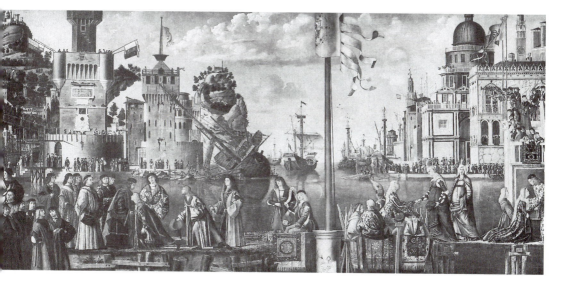

of his predecessors. His art incorporated a new theistical vision of the world populated by sacred and mythological figures of beauty and charm, a world of enchanting light and quietude where nature is endowed with its own expressive qualities. As he approached full maturity, Bellini's work became more monumental, unified, and ultimately, more moving. This late style was the inspiration for a whole generation of Venetian painters, several of whom were his students. While they moved decisively away from his idiom, these artists, nonetheless, almost always worked within the vast boundaries which Bellini's art had already marked. Central concepts about the figure, pictorial composition, the portrait, and the role of nature held by Venetian artists throughout the sixteenth century remained fundamentally indebted to the painting of Giovanni Bellini.

Other important artists–Jacopo Bellini, Mantegna, Gentile Bellini, Carpaccio, and their lesser contemporaries–also contributed to the development of the Venetian idiom and its interpretation of subject, although their work was not as portentous as was Giovanni Bellini's. Nonetheless, by the beginning of the sixteenth century, a manner of painting and perceiving had been developed in Venice that could now undoubtedly be called "Venetian." The next generation of painters would build upon this legacy while propelling the city's art to a place of considerable importance both in the Italian peninsula and throughout Europe.

NOTES

1. Background on the profession of Renaissance painting is offered by B. Cole, *The Renaissance Artist at Work*, New York, 1983. See also the important chapters on art in O. Logan, *Culture and Society in Venice, 1470–1790*, New York, 1972.

2. The major work on Jacopo Bellini is C. Eisler, *The Genius of Jacopo Bellini*, New York, 1989.

3. For information on Gentile da Fabriano, consult K. Christansen, *Gentile da Fabriano*, London, 1982. The decoration of the Doges' Palace is well described in W. Wolters, *Der Bilderschmuck des Dogenpalastes*, Wiesbaden, 1983.

4. The work of Andrea Mantegna is discussed at length by E. Tietze-Contrat, *Mantegna*, New York, 1955, and R. Lightbown, *Mantegna: A Complete Catalogue of Paintings*, Berkeley, 1986.

5. Significant works on Giovanni Bellini include G. Robertson, *Giovanni Bellini*, Oxford, 1968; J. Wilde, *Venetian Art from Bellini to Titian*, Oxford, 1974; and R. Goffen, *Giovanni Bellini*, London, 1989.

6. Valuable sections on the technique of oil painting from G. Vasari's *Lives* have been conveniently gathered in *Vasari on Technique*, trans. L. Maclehose, New York, 1960; see also M. Doerner, *The Materials of the Artist and Their Use in Painting*, New York, 1969.

7. Piero della Francesca's *Resurrection* is discussed in B. Cole, *Piero della Francesca: Tradition and Innovation in Renaissance Art*, New York, 1991: 79–84, passim.

8. For an overview of Piero della Francesca, see B. Cole, *Piero della Francesca: Tradition and Innovation in Renaissance Art*, New York, 1991.

9. Giorgio Vasari (1511–1574) published two editions of his famous *Lives of the Painters, Sculptors, and Architects*–the first in 1550 and the second, much enlarged, in 1568. The importance of this series of artists' biographies cannot be overstated. Vasari, although prejudiced in favor of Tuscan artists, knew many of the most important painters, sculptors, and architects of his time, including Titian. The facts, anecdotes, and descriptions of works of art in Vasari's book form the foundation of the study of Renaissance art. There are two excellent English translations of the *Lives*: G. Vasari, *The Lives of the Artists*, trans. J. and P. Bondanella, Oxford, 1991; G. Vasari, *Lives of the Painters, Sculptors, and Architects*, 2 vols. trans. G. de Vere, New York, 1996. For Vasari as artist and historian, see P. Rubin, *Giorgio Vasari: Art and History*, London, 1995. Vasari as writer and myth-maker is the subject of a series of fine books by P. Barolsky, *Michelangelo's Nose: A Myth and Its Maker*, University Park, Pennsylvania, 1990; *Why the Mona Lisa Smiles and Other Tales by Vasari*, University Park, Pennsylvania, 1991; *Giotto's Father and the Family of Vasari's Lives*, University Park, Pennsylvania, 1992.

10. The work of Antonello da Messina is described in F. Sricchia Santoro, *Antonello da Messina e l'Europa*, Milan, 1986.

11. For the San Cassiano altarpiece, see J. Wilde, *Venetian Art from Bellini to Titian*, Oxford, 1974: 30–31 and plate 30.

12. Information on the subject of repetition in Renaissance painting can be found in A. Thomas, *The Painter's Practice in Renaissance Tuscany*, Cambridge, England, 1995.

13. On the Byzantinizing tendencies, there is no comprehensive study of the influence of Byzantine painting on Venice, nor is there a standard book on the early history of painting in the city–both are much needed; see, however, M. Muraro, *Paolo Veneziano*, Milan, 1969.

14. Donatello's work in Padua is dealt with in H. Janson, *The Sculpture of Donatello*, 2 vols., Princeton, 1957, and J. Pope-Hennessy, *Donatello, Sculptor*, New York, 1993.

15. The Ferrara Camerino d'Alabastro is discussed in J. Walker, *Bellini and Titian at Ferrara*, London, 1956. See also E. Wind, *Bellini's Feast of the Gods*, Oxford, 1948.

16. Ovid, *Metamorphoses*, trans. R. Humphries, Bloomington, 1955.

17. On the history of Renaissance portraiture, consult J. Pope-Hennessy, *The Portrait in the Renaissance,* Princeton, 1969, and L. Campbell, *Renaissance Portraits,* London, 1990.

18. Recent major treatments of Gentile Bellini are in J. Meyer zur Capellen, *Gentile Bellini,* Wiesbaden, 1985, as well as in P. Brown, *Venetian Narrative Painting in the Age of Carpaccio,* New Haven, 1988.

19. For more on Vittore Carpaccio, see J. Lauts, *Carpaccio: Paintings and Drawings,* London, 1962; P. Humfrey, *Carpaccio,* Florence, 1991; V. Sgarbi, *Vittore Carpaccio,* New York, 1994.

3

Giorgione, Sebastiano, and the Young Titian to c. 1510

✤

Between 1500 and 1505, Giorgione, Sebastiano del Piombo, and Titian, three artists of remarkable talent and innovation, emerged from the workshop of Giovanni Bellini. Although it has been the subject of intense scholarly debate, the exact relation of these men to Bellini, and to one another, remains a mystery. This is because many of the key works by these artists are undated and undocumented. It is paradoxical that such an important stage in the history of Venetian painting should be so bereft of facts.

The most enigmatic of these three figures was Giorgione (c. 1477–1510).[1] Much of the knowledge about him and many of the opinions about his character and art stem from his biography in the second edition of Giorgio Vasari's *The Lives of the Most Excellent Painters, Sculptors, and Architects*, published in Florence in 1568.[2] Vasari, a sixteenth-century painter and biographer of artists, furnishes a highly romantic, often fictional,

account of Giorgione, who, he says, was born in the small town of Castelfranco Veneto in 1477. But nothing certain is known about Giorgione until his name surfaces in connection with a painting he was working on in 1507 for the Audience Hall of the Doges' Palace in Venice. Then, in the beginning of November 1508, he was paid for finishing frescoes on the exterior of the Fondaco dei Tedeschi, the German commercial center in Venice. In 1510, a letter from Isabella d'Este, one of the most notable patrons of art of the time, states that he is dead. Thus, Giorgione is recorded for only three years (1507–1510), and only two works, both lost, are documented during this time. There exists, however, a list of his paintings in private Venetian collections, compiled by Marcantonio Michiel between 1525 and 1543.[3] This list furnishes valuable, near-contemporary information on several other paintings, of which only four can be identified with certainty today. Although scores of paintings have been attributed to Giorgione over the years, only these, plus an altarpiece painted by him for his hometown of Castelfranco [24], can serve as the touchstone for authenticating the many works attributed to him.

There is reason to believe that the *Castelfranco Altarpiece* was painted shortly after 1504 on the commission of Tuzio Costanzo, a soldier of fortune. Painted for the chapel of Saint George in the old church of San Liberale, the altarpiece depicts four holy figures: the Madonna and Child with Saints George and Francis. The Madonna, who dominates the upper third of the altarpiece, is seated on a throne high above the two attendant saints, who, unlike the Madonna, are separated from the panoramic background by a wall. It is possible that the towering placement of this throne is related to a similar configuration in Antonello da Messina's painting [11] for the church of San Cassiano in Venice, painted in the 1470s, but such a connection must remain pure speculation. Exactly how the throne in Giorgione's altarpiece is constructed and precisely where it stands is unclear: It defies architectural logic and its exact position in the picture's space is also uncertain.

In a sense, the *Castelfranco Altarpiece* is composed of two separate realms. The first realm is located in the upper third of the picture, and includes the Madonna, Child, and landscape.

24. Giorgione, *Castelfranco Altarpiece,* Castelfranco Veneto, Duomo

This painting contains two references to Tuzio Costanzo. The large centrally-placed roundel at the base of the Virgin's throne encloses Costanzo's coat-of-arms, while the soldier-saint George, the patron of the chapel in which the altarpiece was originally placed, indirectly refers to Costanzo's calling as a mercenary.

This entire area recalls late Bellini Madonna and Child paintings where the figures are placed before a panoramic background [16], although the close rapport between spectator and Madonna in these paintings is absent in Giorgione's altarpiece. The lower two-thirds of the picture's surface constitutes the second realm of the painting: It is filled with two standing saints, the pavement, and the wall that blocks access to the landscape behind and separates the two areas of the painting.

Lacking the architectural framework and the coherent, meticulously planned structure of Bellini's later altarpieces, the *Castelfranco Altarpiece* appears curiously disjointed. It does not

approach the sophistication of composition characteristic of painting in Venice at the time. However, the poses of the two figures, especially that of Saint Francis, recall the standing saints of Bellini's *San Giobbe Altarpiece* [9], which may have been known to Giorgione either directly or through modified copies he may have seen in the Veneto.

The *Castelfranco Altarpiece* undoubtedly depends on Bellini for its figural types and landscape. But it also reveals other influences in more indirect ways. Vasari, always anxious to discern inspiration from his native Tuscany, writes that "Giorgione had seen some things done by Leonardo that, as has been mentioned, were very subtly shaded off and darkened, as has been said, through the use of deep shadows. And this style pleased him so much that, while he lived, he always went back to it, imitating it most especially in his oil paintings."[4] Where exactly Giorgione saw works by Leonardo is unknown, but the softness of the shadow and the blurring of outline throughout the *Castelfranco Altarpiece* may well have been derived from Leonardo's paintings or imitations of them by his north Italian followers.[5]

Aspects of Giorgione's style may also depend on painters from Lombardy and Emilia-Romagna whose work he may have seen in the Veneto. A plethora of influences from Venice, Florence, and Rome was responsible for the eclectic development of the art of many of Giorgione's contemporaries from small towns in the Veneto. Extensively borrowing the most novel or striking characteristics from urban artists working in the vicinity, the art of these local painters is often a compendium of styles. Giorgione's borrowings are much more subtle and more fully absorbed into the mainstream of his personal style, but they characterize the *Castelfranco Altarpiece* as provincial nonetheless. In fact, were this painting not seen solely through the pious, romantic myths which Vasari and others developed around Giorgione's later paintings, one would be hard pressed to judge the earlier *Castelfranco Altarpiece* as anything other than a highly competent work by a talented, mildly eclectic provincial artist who seems to have had his earliest training in or around the small town in which he was born.

There is a particular overall softness and dreamy quality about the *Castelfranco Altarpiece,* especially present in the land-

scape. All the figures seem lost in a reverie of thought tinged
with melancholy, each absorbed in his or her own private and
personal meditation, the meaning of which the spectator can-
not fully fathom. This particular meditative quality and the
open, atmospheric landscape, which play such a prominent
role in the picture, are often called "Giorgionesque," for they
appear in all of the paintings securely attributed to Giorgione.
But similar characteristics are also found in paintings by
Giovanni Bellini dating from the 1470s onward. Both the *San
Zaccaria Altarpiece* of 1505 [13], and his *Madonna and Child* of
1510 [16] are strongly infused with a like spirit, and it may be
that the mood of Giorgione's composition was ultimately
derived from paintings by Bellini or his close followers. It is
also quite possible that Giorgione's paintings, which built upon
and expanded Bellini's vision of landscape and mood, may
have, in turn, influenced Bellini's own late works.

Vasari does not indicate with whom Giorgione studied, but
in the absence of documentation, it has usually been assumed
that it was with Giovanni Bellini. This may in fact be true, but
it is also possible that Giorgione, as evidenced by the
Castelfranco Altarpiece, may have first worked with a local
artist in or around Castelfranco Veneto before migrating to
Venice. The date of Giorgione's arrival there is unknown.
What is certain is that by 1507 he was at work in the Doges'
Palace, and in 1508 he had completed the frescoes for the
façade of the Fondaco dei Tedeschi. Since both of these paint-
ings have been destroyed, the comprehension of Giorgione in
Venice must be based on only the few surviving small-scale
paintings that the early sources attribute to him with certainty.

Among these the most famous, and enigmatic, is the so-
called *Tempest* [25]. In 1530 this painting was seen by Michiel
in the Venetian collection of Gabriele Vendramin. Michiel
attributed the painting to Giorgione and called it "a small land-
scape painting with the storm and with the Gypsy and soldier."
This nearly contemporary identification of the subject, which
Michiel may have obtained from Vendramin, who owned and
possibly commissioned the work, has usually been rejected
as too simple. Since Michiel's time, a multitude of theories,
ranging from sober, learned arguments to incredible, equally

25. Giorgione, *Tempest,*
Venice, Galleria
dell'Accademia

The Tempest has become
a battlefield for conflicting
and usually arcane explana-
tions attempting to unlock
its meaning. To date no
solution has been widely
accepted, and the picture
remains an unsolved
mystery.

learned flights of fancy, have been advanced to explain the
meaning of the *Tempest.*[6]

The most sensible, if not most fashionable, solution to the
problem may be to rely on Michiel's account rather than to
look beyond the surface of the painting for cryptic hidden
meanings. That the painting lacks a clearly defined subject is
also supported by x-rays, which reveal that Giorgione had
originally painted a seated female nude in the place now occu-
pied by the standing soldier. If an obscure, yet specific subject
had been planned for the painting, a carefully drawn layout of
both the iconographic and visual elements would have first
been made. The radical change of sex and position of the two
figures seems to suggest just the contrary, that Giorgione was
doing a fair amount of improvisation during the creation of the
painting.

If indeed the *Tempest* has no subject matter, it would be an
early example of a type that seems to have originated in
Venice. As with Bellini's *Saint Francis in Ecstasy* and *Sacred
Allegory*, its real meaning may lie in its mood of mystery and

anticipation. Who are these figures, what is their relationship, if any, and what are they doing in this beautiful but enigmatic setting that seems to be in the midst of the calm just before the arrival of an impending storm? The mysterious nature of the *Tempest* is one of its most compelling and enjoyable aspects, and all attempts to explain it have, in fact, diminished its meaning rather than enhanced it.

The figural elements in the painting are overshadowed by the ruins, the river, the town, and the dynamic sky illuminated by a flash of lightning. The depiction of the material world—its shape, feel, color, and texture—is executed with consummate skill and understanding to create a palpable, living environment for the foreground figures. The sensuousness of this painting, its use of shadow to veil and soften forms, the physical and psychological distance between the man and woman, and its atmosphere laden with light and moisture are very like Giorgione's *Castelfranco Altarpiece,* although the integration and unification of all the elements here are more accomplished and successful, suggesting a later date for the *Tempest.*

The *Tempest* and several other contemporary paintings that are also seemingly without subject must have appealed to a sophisticated group of collectors who were beginning to search for works outside the conventional thematic range of altarpieces, portraits, and civic images. These same collectors were also increasingly concerned with the artist as much as the subject. The famous patron Isabella d'Este, for instance, instructed her agent to find a painting by Giorgione for her collection. Although she specified which painting was to be bought, it is clear from the correspondence that she was principally after "a Giorgione" rather than, say, a sacred representation to be appreciated solely for its pious qualities.[7]

This sort of perception of art and painters signals a new attitude on the part of both patron and artist. By the first decades of the sixteenth century, several artists of surpassing talent (Raphael, Michelangelo, and Titian, to name the three most important) had begun to rise in economic and social stature well above the traditional craftsman status of their predecessors. Their paintings were eagerly sought by collectors happy to have almost anything from their workshops. This

cult of the artist first appeared in Venice, albeit in embryonic form, in the early 1500s, and Giorgione's life and work were among its first beneficiaries.

Giorgione's reputation must have also been enhanced by his excursions into the realm of mythological subjects, a type of painting that was then just gaining favor. The *Sleeping Venus* [26] (sometimes called the *Dresden Venus,* after its present location) was seen by Michiel in 1525 in the house of Gerolamo Marcello in Venice. Michiel writes, "The canvas of the naked Venus sleeping in a landscape with a small Cupid, was by the hand of Zorzo da Castelfranco, but the landscape and the Cupid were finished by Titian." As in the case of the *Tempest,* such a contemporary opinion must be taken very seriously, and, in fact, the extensive landscape and the drapery below the figure have the breadth and boldness of works by the early Titian. The large recumbent figure of Venus is, however, painted less boldly and exhibits, especially in the legs and feet, some of the slight awkwardness of the nude female in the *Tempest.* Other than this resemblance, one must take Michiel's word that the work is by Giorgione, because there are really no other comparable securely attributed pictures by him with

26. Giorgione, *Sleeping Venus,* Dresden, Staatliche Gemäldegalerie

X-rays of this painting seem to suggest that much of the landscape had been finished before Titian repainted it. Why he should have been asked to make such "improvements" is unknown, but perhaps its owner wished Titian to "correct" it.

which it can be compared. X-rays confirm that the Cupid seen
by Michiel does in fact exist under the surface paint, at the feet
of the *Sleeping Venus.* Thus the identity of the figure as a sleep-
ing Venus is certain; perhaps the little figure was painted out
because it was badly damaged.

Giorgione's *Sleeping Venus* must have created a sensation
when it was new. About 1510, the depiction of a relatively
large (108.5 x 175 cm) female nude was something quite
unusual in Venice or anywhere else in the Italian peninsula.
Giovanni Bellini painted two smaller nudes around the same
time, and Giorgione himself seems to have depicted a standing
nude on the Fondaco dei Tedeschi in 1508. But none of these
could have matched the eroticism and sensuousness of the
Sleeping Venus, where the body is endowed with a degree of
voluptuousness hitherto unknown in Renaissance art.

Much of this sensuousness derives from the manner in
which the figure was painted. The elongated diagonal form of
the body placed close to the observer, the turn of the sleeping
head, and the gentle swelling of the breasts and stomach are all
designed to emphasize the sensory aspects of the body, some-
thing highly desirable in an image of Venus, the goddess of
love. The voluptuousness of the picture is enhanced by the use
of oil paint. The employment of the medium was, of course,
not new in Venice; Bellini, as we have seen, had already used
it in some of his large altarpieces to soften and create form, but
Giorgione seems to have been one of the first artists to utilize
the medium in the creation of the erotic, a subject matter for
which it is particularly well suited. The slow-drying oil allows
the artist to work one layer of paint into another to create
incremental gradations of tone and color of exceptional sub-
tlety. Moreover, its lustrous, viscous nature and its range of
color and light produce a surface of considerable tactility, per-
fect for the depiction of flesh and atmosphere.

Such corporeal depictions would become increasingly com-
mon in Venetian painting and they helped to further the city's
reputation for sensual pleasures. During much of the sixteenth
and seventeenth centuries, Venice was famous for its courtesans
and prostitutes.[8] These women, who numbered in the thousands,
were a major tourist attraction and a source of considerable

income for the Venetian state. They were celebrated in painting and in prose and verse by artists of the stature of Titian and Ariosto. Courtesans were attended by important visitors, who could choose them from an official catalogue complete with addresses, prices, and illustrations. Some of these women, such as Veronica Franco, the most famous of their number, were talented at both writing and music, and occupied a social niche considerably above that of the common prostitute.[9]

But prostitutes and courtesans were only one of many manifestations of the erotic and material sensibility of Renaissance Venice. It is, therefore, no surprise that highly sophisticated depictions of sensuality were developed in Venice, first in embryonic form in the works of Giovanni Bellini (including those of a religious nature) and then, more fully, in paintings by his followers, including Giorgione and Titian. Such depictions were to captivate and influence generations of European artists and decisively direct the nature and tenor of subsequent Western art.

The understanding of Giorgione's art is complicated by the lack of documented works and by the confusion that has always attended the attribution of his paintings. Moreover, there is not an overwhelming communality of style among the works that have been attributed to the artist, even among those cited by Michiel in Venetian collections. Beginning with Vasari's biography, the life and works of Giorgione have been romanticized and seen through a cloud of sentiment. Because much of Vasari's life of Giorgione seems invented by the writer, it is conceivable that Vasari's version of the man arose from his own interpretations of the paintings he attributed to Giorgione. The truth of the matter is that our knowledge of the origins, development, and influence of Giorgione is extremely limited. In short, there appears to be no way to accurately gauge his importance or novelty in the history of Venetian painting, despite the extensive criticism and scholarship devoted to him. He may have been an extremely original and influential painter, but the paucity of hard evidence, both documentary and visual, precludes a definitive judgment about either the man or his work.

Considerable ambiguity also surrounds the early work of Sebastiano del Piombo, who, like his talented contemporaries

Giorgione and Titian, emerged from the circle of Giovanni Bellini. Sebastiano Luciani was probably born in Venice around 1485.[10] Vasari states that he was first apprenticed to Giovanni Bellini, but after seeing work by Giorgione, left to study with that master. This story, which seems based upon an appraisal of Sebastiano's art rather than facts, reveals much about Vasari's attitude toward what he considered the revolutionary character of Giorgione's art. Whoever his teacher or teachers may have been, Sebastiano remained in Venice only until 1511, when he left for Rome to work for his patron, the powerful Sienese banker Agostino Chigi. In Rome, he gradually transformed much of his native Venetian idiom into a monumental, sometimes overbearing style based on the work of Michelangelo, under whose enormous influence he soon fell. Given the office of the papal seal (Piombo) in 1531, Sebastiano took holy orders. While in the Holy City, he produced a number of altarpieces and portraits, some of them very striking and highly dramatic, but after his departure from Venice, his paintings really belong to the history of central Italian art.

Works from Sebastiano's Venetian years are few, but consequential. Around 1508, he painted a set of organ shutters for the church of San Bartolomeo a Rialto in Venice, near the Fondaco dei Tedeschi with its newly completed frescoes by Giorgione. Dürer's *Feast of the Rose Garden Altarpiece,* which the German artist had finished during his second and last trip to Venice in 1505, was also in San Bartolomeo, the German church of Venice.[11] One of the two figures on Sebastiano's organ shutters, Saint Sinibaldus, was the patron saint of Nuremberg, Dürer's hometown. Sinibaldus and Saint Louis of Toulouse, the other figure, each occupy a wing [27] on the inside of the shutter, and both would have been visible when the shutters were pulled back to expose the organ pipes.

Set into a large architectural niche and surrounded by a substantial volume of space, these figures recall, in stance, posture, and glance, those from Giovanni Bellini's *San Giobbe Altarpiece* [9]. But the way in which Sebastiano has used a well-defined single light source to give the architecture and figures substance and relief surpasses anything that Bellini or, for that

27. Sebastiano del Piombo, *Organ Shutters for the Church of San Bartolomeo a Rialto,* Venice, Galleria dell'Accademia

Large painted shutters were frequently found on organs in churches in Venice and the Veneto. These were often prestigious commissions and even the most important artists willingly painted them.

matter, Giorgione had painted. The figures seem to be emerging out of the deep, shadowy space of the niche toward the light which illuminates both of them and the softy glowing apse mosaic above their heads. This wonderfully illusionistic use of light gives the niches and the figures that they contain a striking corporeal existence unmatched in previous Venetian painting.

The absolute calm of both the volumetric figures and their setting resembles the *Castelfranco Altarpiece* [24] and may indeed be indebted to Giorgione, but what is most remarkable about the painting of these two saints is the way Sebastiano has used his brush to create the feeling of form and texture illuminated by the all-encompassing velvety light. The gold embroidery and deep red velvet of Saint Louis' cope are rendered with a quick, flicking, nearly dry brush, but these summary marks coalesce in the eye and mind to form a surface of great verisimilitude. Seldom, if ever, had painting in the Italian peninsula been capable of creating such dazzling material effects with such economical means. Sebastiano's vision and

technique were to be much appreciated by later Venetian artists, including Titian, who would make them their own.

Sebastiano's other major work in Venice was an altarpiece for the high altar of the small church of San Giovanni Crisostomo [28]. Probably finished just before he left for Rome in 1511, this is a highly innovative work that was to have considerable influence on the history of the painted altarpiece in Venice. The traditional configuration of altarpieces in the work of Giovanni Bellini, and the entire school of Venetian painters before him, placed the central figures at right angles to the onlooker. The Madonna, Christ, or saint, either enthroned or standing, was seen immediately before the viewer in a central position. However, the principal figure in the *San Giovanni*

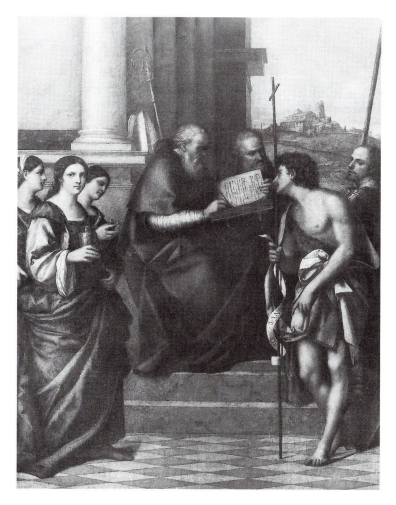

28. Sebastiano del Piombo, *San Giovanni Crisostomo Altarpiece,* Venice, San Giovanni Crisostomo

John Chrysostom (Giovanni Crisostomo in Italian) was Archbishop of Constantinople c. 347–404. A Doctor of the Eastern Church, he was famous for his persuasive preaching and hence was called *Chrysostomos* "mouth of gold."

Crisostomo Altarpiece, Saint John Chrysostom, has been turned ninety degrees so the viewer sees him not in the traditional full frontal view, but in almost strict profile. Moreover, the imposing row of columns behind the saint moves backward diagonally, carrying the onlooker's glance into the deep background space.

Although the San Giovanni Crisostomo painting retains much of the harmony and balance of the traditional Venetian altarpiece in its careful balancing of groups and individual figures within those groups, its axial reorientation, its forceful turning of the principal figures, and its diagonal rush of the huge columns are new. These columns, together with the steps on which the saint sits, seem to form the porch of a huge, undefined building. By their vertical extension beyond the picture's frame, the columns demonstrate that the setting of the altarpiece is only a small part of a much larger continuum of space. This new dynamism, which was soon to influence Titian, was also echoed in one of Giovanni Bellini's last works, an altarpiece in the same church of San Giovanni Crisostomo dated 1513 [29]. Here the central figure of the seated Saint

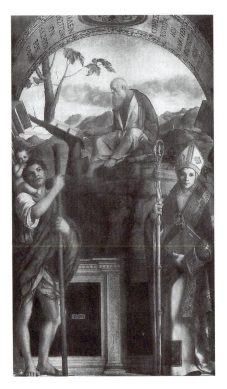

29. Giovanni Bellini, *San Giovanni Crisostomo Altarpiece,* Venice, San Giovanni Crisostomo
 This altarpiece is signed and dated: MDXIII/IOANNES BELLINVS.P. Funds for it and the small chapel where it was placed were provided by the will of Giorgio Diletti in 1494.

Jerome in profile recalls, both in posture and physical type, the daringly positioned Saint John Chrysostom of Sebastiano's altarpiece, painted some three years before. Bellini's willingness to study and reutilize works of younger artists, including those of his own pupils, Sebastiano included, demonstrates the flexibility and receptivity of the aged artist's mind.

Vasari praises Sebastiano's portraits. Although none of these survive from his Venetian years, a painting of Salome with the head of Saint John the Baptist [30] is very portraitlike indeed and may furnish some idea of Sebastiano's earliest portraits. Dated 1510, the work depicts a young woman whose unidealized, realistic face was probably painted from a living model. The manner in which her sleeve and arm protrude toward the viewer and the dramatic, seemingly sudden, turn of

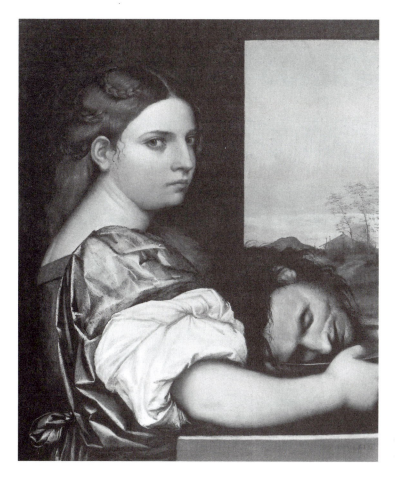

30. Sebastiano del Piombo, *Salome with the Head of John the Baptist,* London, National Gallery

A number of elements in this painting – the finely calculated arrangements of the verticals, horizontals, and diagonals; the sharp turn of the head; the remarkable rendition of fabric; and the landscape – all remind the viewer of Titian's portraits of about the same date.

the head in the same direction animate the painting and make it suspenseful. Such drama was soon to play an important role in Venetian portraiture. The sophisticated arrangement and inter-play of the horizontal and vertical elements of the painting, as well as the large open window through which a distant land-scape is seen, were also prophetic for the history of the por-trait in Venice.

A number of Sebastiano's innovations seem to have been appropriated by a painter who arose from the circle of Giorgione and the late Bellini to become the dominant artistic force of sixteenth-century Europe. This was Tiziano Vecellio, known to the English-speaking world as Titian. He was born in Pieve di Cadore, a small town in the Dolomites, some sixty miles north of Venice.[12]

Unlike most artists of the time, he did not come from a fam-ily of artists. Art in the Renaissance was a trade and artists, like goldsmiths, saddle makers, and butchers, were associated in family workshops that were passed on from father to son or nephew. Titian's father, Gregorio di Conte dei Vecelli (d. 1527), came from a familial line of soldiers and governmental officials. Little is known about his wife, Lucia, Titian's mother. Titian's attachment to his family and his hometown remained strong throughout his life. He kept a house there and made fre-quent visits to his native mountains, even when very aged.

The date of Titian's birth is not documented and much con-troversy surrounds it. However, there exists general agreement that he was born sometime between 1480 and 1490. Titian died in 1576, so even if he were born in 1490, he would have been eighty-six at the time of his death. In these eighty-six or so years (equal to about the span of the working lives of two generations of the typical Renaissance artist), he produced scores of ground-breaking masterpieces, became the first artist to rise to international fame, worked for the most powerful patrons in Europe, and decisively influenced the development of Western art up to the twentieth century. So prodigious and prolific was Titian and so long-lived was he that his career remains unparal-leled in the history of Venetian painting.

This career almost certainly began with an apprenticeship in Venice. Vasari, who knew Titian and included an invaluable, if

not always accurate, biography of him in his *Lives,* writes that Titian first studied with Giovanni Bellini, but after seeing Giorgione's style and working method, Titian "abandoned the style of Giovanni Bellini, although he had not followed it for long, and drew closer to Giorgione's." He also claims that Titian soon was imitating Giorgione's works so skillfully that his pictures were sometimes thought to be by Giorgione himself.[13]

Another version of Titian's beginnings is found in Ludovico Dolce's 1557 treatise, *Dialogo della pittura.*[14] Dolce, who, like Vasari, knew Titian, says that at the age of nine, the artist, along with his older brother Francesco, was sent to Venice to learn the art trade from Sebastiano Zuccati, a member of an active family of mosaic makers. According to Dolce, Titian lived with an uncle while in Venice. From Zuccati, the boy went to the workshop of Gentile Bellini, which he then left in favor of a more up-to-date apprenticeship with Giovanni Bellini. It is impossible to know if Dolce's version of Titian's artistic origins is more accurate than Vasari's.

There is no documentation of Titian's work until 1510, when his name is mentioned in connection with the first of three frescoes for the Scuola del Santo in Padua, a city then strongly under the sway of Venice. There certainly must have been earlier, esteemed works–without them, Titian would not have been given such a prestigious commission. Several small devotional paintings do, in fact, seem to predate the Santo frescoes and constitute what we know of Titian's earliest independent work. The earliest of these is a painting entitled *Jacopo Pesaro Presented to Saint Peter by Pope Alexander VI* [31]. Because of its strong dependency upon Giovanni Bellini, especially in the seated figure of the saint, this work probably dates several years before the Santo frescoes and demonstrates the inescapable influence Bellini exercised on the young Titian, who imitated his figure type and color.

This early series of paintings by Titian includes several images of the Madonna and Child, either alone or accompanied by saints. The type, with half-length figures placed before a landscape, drapery, or some other prop, was popularized, as we have seen, by Bellini and other late-fifteenth-century artists. It had a limited, albeit important, development in the early 1500s.

Titian painted several of these pictures, but none more successfully than the so-called *Gypsy Madonna* [32]. Why it bears this title is unknown: perhaps because of the Madonna's dark complexion. Like most of his earliest attributed works, the *Gypsy Madonna* is unsigned and undocumented. Comparison with prototypes by Bellini [16] suggests a date around 1510. But Titian's vision is broader and more synthetic than that of his master, who was almost certainly still alive and working when the *Gypsy Madonna* was painted. The painting is lit by a strong light source from the left which illuminates the figures. At the lower right hand corner, the light is blocked by their bodies. This shadowy area provides space and relief behind the figures while giving tonal variety to the painting. The composition is unified throughout by light and dark employed with a skill and subtlety beyond even Bellini's understanding. Titian's unprecedented manipulation of overall tonality brings the Madonna and Child into the viewer's world by making the painted space and its illumination seem an extension of our physical reality. Such adroit use of tonality, perhaps influenced by Sebastiano, will become a distinguishing hallmark of the rest of Titian's paintings.

The figures themselves are larger, more expansive, and closer to the viewer than in any previous examples of the same type by Bellini, but like Bellini, Titian has been careful not to let the volume of the figures overwhelm his composition. The drapery of the Madonna, for example, has been divided into sections by color: red robe, white headdress, and blue mantle with gold lining. A white swaddling cloth breaks up the vertical expanse of the standing Christ, while the background is divided into two almost equal sections: the luminous landscape and the cloth of honor hanging behind the figures. This green cloth striped with red separates the figures from the deep landscape background, blocks deep spatial recession, and keeps the Madonna and Child close up to the picture plane. Only the blue sleeve of the Madonna's mantle is allowed to overlap the cloth, its pale color echoed by the blue mountains in the background. Titian's sense of the calibration of form, even in these very early works, is always masterful, and very Venetian.

The forms of the *Gypsy Madonna* are rendered in oil paint. Even in his earliest works, Titian's command of oil paint

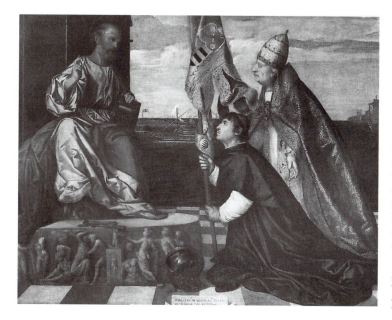

31. Titian, *Jacopo Pesaro Presented to Saint Peter by Pope Alexander VI,* Antwerp, Musée Royal des Beaux-Arts

Rodrigo Borgia (Pope Alexander VI between 1492 and 1503) was noted for his dissolute ways. He fathered a number of children, including Cesare and Lucrezia Borgia. This painting was once in the collection of Charles I of England.

32. Titian, *Gypsy Madonna,* Vienna, Kunsthistorisches Museum

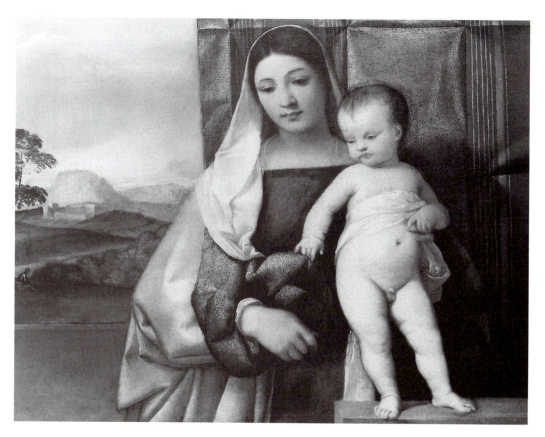

demonstrates why he had few rivals in this medium in the history of Western art. Bellini, Sebastiano, and Giorgione were all sophisticated users of oil paint, but none of them were able to develop their potential as fully as Titian, who would set the boundaries within which all subsequent artists using the medium were to work.

In the *Gypsy Madonna,* Titian's mastery of the oil medium is seen in the spectrum of color and tonality, ranging from the brilliant white of the Madonna's headdress to the deep green-black shadows of the hanging cloth. He has glazed his paint throughout, blending one layer of color into another to establish a surface of considerable subtlety and modulation. A complicated structure of light, mid-range, and dark colors creates volume that seems to actually exist in the painting's space. In Titian's hands, oil paint is made to conjure form hitherto unequaled in its sensual, vibrant, and tactile immediacy. The shimmering green cloth hanging is clearly made of silk (its fold marks are still visible), the hair of the Child is soft, fine baby hair, and the clouds seem to float in a real sky. Oil paint is used to vividly summon the physical nature of all that Titian depicts. Although the foundation for this new materialism was laid by Bellini and Giorgione, Titian's *Gypsy Madonna* and his other early paintings make a quantum leap into a new illusionism.

By the time of the Santo frescoes in 1510, Titian had moved away from Bellini's style even more decisively. Depicting scenes from the legend of Saint Anthony of Padua, these three frescoes present the first manifestations of a fully constituted, personal idiom recognizable both in the painting process and in the formal and psychological construction of narrative. These are not the works of a fledgling artist, but rather of someone already well practiced in picture-making.

From his earliest days in Venice, Titian must have been aware of the large-scale paintings in the *scuole.* Certainly he knew the most brilliant examples by Carpaccio and Gentile Bellini. When Titian was commissioned to paint his own frescoes in the Scuola del Santo in Padua, he thought at once of these famous paintings and, indeed, of the general type and nature of such works. When it came time to paint, he utilized these examples, but ultimately transubstantiated them.

Throughout his long career, Titian respected tradition. Never can we think of him as an avant-garde artist. Yet in the Santo frescoes, and in many other paintings, while his work always depended on the past, he subtly transformed what he took into something new.

In the *Miracle of the Infant* [33], a story in which a baby miraculously declares his mother innocent of adultery, Titian has retained the screenlike row of figures so characteristic of earlier *scuola* paintings [23], but here ends the resemblance to such earlier works. Instead of the diffuse, anecdotal amalgam of the earlier examples, Titian has forged a compact drama that hinges around Saint Anthony of Padua holding up the infant, who speaks to the startled husband. United by the broad semi-

33. Titian, *Miracle of the Infant*, Padua, Scuola del Santo

Titian's commission for the Scuola del Santo, Padua testifies to his growing reputation outside of Venice. Although he painted three frescoes for the Scuola, he was one of just several artists chosen to decorate its meeting hall.

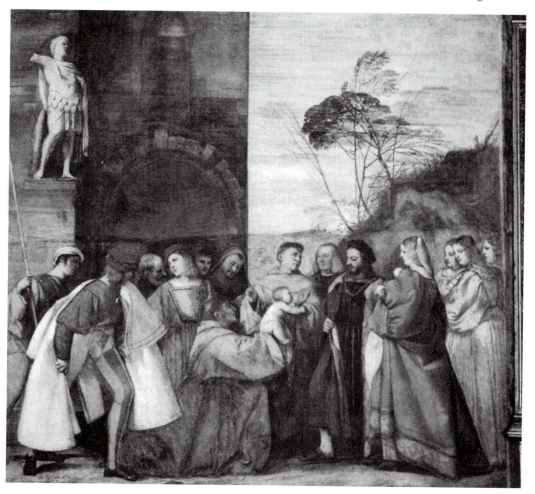

circle of their bodies, their inward movement, and the focus of their gaze upon the speaking child, the figures are welded into a single dramatic element–something unknown in earlier *scuola* narratives. The protagonists are also notable for their breadth; their weighty, volumetric bodies stand firmly on the ground, decisively occupying space. Antecedents for these figures are found in late Bellini works, and similar beings appear in Sebastiano's paintings, but neither of these artists had been able to so convincingly place bodies in space and unify them into a tightly knit, dramatic whole.

Another of Titian's Santo frescoes is the *Miracle of the Jealous Husband* [34]. A woman was stabbed to death by her husband, who wrongly believed that she had committed adultery. Repenting, he implored the aid of Saint Anthony of Padua, who restored the woman to life. For the figure of the wife in the fresco's foreground, Titian seems to have looked for help beyond the Venetian lagoon, for the sprawling figure depends upon the image of Eve in Michelangelo's *Temptation and Expulsion* [35] on the Sistine Ceiling. It is impossible to know exactly when this fresco was finished, but it must have been around the date of the Paduan frescoes. We do not know how Titian could have seen Michelangelo's composition so quickly, for he certainly was not in Rome. Titian may have known the figure by way of drawings made by other artists or as the subject of a print–the reversal of the figure may suggest the latter, since reproductive prints often depicted their subjects in reverse. Although this is the first known borrowing by Titian from Michelangelo, it will not be the last. Throughout his long working life, Titian remained fascinated by the Florentine artist's depiction of the human body. But while he borrowed from Michelangelo, he always, as in the case of the Santo fresco, transformed what he took and made it his own. The twentieth century such considers borrowing artistic larceny, but all great artists of the past have freely taken from their predecessors and contemporaries, and then re-created what they appropriated.

Michelangelo's champion Vasari, promoter of Florentine art, claimed that Titian, and his Venetian contemporaries, did not possess a mastery of drawing, but even the most cursory look at

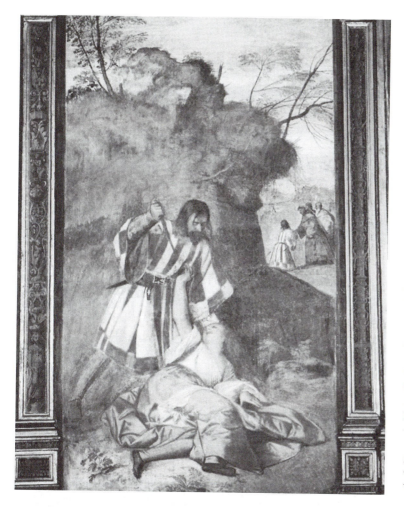

34. Titian, *Miracle of the Jealous Husband,* Padua, Scuola del Santo

Titian received the contract for the Scuola frescoes in December 1510, and seems to have begun work in April 1511. Final payment for the frescoes was given to him in December of that same year.

35. Michelangelo, *Temptation and Expulsion,* Vatican, Sistine Chapel

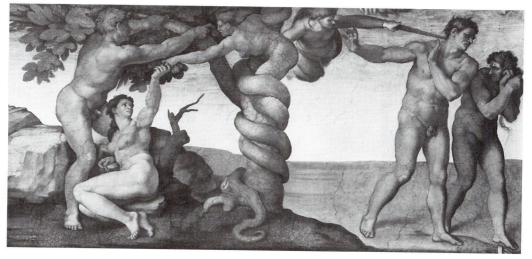

the figures in the Santo frescoes reveals the untruth of his statement. What Vasari probably meant was that Titian drew on the canvas with charcoal and paint rather than using the complicated paper drawing process of which Vasari approved. Central Italian artists, like Vasari, began the design of a painting by first making a composition drawing that demarcated the form and relationship of the principal objects to be portrayed. After this overall plan was fixed, many studies of individual figures, drapery, landscape, and other elements to be painted would be drawn. Each drawing refined and idealized the forms, bringing them to a high degree of resolution and finish. When all the components of the painting were worked out to the artist's satisfaction, the perfected design was then transferred to the canvas by means of a full-scale cartoon.[15]

Titian and his fellow Venetian artists used quite a different method to create paintings. While they may have made some preparatory drawings, most of their composing was done right on the canvas itself. X-ray's of Titian's paintings reveal that he used an empirical method, working his way through the design as he laid it out on the primed canvas either with charcoal or with paint. What Vasari disliked about this process was what he considered its distressing lack of idealization and refinement. But it is exactly the experimental, spontaneous nature of Titian's painting that we find so attractive. We should not, however, be fooled into thinking that Titian ever simply worked in an inspired fit of creativity. Rather, he painted slowly and carefully, always adjusting his forms and paint to achieve a premeditated effect and often strikingly original results.

This is readily apparent in Titian's *Portrait of a Man* from around 1512 [36]. The half-length format set behind a stone ledge in the foreground had already appeared in Venetian paintings, most notably in works by Giovanni Bellini and his followers. But Titian, perhaps inspired by Sebastiano, has rethought the traditional type by turning the figure sideways, thrusting the vast expanse of magnificently painted blue sleeve outward, and, most importantly, making the haughty head of the man confront the observer. The physical torsion of this portrait endows it with a dynamism and bravado new to the

36. Titian, *Portrait of a Man*, London, National Gallery
As early as the seventeenth century, this was called a portrait of Ludovico Ariosto (1474–1533), the poet and dramatist from Ferrara. Because the face in this painting does not resemble other portraits of Ariosto, the earlier title is certainly erroneous. It has also been suggested that the work is a self-portrait, which is understandable, given the direction of the eyes as if towards a mirror.

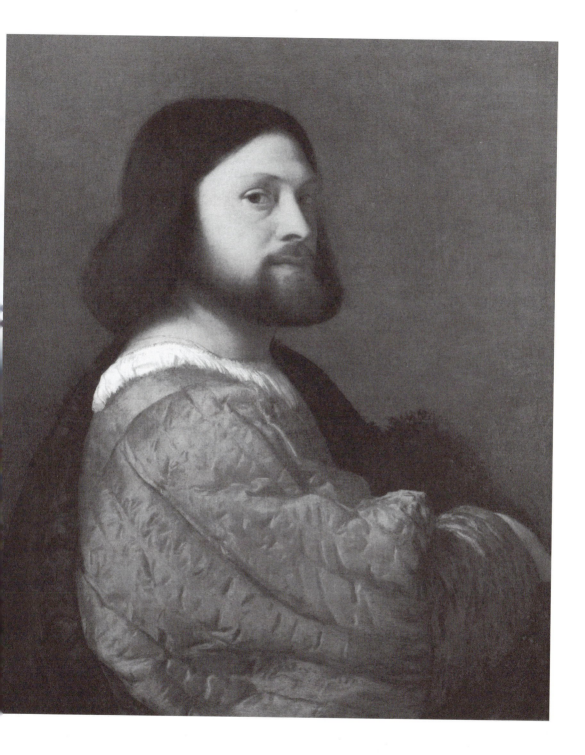

history of Venetian art; its physicality conveys the expression of personality and character effectively and immediately.

Earlier Venetian portraits centered around the portrayal of the individual's likeness and the documentation of his or her rank and social position. Seldom did the painter express the intellectual or emotional constitution of the sitter–a likeness of character, not persona. In Titian's portrait, the nature of the man is inextricably formed by the painting's composition. The lunge of the blue silk sleeve, the twist of the body, the glare of the disdainful face, and the strikingly realistic rendering of material and atmosphere forcefully convey disquieting physical and psychological messages. It is interesting to observe that such probing of character is, as a rule, found only in the early works of Titian. In these first portraits, Titian was most likely working for friends or patrons of only middling status, but from about 1530 onward, his clients were much more important personages, with different demands. In the early, less formal works, he must have felt freer to investigate both form and psyche, while it was his task to convey an idealized status and importance in the later portraits.

Idealization was necessary in Titian's early paintings of mythology and allegory, however. Here again he was influenced, but not overawed, by examples of Bellini and Giorgione. One of Titian's earliest essays in this type is the *Three Ages of Man,* probably painted around 1512 [37]. The title is modern, and was given to the painting because it appears to depict the cycle of life from childhood (the infants in the foreground) to old age (the aged man contemplating skulls in the background). Like the *Tempest* by Giorgione, this is a secular work that was meant to hang in a private home, where it would be admired as much for its composition and style as for its allegorical depiction of the ages of man. But the work would also have been appreciated for its only slightly veiled erotic content, which arises from the embracing man and woman who gaze lovingly at each other. Not only is the man almost nude, but the woman holds musical pipes, one placed just above the man's genitals. Even in the pre-Freudian Renaissance, these pipes were objects associated with physical love. Both figures are painted with the full range of the oil

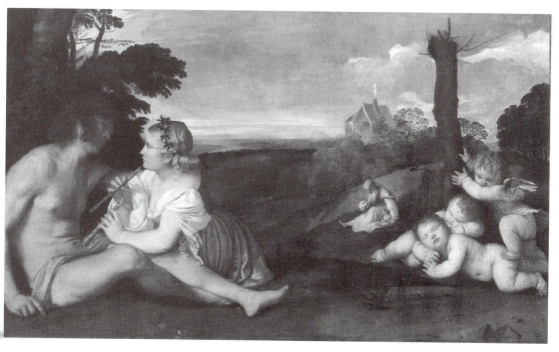

medium to create volumetric bodies whose presence is made
even more palpable through the subtle and sensuous depiction
of flesh, hair, and cloth.

The mood of physical love and eroticism, which really over-
powers the allegorical theme of the painting, is echoed and
reinforced by the sylvan landscape setting. Gentle and rolling,
dappled by sunlight and shadow, the landscape extends to the
horizon, where it is enveloped by the blue mist of the distance.
The soft, yielding world of the *Three Ages of Man* closely
resembles the atmosphere of Giorgione's *Sleeping Venus* [26], a
picture in which Titian may have had a hand, but it is more
sensuous and luxurious than any work by Giorgione. Titian's
astounding skill in the transubstantiation of allegorical con-
cepts into living, breathing flesh (no other word will do) set in
a landscape filled with realistic light and atmosphere must have
astounded contemporary Venetians, even those who were
already acquainted with the painted marvels of the late Bellini
and Giorgione. But Titian's recognition as the leading figure in
Venetian painting would come only several years later, when
his gigantic altarpiece, the *Assumption of the Virgin* [38], was

37. Titian, *Three Ages of
Man,* Edinburgh, National
Gallery of Scotland

X-rays of this paintings
reveal that Titian made a
number of modifications as
he painted. The position of
the woman's head, the drap-
ery of the youth, and the
number of skulls held by the
old man were all changed.

erected in the church of the Frari. This important commission for the *Assumption* signaled Titian's new-found position as the most important painter in Venice. The painting itself is the first masterpiece of Titian's maturity.

NOTES

1. The literature on Giorgione is vast. See, above all, S. Freedberg, *Painting in Italy, 1500–1600,* New Haven, 1993. Besides its pages on Giorgione, this magisterial book should be consulted for all the sixteenth-century artists discussed below. See also T. Pignatti, *Giorgione,* Milan, 1978.

2. G. Vasari, *The Lives of the Artists,* trans. J. and P. Bondanella, Oxford, 1991: 299–304.

3. T. Frimmel, *Der Anonimo Morelliano: Marcanton Michiel's notizie d'opera del disegno,* Vienna, 1896.

4. G. Vasari, *The Lives of the Artists,* trans. J. and P. Bondanella, Oxford, 1991: 299–300.

5. Leonardo da Vinci: K. Clark, *Leonardo da Vinci,* New York, 1989.

6. For theories on the meaning of the *Tempest,* see S. Settis, *Giorgione's Tempest: Interpreting the Hidden Subject,* Chicago, 1990.

7. Isabella d'Este's desire for a Giorgione is discussed by J. Cartwright, *Isabella d'Este, Marchioness of Mantua,* 2 vols., London, 1903, I: 389–390.

8. One of the more recent works on the Venetian courtesans is L. Lawner, *Lives of the Courtesans: Portraits of the Renaissance,* New York, 1987.

9. An excellent work on Veronica Franco is the volume by M. Rosenthal, *The Honest Courtesan: Veronica Franco, Citizen and Writer in Sixteenth-Century Venice,* Chicago, 1992.

10. M. Hirst, *Sebastiano del Piombo,* Oxford, 1981.

11. The comprehensive work on Albrecht Dürer is still E. Panofsky, *Albrecht Dürer,* 2 vols., Princeton, 1948. For Dürer and Venice, see *Dürer's Record of Journeys to Italy and the Low Countries,* ed. R. Fry, New York, 1995.

12. There are two essential works on Titian. The first is J. Crowe and G. Cavalcaselle, *The Life and Times of Titian,* 2 vols., London, 1881. Although written over a century ago, this study is notable for it comprehensive treatment of Titian's life and art. Crowe and Cavalcaselle's book was the first modern treatment of the artist, and its collections of archival sources and its authors' keen powers of observation remain unmatched. The second book is H. Wethey, *The Paintings of Titian,* 3 vols., London, 1969–1975. This is a complete, fully-illustrated catalogue of all of Titian's paintings. All of the paintings discussed below are catalogued in Wethey's volumes. Wethey has also written a catalogue of drawings attributed to Titian and his circle: H. Wethey, *Titian and His Drawings,* Princeton, 1987. For a recent and very full bibliography on Titian, see the catalogue of the huge Venetian exhibition held in Paris in 1993: *Le siècle de Titian,* Paris, 1993.

13. Vasari's *Life of Titian:* G. Vasari, *The Lives of the Artists,* trans. J. and P. Bondanella, Oxford, 1991: 489–508. An Italian edition of the life of Titian has been published recently: G. Vasari, *Vita di Tiziano,* ed. G. Milanesi and I. Bomba, Pordenone, 1994. For another early (1648), impor-

tant biography of Titian, see C. Ridolfi, *The Life of Titian,* ed. J. and P. Bondanella, B. Cole, J. Shiffman, University Park, 1996.

14. M. Roskill, *Dolce's Aretino and Venetian Art Theory of the Cinquecento,* New York, 1968, includes the dialogue in the original Italian as well as a facing translation, copious notes, and commentary.

15. There is no comprehensive survey of drawing and drawing techniques in the Renaissance. The reader is advised to consult the many museum and exhibition catalogues of Renaissance drawing published in recent years. Especially noteworthy is the series of catalogues of the drawing collection of the British Museum.

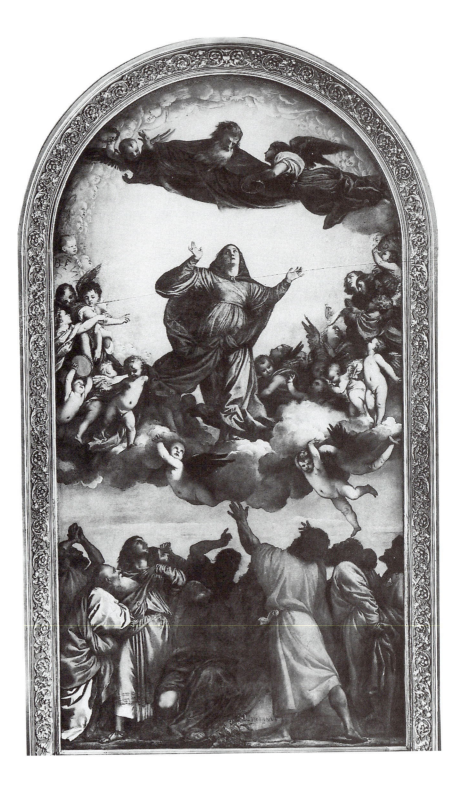

4

Titian:
Early Success,

1516–1530

❧

<p style="margin-left:2em">Titian's enormous *Assumption of the Virgin* [38], the world's largest painting on panel (690 x 360 cm), was a prize commission. Intended for the principal altar in the choir of the Franciscan church of Santa Maria Gloriosa dei Frari in Venice, it is a work of immense importance, both for its size and prestige, in the history of Venetian painting. It was commissioned around 1516 and consecrated on May 20, 1518.[1]</p>

By 1516, many of the most important artists of the early sixteenth century had passed from the Venetian scene. Giorgione had been dead for six years, Sebastiano was residing in Rome, and in that very year Giovanni Bellini, the eminent pioneer of Venetian painting, died. No serious rival to Titian remained in Venice, and thus, no one as worthy of the Frari *Assumption* commission. These circumstances, perhaps as much as his already proven talent in his previous paintings, launched what was to be among the most brilliant careers in the history of Western painting.

38. Titian, *Assumption of the Virgin*, Venice, Santa Maria dei Frari

For his version of the *Assumption*, Titian, like all
Renaissance artists, studied traditional examples of the subject.
He must have recalled the large fresco of the Assumption by
Andrea Mantegna, Giovanni Bellini's brother-in-law, painted
in the church of the Eremitani in Padua sometime in the 1450s.
Titian would have had ample opportunity to study the painting
while he was at work on his own frescoes for the
Confraternity of the Santo in 1510. Moreover, there was also a
late (1513) version of the subject by Giovanni Bellini and his
workshop on the Venetian island of Murano. But although
Titian certainly looked upon these earlier examples with rever-
ence and admiration, he approached his own version of the
Assumption with an inventive attitude. Titian imposed a new
and monumental unity upon his *Assumption*, both of form and
subject, vastly different from the more static and fragmented
earlier versions of the story. So striking is the overall impres-
sion of this huge altarpiece that it rivets the onlooker's atten-
tion even in the monumental, light-filled choir of Santa Maria
dei Frari. It is a commanding work equal to its august sur-
roundings.

All three realms of the Frari *Assumption*–the earth-bound
apostles, the soaring Madonna and accompanying angels, and
the heavenly dominion of the welcoming God the Father–are
knit together to form one unified, glorious whole. The spatial
dynamism of the work is created by a continual recession from
the screen of gesticulating apostles in the lower foreground,
through the semicircle of clouds and angels surrounding the
Virgin, and back to God the Father, set still further backward
into space. This subtle but continual spatial recession is
emphasized by the ranges of tonality from the dappled, earth-
bound figures to the resplendent golden aura of heaven, whose
divine blaze is so powerful that it obscures the faces of the sur-
rounding angels. The Virgin's ascent through vast stretches of
space and light, from the mundane realm of her followers to
the golden empyrean, is achieved with the same synthesis and
boldness that mark Titian's other early paintings. However, in
this work it is carried out on such a gigantic scale that it must
have been a startling experience for those who saw it newly
installed in the Frari choir.

A similar experience must have awaited those who first saw Titian's *Resurrection of Christ with Saints Nazaro and Celso* [39] in Brescia. This unusually well-documented altarpiece was painted for Altobello Averoldo of Brescia, Bishop of Pola and papal legate to Venice, where he had been sent by Leo X to enlist Venice in a crusade against the Turks. The painting, which is divided into five separate panels, probably in imitation of an older altarpiece type, was commissioned in 1520 and completed two years later. The fact that by this date, just two years after the installation of the Frari *Assumption,* Titian had been commissioned to do this large and important work for a location outside Venice by such a significant patron is proof of his rapidly growing reputation.

39. Titian, *Resurrection of Christ with Saints Nazaro and Celso*, Brescia, SS. Nazaro and Celso

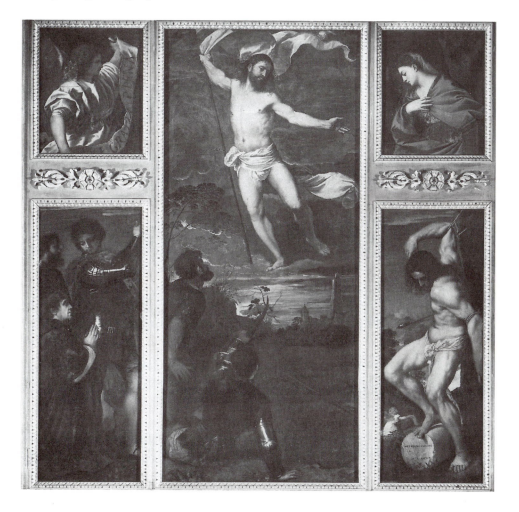

In the Brescia *Resurrection* Titian introduces a daringly new vision of the event. Instead of the hovering, ethereal Christ depicted in Bellini's *Resurrection* [7] and almost all previous paintings of the narrative, Christ here literally bursts out of His tomb. The dynamism that so characterized and energized the Frari *Assumption* is seen in even greater measure in this painting. The great diagonal of Christ's body, His outflung arms, and the fluttering flag which He holds fill the upper part of the altarpiece with dynamic pictorial action. Moreover, the drama is heightened by light as Christ's body springs into the brilliant illumination from the darkness that still envelops the soldiers below. As in the Frari *Assumption,* light and dark create drama in an unprecedented way. Titian, always skillful in the use of visual metaphors, has equated light here with the divinity and salvation signified by the miraculous moment of the Resurrection.

Light is the most important element in establishing the landscape's mood. Titian must have studied the luminous landscapes of Giovanni Bellini with care (he may have studied Giovanni's own splendid version of the story), for, as his *Resurrection* shows, Titian knew how to make nature perfectly express and create drama and mood. Behind the gasping soldiers cloaked in darkness, the distant landscape and sky are illuminated with the first pink rays of the dawning sun. The sky is filled with a dramatic cloudscape of wispy ribbonlike clouds near the horizon and large billowing clouds higher in the sky. Titian was a superb painter of clouds, and his skies always possess a beauty and drama seldom matched in the history of art. The dawning light of the *Resurrection* is, of course, like the luminous Christ, a metaphor for the renewal and salvation which the Resurrection promises.

The side panels of the Brescia *Resurrection* depict the kneeling Altobello Averoldo on the left, and Saint Sebastian on the right. The latter is a remarkable figure, both for the weight and torsion of the body and its exaggerated musculature. There are several pen-and-ink drawings for this figure. One shows the artist experimenting with the position of the body in six quick sketches, some of them very tentative thoughts indeed [40]. (Interestingly enough, the upper left of this sheet contains columns listing amounts of money, *soldi* and *dinari*, probably some kind of payment or debt account.)

A larger, more fully resolved sheet on blue paper is a master-piece of drawing, probably slightly later in date [41]. This pow-erful sketch now contains the column upon which Sebastian's foot rests in the painting. Titian, however, is still experimenting with the position of the left arm and foot, both of which will be slightly modified in the painting. Such drawings by Titian are extremely rare–only about a dozen or so exist. The reason for this, as we have seen, is that the artist and most of his Venetian contemporaries drew directly on the primed canvas. Unlike their central Italian counterparts, they did not use paper car-toons to transfer designs (initially worked out in drawings) to the surface to be painted. Consequently there are relatively few Venetian drawings extant in comparison to the thousands of central Italian drawings that survive today.[2]

In addition to their role in composition-building, drawings transmitted style. By the date of the Brescia *Resurrection,* through the medium of drawings and prints, Titian was well

40. Titian, *Sketches of Saint Sebastian,* Berlin, Kupferstichkabinett

41. Titian, *Drawing of Saint Sebastian,* Frankfurt am Main, Städelsches Kunstinstitut

In 1520, an agent of Alfonso d'Este (who was later to become a patron of Titian) attempted to buy the Saint Sebastian panel of this altarpiece for his employer. Alfonso discouraged further attempts because he did not wish to anger the powerful Bishop Altobello Averoldo who had commissioned the painting.

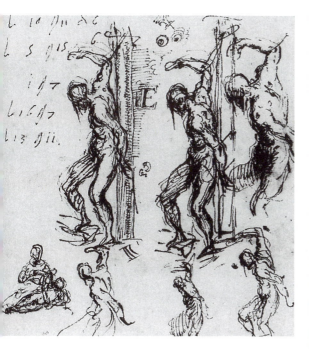

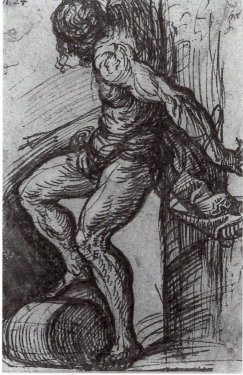

aware of the work of Michelangelo and many of the other artists painting in central Italy, including Raphael, who had died in 1520, the very year in which Titian's Brescia altarpiece was commissioned.[3] Titian must have been impressed by these artists and their work. And, in fact, the Brescia Saint Sebastian may have been influenced by Michelangelo's *Dying Slave* and other works that Titian could have known through drawings made by other artists. But since he modified what he took and made it his own, his borrowings may be characterized as exercises in inspiration rather than slavish imitation.

Titian's considerable capacity for invention is made evident in a picture finished some six years after the Brescia *Resurrection.* This altarpiece [42], arguably one of the most seminal in the his-

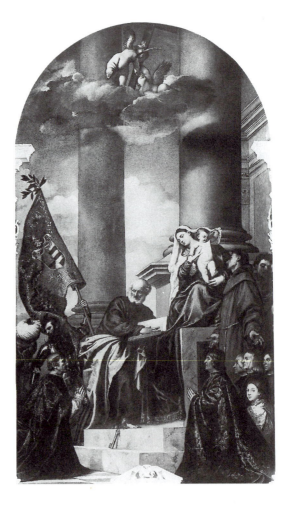

42. Titian, *Pesaro Altarpiece,* Venice, Santa Maria dei Frari

The banner displays the escutcheons of the Borgia and Pesaro families. Jacopo Pesaro and the Borgia pope, Alexander VI, appeared together on an earlier painting by Titian (fig. 31), which also commemorated the battle of Santa Maura in Cyprus. The altarpiece was contracted in 1519, and the final payment was made in 1526. *(See color plate 1)*

tory of Italian art, was commissioned in 1519 by a member of the
powerful Pesaro family to be installed in the church of the Frari,
the location of Titian's first major triumph, the *Assumption of the
Virgin*. The *Pesaro Altarpiece,* as it is now known, commemorates
the battle of Santa Maura in which the Venetian forces, led by
Admiral-Bishop Jacopo Pesaro, defeated the Turks. Although of
relatively minor significance, this victory was symbolically
important both for the prestige of the Pesaro family and as a vic-
tory, no matter how small, over the infidel Turks, Venice's great-
est nemesis during the sixteenth century.

For the *Pesaro Altarpiece,* Titian did not have to labor under
the demanding constraints of size and venerable iconographic
tradition that he had to face in the Frari *Assumption*. Moreover,
in the Pesaro family he found patrons who were willing to
sanction and pay for pictorial invention, for his painting
amounts to nothing less than a transformation of the tradi-
tional altarpiece type.

Before the Pesaro painting, figures and objects in altar-
pieces were disposed along a plane perpendicular to the spec-
tator. Bellini's *San Giobbe Altarpiece* [9] is a classical example
of this sort of composition; all its elements are arranged in a
row that more or less parallels the picture plane. Titian had
been brought up with this altarpiece configuration and had
used it for his Frari *Assumption;* however, in the *Pesaro
Altarpiece,* he broke decisively with the accepted form by radi-
cally rearranging the figures, the objects, and the painted
space in which they exist.[4] Here he may have been assisted by
Sebastiano's daring *San Giovanni Crisostomo Altarpiece* [28].

He accomplished this by shifting the major spatial orienta-
tion of the painting. Instead of confronting the viewer perpen-
dicularly, many of the figures and objects are now diagonally
disposed in space. The traditional row of figures and objects is
gone and the spectator's view now moves into space along the
diagonally receding orthogonals of the steps, the Virgin's
throne, the towering columns, and the architecture. It is, in
fact, as though the traditional altarpiece configuration has been
set some forty-five degrees on its axis.

This new configuration is quite dynamic, but the diagonal
movement is just one of several devices that create a sense of

expansion and excitement. The sweeping slant and upward drive of the columns imply a vast extension of space far beyond the limits of the frame. Moreover, the opposition of the strong backward diagonal and horizontal flight of the columns establishes a spatial opposition that creates new-found drama and torsion. Never before in the long history of the type had an altarpiece been made so active and forceful. The lessons of the *Pesaro Altarpiece* were not to be forgotten by Titian nor by the many artists who reutilized his composition, either in whole or in modified form, throughout the rest of the century. Moreover, through Tintoretto and Veronese, the example of the *Pesaro Altarpiece* would be transmitted to the next century, where it would exert considerable influence. As we shall see below, it may be argued that the Baroque altarpiece owes it origins to this remarkable painting.

At first glance, the beautifully realized figures of the Virgin, Child, Saint Peter, the other attendant saints, and the skillfully interwoven portraits of the Pesaro family seem to occupy a comprehensible, fathomable space, but further contemplation of the painting reveals that this is not the case. Like most other Venetian artists, Titian rejected the logical spatial and architectural construction of his central Italian contemporaries. Instead of the rational buildings and space of Raphael and his central Italian followers working in Rome and Florence, Titian and his contemporaries ideated scenes that are dramatic and convincing, but no more susceptible to logical analysis than the miracles and other holy visions that they portray. For instance, one might well ask what sort of a building is being represented in the *Pesaro Altarpiece*: what part of that building is being shown, and what do the vast columns support? There are no clear answers to these questions because Titian was not interested in them. The construction of much of his space, architecture, and landscape is brilliantly intuitive, often illogical, but always impressive and somehow believable. It lacks the mathematical precision and clarity of the central Italian painters, but what it lacks in logic, it gains in energy and majesty. In truth, questions of logic seldom arise in Titian's work because the entire fabric of his paintings seems itself so completely convincing and plausible.

The dialogue, and occasionally the argument, between Titian and central Italian painting is again well illustrated in the dramatic *Entombment of Christ* [43] of c. 1525, painted around the time of the *Pesaro Altarpiece.* This *Entombment* was once part of the collections of the Gonzaga family in Mantua (it also belonged to King Charles I of England), but there are no records documenting its commission. It does seem certain, however, that Titian knew a famous version of the subject [44] that the young Raphael had painted in Florence in 1508. Titian could not have seen the painting itself, for it was in Perugia, a city he had not visited, but drawings by other artists recording the composition and major characteristics of the *Entombment* seem to have been available to Titian, just as Raphael's *Transfiguration* was known to him in the same way.

While he seems to have been inspired by Raphael's painting, he in no way copied it. Instead, he used some of its most basic organizational elements, completely transforming its composition and tenor. Like Raphael, he organized the painting around the figure of Christ, whose body is the focal point and

43. Titian, *Entombment of Christ*, Paris, Musée du Louvre

This painting has a distinguished history. Sold by the Gonzaga family of Mantua in 1627, it then passed through the collections of two famous kings, Charles I of England and Louis XIV of France, the Sun King.

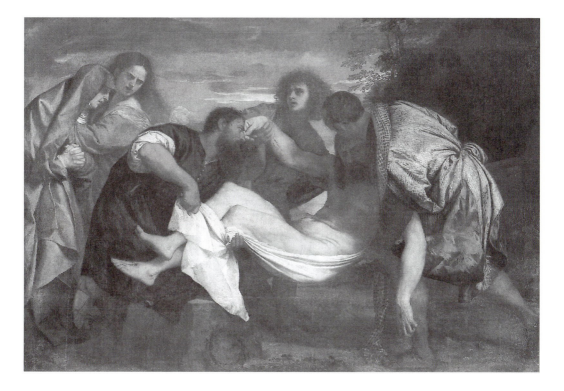

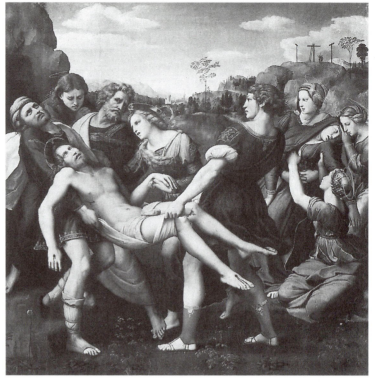

44. Raphael, *Entombment of Christ*, Rome, Galleria Borghese

Although it is usually called the *Entombment*, the exact subject of this painting is hard to determine. We know from drawings that the artist had first intended to paint a Lamentation, but then gradually transformed the composition into something that might best be defined as "Christ's Body Carried to the Tomb," an event occurring between the Lamentation and the Entombment.

linchpin of the physical and emotional action. Raphael had based his own image of Christ on the figure in Michelangelo's early (c. 1499) Vatican *Pietà,* a fact that Titian might not have known.

He reduced the number of figures by four and allowed each figure to occupy more of the picture's space. Moreover, he made the three figures carrying Christ move toward the center of the painting instead of outward, as they do in Raphael's altarpiece, thereby concentrating the action more on Christ's body and the effort to carry it. Unlike Raphael, whose landscape is one of the glories of his painting, Titian has tightly focused attention on the foreground by suppressing almost all the landscape—only a tree-covered hill is seen at the right.

The drama and sorrow of Titian's *Entombment* are amplified by the lowering sky (perhaps influenced by Giorgione), so dissimilar from Raphael's bright, cloud-filled vision. Yet, more than anything else, it is the dramatic lighting of Titian's paint-

ing that makes it so strikingly different from Raphael's. The fig-
ures seem to be emerging out of or receding into a surrounding
darkness. Christ's face and torso, the most symbolically impor-
tant parts of the painting, are cast in shadow while His legs
and, most dramatically, His dangling, lifeless right arm are
starkly illuminated. Raphael's painting is evenly and clearly lit;
the eye wanders through it savoring its multiplicity of sharp
details and its luminous color. Titian's version is a distilled and
synthetic narrative, its colors more muted, its forms larger and
less distinct. The drama has been simplified, pared down to the
essential element of grief and the physical effort of the entomb-
ment itself. So, whereas Titian may have studied Raphael's
composition and even been inspired by it, his painting is a
work of originality, quite different from its possible model.

But Titian's inventive mind was not focused solely on the
major altarpieces discussed so far, and the singularity of his
creative imagination is again apparent in a series of other paint-
ing types. One of these was a portrait type that originated in
Venice in the early sixteenth century. This is the so-called
courtesan portrait, which depicts courtesans in varying
degrees of idealization, either in contemporary guise or thinly
veiled as Venus, Flora, or other mythological or allegorical per-
sonages.[5] Such portraits, and the ideals of beauty and desirabil-
ity they embodied, were to be influential in the development of
the depiction of women throughout much of the subsequent
history of European art (see Chapter 9).

Around 1510, courtesan portraits began to be produced fre-
quently and soon thereafter became an accepted subject of
Venetian painting. Who commissioned them and for what
purpose remains a mystery. They are usually half-length,
depicting the youthful sitter with flowing, loose hair and in a
state of partial undress, occasionally with an attribute that sug-
gests a mythological or allegorical identity.

An early and defining example of the type is Titian's *Flora*
[45] of around 1520. It contains all the elements of the courte-
san portrait: the half-length woman sensually clothed with
long, cascading hair (no respectable Venetian woman would
have ever been seen with her hair undone or with so much
flesh exposed). She also proffers a posy that may, in this case,

be the attribute of Flora, the mythological goddess of flowers often associated with courtesans because of the licentiousness of her festival. The sitter is now universally called Flora, a title assigned to the painting by art critics of this century.

In any case, Titian's figure is far removed from the realm of mythology by her contemporary clothes. The garment she wears is a *camicia,* a long, white undershirt worn by Venetian women, while the pink embroidered material she holds is her dress, which she has allowed to seductively slip off her body.[6] There can be no doubt that this is an idealized portrait of a contemporary woman, most likely a courtesan.

The *Flora* is, however, most remarkable for the nature of its depiction. Using the slow-drying oil medium in which one layer

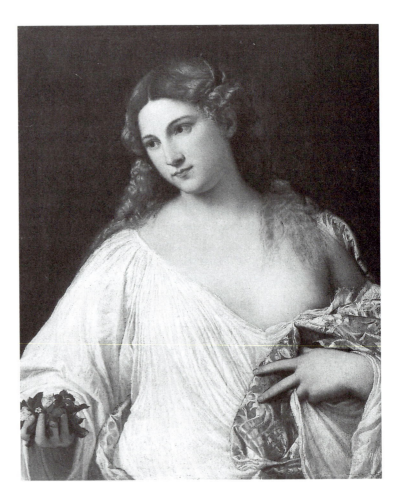

45. Titian, *Flora,* Florence, Galleria degli Uffizi

of pigment is brushed into another, thus modifying and enriching both, Titian has created a living, breathing presence. The *Flora* must have struck his contemporaries as a marvel of sumptuous eroticism, even surpassing Giorgione's sensuous depictions of the human form. The soft, yielding flesh, built up with a subtle, nuanced network of brushstrokes and color, is delicately covered by strands of lustrous auburn hair and by the brilliantly realized linen of the *camicia*. The face, which is a slightly idealized portrait, is rapt in thought. There is a reticence and modesty about the *Flora* that is uncharacteristic of courtesan portraits by other contemporary Venetian artists, most of which are much more blatant and often cruder in their sensuality as well as overt in their eroticism. It is in the nature of Titian's genius that even when dealing with a type which by its very nature involved a rather graphic display of carnality, he maintains a reserve and distance that was to become a defining characteristic of his later painting, especially his portraiture.

Titian's ability to reinvent traditional, time-honored types is seen again in full measure in the three large mythologies that he painted around the time of the *Pesaro Altarpiece*. The extremely prestigious commission for the mythologies was given to the artist by Alfonso d'Este, Duke of Ferrara, for his Camerino d'Alabastro in the castle of Ferrara, the same location for which Giovanni Bellini's *Feast of the Gods* [19] had been painted in 1514 (see above). As aforementioned, Alfonso was the brother of Isabella d'Este, whose own patronage of mythological paintings he may have wished to imitate. Isabella's children, Federico II Gonzaga [52] and Eleonora Gonzaga della Rovere [54], nephew and niece of Alfonso, were both painted by Titian in the following decade. That the young Titian was now in the employ of the d'Este court, one of the most important and cultured of northern Italy, demonstrates his increasing importance outside Venice. He was certainly aware of this, for his Ferrarese paintings are among the most brilliant of his youthful career.[7]

Titian, however, was not Alfonso's first choice. The duke had tried to enlist the services of Raphael and Fra Bartolommeo, two famous central Italian artists, for his Camerino.[8] Fra Bartolommeo sent Alfonso a compositional sketch for one of the

paintings, but died before he could begin the commission. As in the case of Fra Bartolommeo, Alfonso received no more than a drawing from the celebrated Raphael. Frustrated with these attempts, he then turned to the young Titian, the emerging star of Venetian painting.

Titian's canvases for Alfonso are entitled *Bacchus and Ariadne, Worship of Venus,* and *Bacchanal of the Andrians.* It appears that they were all executed between 1518 and 1523. The sources for these paintings, as for Bellini's, are found in literary descriptions of ancient works of art by classical authors. Titian worked from texts by Philostratus the Elder, Catullus, and probably also Ovid.[9]

Although these texts are not detailed, specific reports of ancient works of art, they do contain descriptions of many figures and objects, which Titian subsequently included in his paintings. Moreover, through their poetry and beauty of description, they evoke a lush, sybaritic mood. This mood inspired him to create nothing less than a new vision of mythology, a vision that essentially defined the type for centuries to come.

The *Bacchanal of the Andrians* (c. 1518) depicts the inhabitants of the Greek Aegean island of Andros celebrating the annual visit of Bacchus to their shores [46]. During this visit, there appeared a stream of wine, from which the Andrians drank deeply while they reveled. Wine and wine drinking play a prominent role in Bellini's and Titian's paintings for Ferrara, although there does not seem to have been a tightly knit overall iconographic program for the Camerino.

Building upon a foundation first laid down by Giorgione, Titian created a world of earthly pleasure and desire in the *Bacchanal of the Andrians* that was, in its material and emotional characteristics, fundamentally new. It appears that this was the painting that Alfonso first wanted Raphael to execute, and it is possible that a compositional drawing by the artist may have been available for Titian's perusal. Nonetheless, this beatific vision of a benevolent and mild nature in which comely men and women frolic on a breezy, sun-dappled shore under a vast, towering sky filled with billowing white clouds is a painted ode to the pleasures of the flesh. Its palette is different from

46. Titian, *Bacchanal of the Andrians,* Madrid, Museo del Prado

The text by the Greek writer Philostratus the Elder (born c. AD 190), which Titian followed for this part of the painting, reads in part, "The stream of wine which is on the island of Andros, and the Andrians who have become drunken on the river, are the subject of this painting. For by the act of Dionysus the earth of the Andrians is so charged with wine that it burst forth and sends up for them a river: if you have the water in mind, the quantity is not so great, but if wine, it is a great river – yes, divine!"

anything painted by Raphael, Giorgione, or any of Titian's con-
temporaries.

Using the same masterful drawing style as seen in the nearly
contemporary Frari *Assumption of the Virgin,* although here it is
slightly more accomplished, Titian has stretched a screen of
twisting, intertwined figures across the picture plane. The able
interrelation of the bodies and the poses of some of the figures
themselves were probably strongly influenced by drawings
after Michelangelo's then-famous cartoon for the *Battle of
Cascina* [47]. This large cartoon was originally drawn for a
fresco to be executed in the republican town hall of Florence.[10]
The fresco was never painted, but the cartoon became
instantly famous and was frequently copied by artists. One of
these copies must have reached Venice, where it was admired
and studied by Titian, who learned much from Michelangelo's
masterful construction, foreshortening, and interrelation of the
human body. In turn, many of Titian's figures, which equal and
sometimes surpass those of Michelangelo for their skillful
drawing, influenced the rendering of the human body for cen-
turies to come, as successive generations of artists fell under
their spell.

As in the *Assumption of the Virgin,* the figure of the *Bacchanal
of the Andrians,* as well as the trees, sea, and skyscape behind
and above them, are kept large and up close to the observer.
Background space is also restricted in order to hold the
observer's eye at the picture plane. As in a Giovanni Bellini
Madonna and Child or *Pietà,* abstract pattern is of key impor-
tance. Such adherence to the surface by color, shape, and light
was one of the defining properties of Venetian painting from its
inception throughout its long and distinguished history.

The *Bacchanal of the Andrians,* like the *Assumption of the
Virgin,* is also remarkable for its subtle, variegated network of
light. However, unlike the *Assumption,* the *Bacchanal* unfolds
not in a blaze of celestial brilliance, but under a bright sky filled
with scudding clouds propelled by the same gentle breezes that
bend the feathery trees shading the revelers. As the clouds
move across the sky, the light shifts momentarily, dappling the
celebrants. In another moment, different patterns of light and
dark will form as the clouds shift. This sense of evanescence

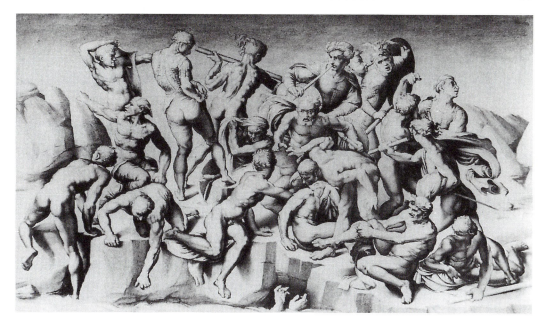

enlivens the painting, giving it a feeling of movement and change; it is a milestone in Titian's ever-increasing ability to endow his paintings with palpable ambience and life.

The colors and atmosphere of the *Bacchanal of the Andrians* are also exceptional and new. A wide, varied, and original range of hues—greens, reds, blues, pinks, whites, and browns—is recorded across the surface. Flesh, very much the subject of this painting, is seen in abundance. Ranging from pale white to swarthy, the flesh tones are as variegated as the other colors. Moreover, in the *Bacchanal* and in Titian's two other paintings for the Camerino, human skin is constructed with the most subtle range of glazed hues, imparting it a pulsating life. The sixteenth-century poet Aretino's claim that Titian's brush turned paint into flesh is nowhere more apt than in these three mythological paintings.

While retaining the characteristics of the *Bacchanal of the Andrians*, the two other mythologies painted for Alfonso d'Este are notably different. In the *Worship of Venus* [48], Titian was required to introduce many small putti performing the antics so carefully described by Philostratus. Consequently, there is an unavoidable turmoil that makes the foreground and middle

47. Michelangelo, *Battle of Cascina* (Copy of center section of Michelangelo's cartoon by Aristotile da Sangallo), Holkham Hall, Norfolk, England

Although Michelangelo's cartoon for the gigantic but never-executed *Battle of Cascina* was cut into pieces in 1516, it had already become one of the most famous and frequently copied works of the early sixteenth century. Benvenuto Cellini said of it, "though the divine Michelangelo in later life finished the great chapel of Pope Julius [the Sistine Chapel], he never rose half-way to the same pitch of power; his genius never afterward attained to the force of these first studies."

48. Titian, *Worship of Venus*, Madrid, Museo del Prado

Titian followed Philostratus' long description of this scene with considerable fidelity. Alfonso d'Este, Titian's patron, had borrowed a translation of Philostratus' *Imagines* from his sister, Isabella d'Este, well-known for her support of the arts and another of Titian's patrons.

ground of the painting less satisfactory in terms of the composition than the other two canvases for the Camerino. For the *Worship of Venus*, Titian seems to have studied Fra Bartolommeo's compositional drawing and adopted some of its general plan and several of its figures. Like all of his Renaissance contemporaries, Titian saw borrowing as a perfectly acceptable way to learn and to improve one's art and so took inspiration wherever he could find it.

Bacchus and Ariadne [49], the third painting, is one of Titian's most daring and original compositions, however. Deserted by Theseus, the desolate Ariadne stands by the seashore, looking out at his departing boat sailing off under a glorious, cloud-

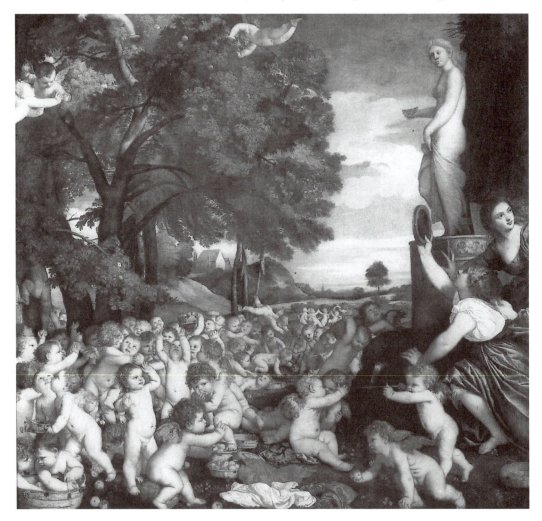

streaked sky of bright blue. At that instant, Bacchus and his rowdy company of satyrs and maenads enter from the right. They are a boisterous, ill-mannered, and somewhat frightening band. The snake-girt man (snakes were involved in bacchic ritual) is reminiscent of one of the figures of the *Laocoön,* a famous classical statue unearthed in Rome during the first years of the sixteenth century. This work was surely known to Titian from drawings, and its incorporation here demonstrates his interest in antique sculpture, especially when it aided his study of how to better form and articulate the human body.

Perhaps the most amazing part of this action-filled, dynamic painting is the figure of Bacchus. His leap from the chariot pulled by cheetahs is, at one and the same time, both awkward and brilliant. Pictured in mid-air, his leaping body and billowing draperies are fully expressive of his agitation and yearning for Ariadne—he is truly smitten. Moreover, his energy is the perfect reflection of his wild and disorderly band. This painting, like the other two, is set before a verdant, if restricted, landscape. As in the *Bacchanal of the Andrians* and the *Worship of Venus,* the atmosphere seems filled with light, shadow, moisture, and atomized color.

With the extinction of the house of Este at the end of the sixteenth century, the paintings of Bellini and Titian were removed from the Camerino, sent to Rome, and eventually dispersed. No reliable sources tell us exactly how they were hung in Ferrara, but the original ensemble must have been remarkable. The powerfully evocative combination of subjects, compositions, and sensual expressions of the works in their original setting can, unfortunately, now only be imagined. There can, however, be no doubt that Titian's three paintings for the room are major monuments of Western art and the ancestors of a long and distinguished line of mythological paintings, from Rubens and Velázquez to Turner and Manet. These three canvases set the stage for Titian's rise to international fame.

NOTES

1. For Titian's Frari *Assumption* and the *Pesaro Altarpiece* (discussed below), also in Santa Maria Gloriosa dei Frari, see R. Goffen, *Piety and Patronage in Renaissance Venice: Titian and the Franciscans,* New Haven, 1986.

2. On Venetian drawings, the best works to consult are H. Tietze and E.

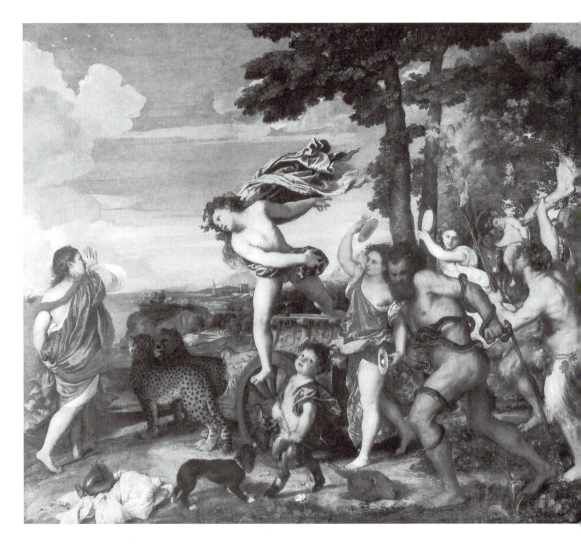

49. Titian, *Bacchus and
Ariadne,* London, National
Gallery

Alfonso d'Este originally
commissioned Raphael to
paint a *Triumph of Bacchus*
for his Camerino and in
1518 paid him an advance.
When Raphael died in 1520,
only a drawing for the
project had been completed.
(See color plate 2)

Tietze-Conrat, *The Drawings of the Venetian Painters*, 2 vols., New York, 1970, and J. Byam Shaw, "Drawing in Venice," *The Genius of Venice, 1500–1600*, ed. J. Martineau and Charles Hope, London, 1983: 243–245.

3. The best introduction to Michelangelo is H. Hibbard, *Michelangelo*, New York, 1985. For an extended discussion of Michelangelo's individual works, see C. de Tolnay, *Michelangelo*, 5 vols., Princeton, 1943–1960.

4. A recent work devoted to the history of the Venetian altarpiece is P. Humfrey, *The Altarpiece in Renaissance Venice*, London, 1993.

5. For courtesan portraits, consult L. Lawner, *Lives of the Courtesans: Portraits of the Renaissance*, New York, 1987.

6. An important study of Venetian Renaissance costume is S. Newton, *The Dress of the Venetians, 1495–1525*, Aldershot, 1987.

7. Works on the d'Este family and Ferrara include E. Gardner, *Dukes and Poets in Ferrara*, New York, n.d.; W. Gundersheimer, *Ferrara: The Style of a Renaissance Despotism*, Princeton, 1973; and T. Tuohy, *Herculean Ferrara: Ercole d'Este, 1471–1505*, Cambridge, England, 1996.

8. For more on the history of the Camerino, see J. Walker, *Bellini and Titian at Ferrara*, London, 1956.

9. Translations of Philostratus, Catullus, and Ovid are as follows: Philostratus, *Imagines/Descriptions*, trans. A. Fairbanks, Cambridge, Mass., 1931; Catullus, *Works*, ed. G. Gould, London, 1983; and Ovid, *Metamorphoses*, trans. R. Humphries, Bloomington, 1955. See also F. Saxl, "A Humanist Dreamland," *A Heritage of Images*, London, 1970: 89–104.

10. The *Battle of Cascina* cartoon is discussed by J. Wilde, "The Hall of the Great Council of Florence," *Journal of the Warburg and Courtauld Institutes* VII (1944): 65–81.

5

Titian:
International Fame,

1530–1543

❧

The mythologies for Ferrara indicate that Titian's fame had echoed well beyond the Venetian lagoon by the early 1520s. However, it was neither his mythologies nor his religious paintings that won him larger acclaim. Rather, it was his portraits. The portrait, and especially the royal portrait, was of singular importance to Renaissance society.[1] Before the age of photography, the painted portrait was the principal vehicle by which the image and nature of rulers were transmitted. Successful portrait painters, like Titian, succeeded because they were able to furnish prominent people with portraits that were images of nobility and power, likenesses that conveyed the social and economic status of the sitters themselves. These portraits, moreover, also confirmed and thereby enhanced the sitter's self-image, something that the successful portraitist fully understood. Titian's achievements in portraiture were unmatched in the sixteenth century. His

clientele included the most famous and powerful rulers of his time: dukes, princes, kings, popes, and even the Holy Roman Emperor. Titian was, quite simply, the preeminent portrait painter of his age, and to have one's likeness painted by him was itself an affirmation of one's importance.

Titian was catapulted to international fame and fortune after executing several full-length portraits of the Holy Roman Emperor Charles V.[2] The circumstances surrounding these paintings are not entirely clear, nor can their dating be established with certainty. The emperor and artist seem to have first met in Bologna in 1530, when Charles was in the city for his coronation as Holy Roman Emperor. It is possible that Titian's introduction to Charles was facilitated by Federico II Gonzaga of Mantua, one of the artist's most important Italian patrons. According to Vasari, in 1530 Titian painted his first portrait of the emperor, a full-length picture in which Charles was wearing armor. This painting is now lost, but another portrait [50], done several years later, still survives. It was probably painted in 1533 when Charles was in Italy again, and depicts him full-length with a hound. Charles was so pleased with Titian's work for him that he made the painter Count Palatine and Knight of the Golden Spur. These titles not only ennobled the artist and increased his prestige, but also conferred on him various privileges, such as the right of attendance at court.

An identical portrait of the emperor [51], signed and dated 1532 by the German court artist Jacob Seisenegger, is often cited as the model for Titian's portrait of Charles V. It has been suggested that Charles brought his portrait by Seisenegger on his second trip to Italy. The full-length type does seem to originate in Germany, and it is quite possible that Titian copied from Seisenegger's painting, although the fluidity of the hanging green cloth and the broad, synthetic painting of the clothes seem Venetian in origin. It may indeed be possible that Seisenegger's painting depended on Titian's portrait, rather than the other way around.

Whatever the temporal relation between these two paintings, they are separated by a considerable qualitative and interpretive distance. Seisenegger's version is harder and more detailed than Titian's; there is a particularity of vision and

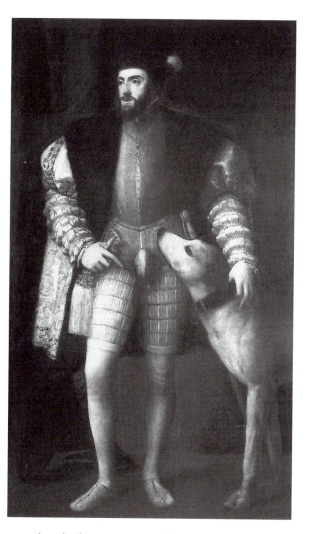

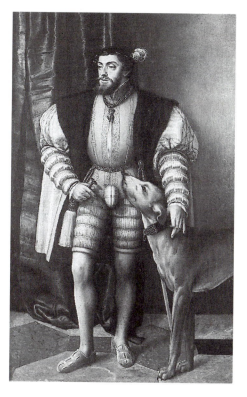

detail characteristic of much German painting of the time. Moreover, Seisenegger's image of Charles lacks the overall unity and the subordination of the parts to the whole that make Titian's portrait so remarkable. Only Titian's portrait of Charles illustrates that reserve, dignity, and commanding pres-ence–seen as early as the great *Portrait of a Man* [36]–which must have corresponded almost exactly to the sitter's exalted position and self-image.

Occasionally, as in the case of the portrait of Federico II Gonzaga of Mantua [52] of around 1530, Titian lets us glimpse something more of the sitter's character. Federico, was the son

50. Titian, *Charles V*, Madrid, Museo del Prado

In a report to the Venetian Senate on November 7, 1530, the chronicler Marino Sanuto makes specific reference to the animal that Charles brought to Bologna, calling it "a large racing dog."

51. Jacob Seisenegger, *Charles V,* Vienna, Kunsthistorisches Museum

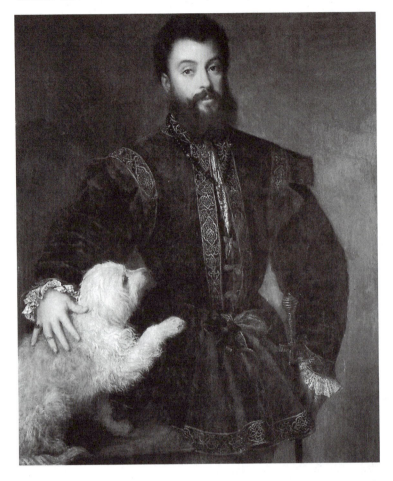

52. Titian, *Federico II
Gonzaga,* Madrid, Museo
del Prado
 Federico II Gonzaga
(1500–1540) was the first
duke of Mantua. As a child
he was hostage to Pope
Julius II between 1510 and
1513. Vasari claims that
Federico's portrait appears
in Raphael's *School of
Athens.*

of Isabella d'Este Gonzaga, a formidable, knowledgeable, and
demanding patron who was herself twice painted by Titian.[3]
Like his mother, Federico was interested in art and the prestige
it could bring to its owners; he was, in fact, one of the most
important patrons of the Renaissance.[4] Quick to recognize
Titian's skill, the Gonzagas were among the earliest of his aris-
tocratic patrons outside Venice–Federico himself owned a
number of Titian's paintings. The Gonzagas' discernment of art
was extraordinary, and over the decades, the court at Mantua
amassed a collection of distinction, which was eventually sold
in large part to King Charles I of England.

 In Titian's portrait of Federico, the subject is portrayed
three-quarter length. Unlike the *Charles V,* we are here
engaged by the sitter, who turns his head to look out at us. The

handsome, expressive face with its soft eyes and full mouth is framed by a halo of dark hair. Federico touches his sword, but his delicately painted blue velvet jacket and plump hand resting on his faithful, fluffy dog (compare this to Charles' hound!) hint at a certain malleability of character that Titian saw in this sitter.

Portraits like the *Federico II Gonzaga* were much admired in the close-knit world of the courts of northern and central Italy, especially after Titian had painted the portrait of the Holy Roman Emperor, a commission of enormous prestige. Not surprisingly, the lesser aristocrats of these small but highly cosmopolitan city-states also wanted to have their likenesses done by the emperor's portraitist. Like Charles V and Federico II Gonzaga, they wished to be idealized and immortalized by a painter of such skill and growing fame.

Among the most interesting of these works for courtly patrons are the two portraits [53, 54] of the Duke and Duchess of Urbino painted around 1536.[6] The duke, Francesco Maria I della Rovere, was the scion of an important Italian family whose members included his uncle Pope Julius II, the patron of Michelangelo's Sistine Ceiling. Eleonora Gonzaga della Rovere, the duchess, was the daughter of Isabella d'Este and sister of Federico II Gonzaga, whose portrait she and her husband must have admired.[5] The duke and duchess are each painted on a separate canvas, perhaps in both imitation and homage to Piero della Francesca's double portrait of their predecessors, Federigo da Montefeltro, Duke of Urbino, and his wife, Battista Sforza, painted some sixty-five years earlier [55]. Although Eleonora was to live another fourteen years, the duke died shortly after he was painted by Titian. Baldassare Castiglione's famous *Book of the Courtier*, a manual of correct court behavior, was written while the author was in the service of Francesco Maria, but the duke was certainly no paragon of virtue.[7] He was an unsavory, murderous character who stabbed a cardinal to death, and it was rumored that he was killed by poison poured into his ear while asleep. Like Federigo da Montefeltro, he was a military commander, although not as skilled, who had been in the employ of Venice and the papacy, and it was in this martial role that he chose to be portrayed.

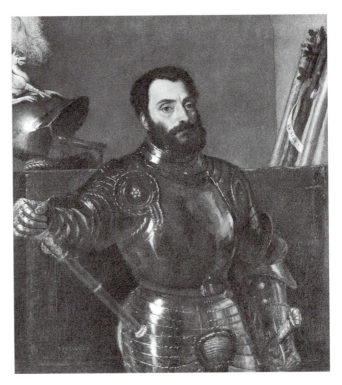

53. Titian, *Francesco Maria I della Rovere,* Florence, Galleria degli Uffizi

In 1509, Francesco Maria I della Rovere (1480-1538) married the sixteen-year old Eleonora Gonzaga, daughter of Francesco II and Isabella d'Este Gonzaga of Mantua. Such marriages between aristocratic families often served as the basis of a network of economic and political alliances.

54. Titian, *Eleonora Gonzaga,* Florence, Galleria degli Uffizi

Eleonora Gonzaga della Rovere (1493–1550), Duchess of Urbino, was about forty-three when she sat for this portrait by Titian. The little dog could have been intended as a symbol of fidelity, but such animals appear with frequency in paintings by Titian and his Venetian contemporaries. They may, in fact, be likenesses of actual pets.

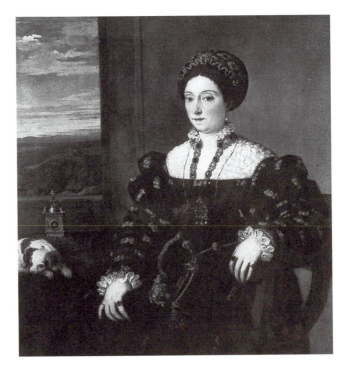

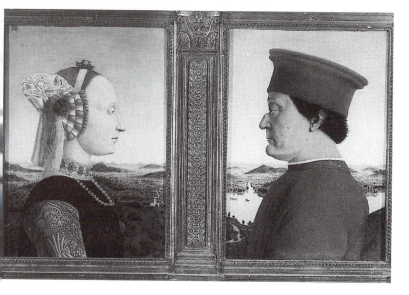

55. Piero della Francesca, *Federigo da Montefeltro and Battista Sforza,* Florence, Galleria degli Uffizi

Piero della Francesca's double portrait was a treasured possession of the dukes of Urbino. Federigo da Montefeltro (1422–1482), first duke of Urbino, was a skilled and famous soldier.

The recent cleaning of the portraits of the duke and duchess of Urbino has revealed that both are exceptionally well preserved and still possess the network of fine glazes with which all Titian's portraits were originally covered. These delicate glazes, all too often lost through overcleaning and natural deterioration, were the means by which Titian was able to convey his remarkable mimetic effects. The lustrous shimmer of the duke's black armor, the way the heavy red velvet of the background absorbs light, and the pervading color-laden atmosphere enveloping sitter and objects are seen here in all their original splendor.

A preliminary study in pen [56] exists for the duke's portrait. The only known preparatory drawing for an extant portrait by Titian, it depicts a full-length armored figure standing before a niche. The figure's face is bearded and generic in nature, and is certainly not a likeness of the duke. We can be sure, however, that the armor did belong to Francesco Maria from letters informing us that he lent it to Titian and was anxious to have it returned to him as soon as the painter had sketched it. He also requested a drawing–perhaps this very one. The drawing is, in fact, mainly a portrait of the armor about which the duke was so concerned and which figures so prominently in the painted portrait. Titian resolved the posture and gesture of the standing figure in the drawing, but he

pictured only a half-length figure in the painting. X-rays reveal that he reused a canvas with a previously painted portrait for the duke's image. Titian reutilized previously painted canvases on a number of occasions because, like all Renaissance artists, he was extremely economical with both his materials and his time.

A beautiful drawing of a helmet [57] done in black and white chalk on blue paper has also been connected with the portrait of Francesco Maria.[8] Such an association is probably unfounded because the drawn helmet lacks the dragon and plume found in the painting. In any case, the vigor and bold-ness of the masterfully conceived helmet and the artist's ability to turn charcoal into the semblance of hard, lustrous metal are remarkable. Moreover, the helmet seems infused with energy, even monumental in scale. Because Titian drew directly on the canvas, only a handful of such drawings exists. This is even more unfortunate when we are confronted with a real master-piece of draftsmanship such as this.

56. Titian, *Drawing of Francesco Maria I della Rovere,* Florence, Gabinetto dei Disegni e Stampe degli Uffizi

57. Titian, *Drawing of a Helmet,* Florence, Gabinetto dei Disegni e Stampe degli Uffizi

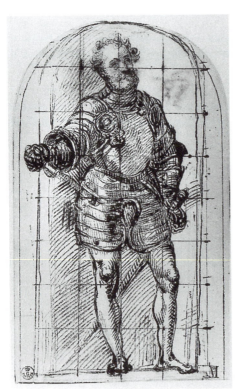

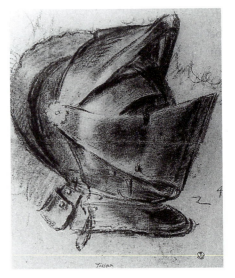

The armor worn by the duke in the portrait is, like the drawn helmet, a tour de force of art. Its lustrous polished surfaces gleam with light while reflecting the deep red of the background velvet. Francesco Maria holds the baton of a Venetian general–two other batons of command and a flowering oak branch (his family name, Rovere, is the Italian word for oak) share the velvet-covered ledge with a dragon-crested helmet. The duke is portrayed by Titian as a commanding figure surrounded by the symbols of his authority and power. Standing close to the onlooker, the duke's body is placed at an angle to the picture plane, but his head with its quizzical eyes turns in the opposite direction, toward the viewer. The dynamism and torsion of the posture is enhanced by the protruding, sharply foreshortened right arm and the diagonal of the baton. The posture and gestures of Francesco Maria I della Rovere animate his figure while rendering it expansive and endowing it with a commanding presence.

The duke's wife, Duchess Eleonora Gonzaga della Rovere, is a much less compelling figure, it must be admitted. The dynamism and bearing of her husband would, of course, have been most unsuitable for the depiction of a Renaissance lady, such as those praised by Castiglione in the *Book of the Courtier*. Instead, Eleonora is demurely seated near a window from which one sees a panoramic view crowned with one of Titian's remarkable cloudscapes. Titian's friend Pietro Aretino wrote a sonnet in praise of the painting that gives us a fascinating description by an acute contemporary observer: "The union of colors which the style / Of Titian has painted, brings out / The harmony which rules in Leonora / The ministers of her gentle spirit. / In her resides modesty in a humble act. / Honesty resides in her clothes / Shame in her breast / And her locks veil her and honor her, / Love afflicts her with a noble gaze. / Modesty and beauty, eternal enemies / Range in her countenance, and among her lashes."[9]

The Eleonora's sumptuous, expensive gown of gold and black with white collar and cuffs, which, along with her pearls and gold necklace, indicates both her social position and her wealth. Perhaps the poet called her clothes honest because they are so sober. Eleonora's self-contained reticence and quiet

pose are the domestic counterparts of the duke's vigorous and
military bearing, as well as Aretino's ideal of female modesty.

Throughout his entire career, Titian's portraits of aristo-
cratic women are frequently, but not exclusively, less absorb-
ing than his portraits of men. Sometimes the gowns worn by
the women and the props that surround them are as interest-
ing to Titian as the sitters themselves. Like many of his con-
temporaries, he often saw women stereotypically and painted
them accordingly. It was the Renaissance conception of man as
the embodiment of command, power, and intelligence that
most attracted Titian and his fellow artists' critical intellect
and powers.

The duke's portrait, like that of the emperor, was carefully
planned and executed to be an image of power and authority
that would not only conform to the sitter's self-image, but also
impress all those who saw it. In the sixteenth century Titian's
portraits of important men and women were paragons of the
type. However, he also painted likenesses of their young sons
and daughters that reveal his sympathetic understanding of
youth, and remain among the finest examples of portraits of
children. It is, in fact, no exaggeration to claim that in these
portraits, Titian broke with the tradition of portraying children
as little adults. Instead, he imbued his small sitters with all the
attributes and feelings of childhood, thereby creating a new
and important type of portraiture.

Titian's skill in the portrayal of children is readily apparent
in his *Clarice Strozzi* [58] of 1542. Clarice was the daughter of
the Florentines Roberto Strozzi and Maddalena de' Medici,
who were then living in exile in Venice. It was Titian's task to
picture Clarice, who was two years old at the time of the sit-
ting, as both a small child and a member of a powerful and
ancient family. This he did with consummate skill. Clarice is a
charming diminutive girl with a crown of soft, curly hair.
Embracing her alert little dog, whom she feeds a large pretzel-
shaped roll, she is a childlike, vivacious presence. But she is
also surrounded by symbols of her status. Placed in a room of a
palazzo illuminated by a large opening through which a
wooded landscape is revealed, she stands next to what appears
to be a classical altar, decorated, most appropriately, with a

58. Titian, *Clarice Strozzi*, Berlin, Gemäldegaleria, Staatliche Museen

Clarice Strozzi (1540–1581) lived with her parents during part of their exile in Venice. The type of roll she feeds her dog appears in other Venetian pictures of children with their pets; perhaps it was the sixteenth-century equivalent of a dog biscuit!

base relief of two dancing putti who seem to be about her age. The appearance of this ancient altar would have alerted the onlooker to the humanistic learning and love of antiquity of the child's family.

Clarice is carefully and expensively dressed: She is adorned with pearls, a brooch, and a gilded, bejeweled belt. She is clearly recognizable as a scion of a wealthy family, a fact confirmed by the inscription on the wall identifying her as a Strozzi. It is, however, Titian's particular portrayal of her as both young patrician and innocent little child that makes this portrait so attractive and complex. Clearly a member of a powerful and famous Renaissance family, Clarice is also a vivacious, carefree child, who, for the moment, seems blissfully unaware of this fact.

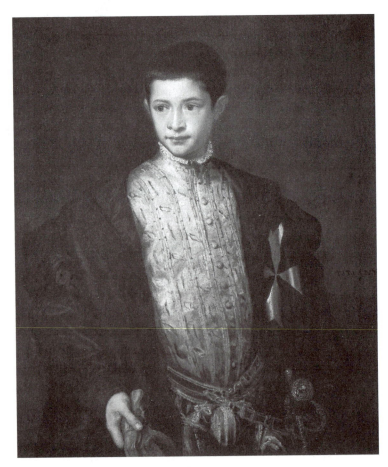

59. Titian, *Ranuccio Farnese*, Washington, D.C., National Gallery of Art

Pierluigi Farnese (1503–1547), the son of Pope Paul III and the father of Ranuccio Farnese, was created Duke of Parma and Piacenza in 1545. His harsh rule led to his assassination. His son, perhaps remembering his father's troubles, was an able and admired administrator.

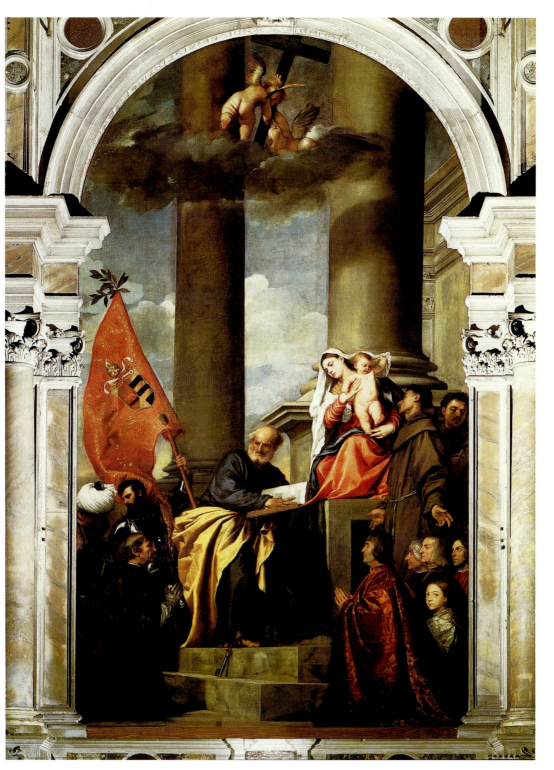

1. Titian, *The Pesaro Altarpiece,* **1519-1526**
Venice, Santa Maria dei Frari
(Scala/Art Resource)

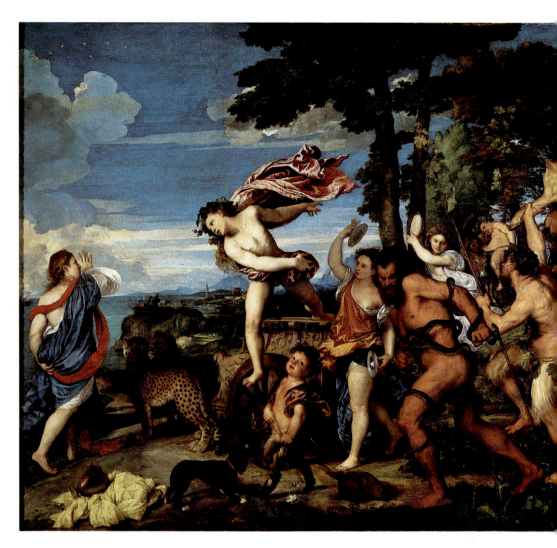

2. Titian, *Bacchus and Ariadne,* 1523
London, National Gallery
(Scala/Art Resource)

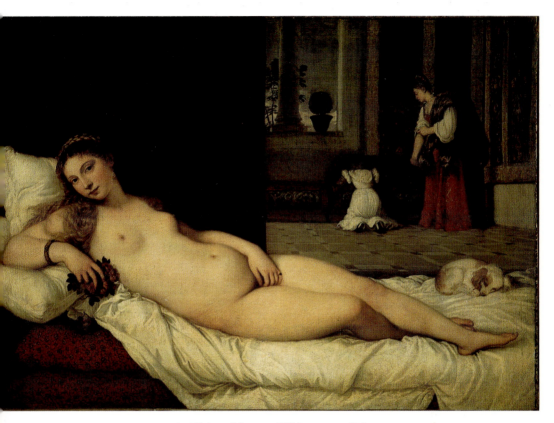

3. Titian, *Venus of Urbino,* c. 1538
Florence, Galleria degli Uffizi
(Scala/Art Resource)

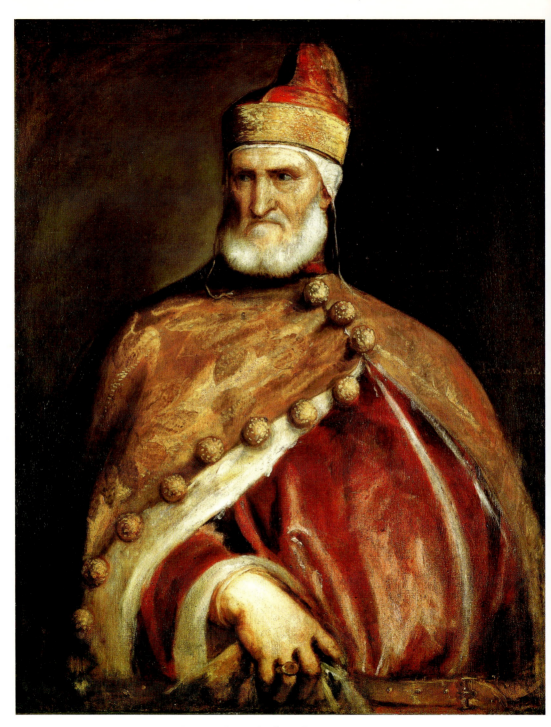

4. Titian, *Doge Andrea Gritti, 1546-1548*
Washington, D.C., National Gallery of Art
(Scala/Art Resource)

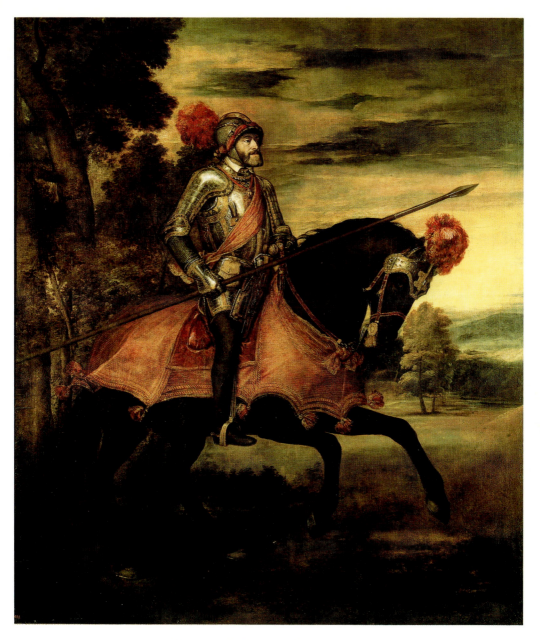

5. Titian, *Charles V at Mühlberg,* 15–?
Madrid, Museo del Prado
(Scala/Art Resource)

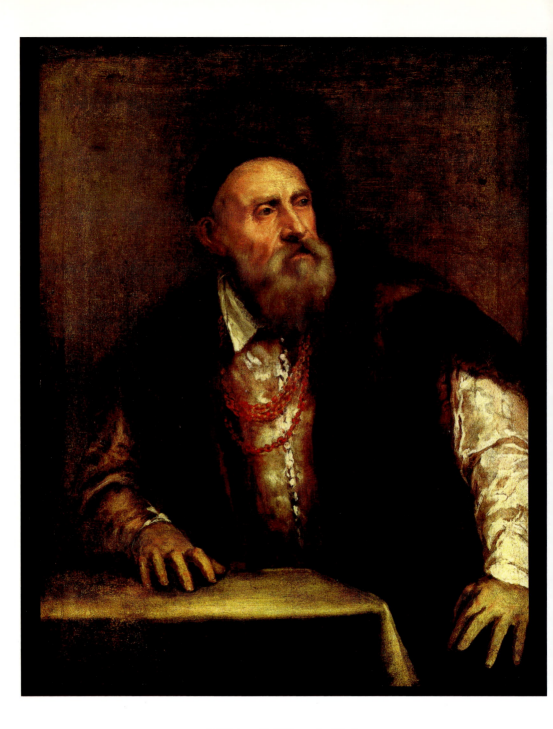

6. Titian, *Self-Portrait,* 15–?
Berlin, Gemäldegalerie, Staatliche Museen
(Scala/Art Resource)

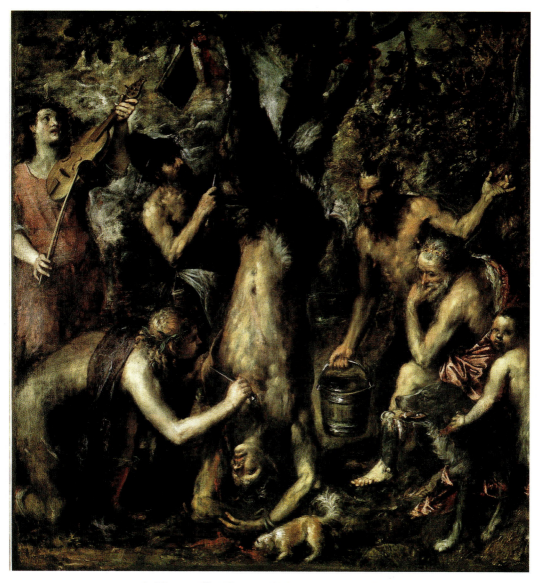

7. Titian, *The Flaying of Marsyas, 1570–1575*
Kremsier, National Gallery
(Scala/Art Resource)

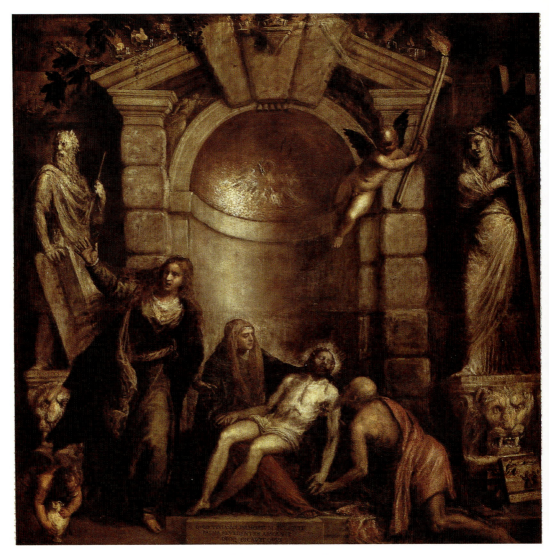

8. Titian, *Pietà*, 1576
Venice, Galleria dell'Accademia
(Scala/Art Resource)

Ranuccio Farnese (1530–1565) was also the offspring of an important family, but his portrait [59] is far more complex than that of Clarice Strozzi. The grandson of Pope Paul III, the patron of Michelangelo's *Last Judgment* in the Sistine Chapel, Ranuccio benefited early from his grandfather's nepotism. By 1542, the date of Titian's portrait of him, Ranuccio was living in Venice as prior of San Giovanni dei Furlani, a church owned by the powerful Knights of Malta. Three years later he was made a cardinal and, shortly thereafter, a bishop.[10]

The portrait is mentioned in a letter of 1542 from one of Ranuccio's guardians, who states that it was commissioned as a gift for the boy's mother and that it was painted only partially from life. Such a procedure was not uncommon because most Renaissance sitters, including the twelve-year-old Ranuccio, were important personages too busy for extended sittings. Titian and his fellow artists would usually make drawings from life and, if possible, oil sketches of the face. Posture, costume, and attributes would be added by the artists later, as we know from the portrait of Francesco Maria I della Rovere.

Costume plays a key role in the portrait of Ranuccio Farnese. The boy's black cloak, which bears the cross of the Knights of Malta, merges with the dark background. In strong contrast, the beautifully painted red tunic, white collar, and youthful face seem to emerge from the surrounding darkness. Because of paint deterioration, both the cloak and the background are flatter and darker than they were originally, but the distinction between light and dark must have been intended from the start. The creation of such a wide range of tonalities to focus attention on the face owes much to Titian's study of the work of Leonardo and his followers. However, the increased drama of the stagelike lighting anticipates the manner of Caravaggio, who could have seen the portrait of Ranuccio in the Farnese collection in Rome.

The *Ranuccio Farnese* is both a finely composed portrait and a subtle study of early adolescence. The handsome, if idealized, face seems lost in thought, unaware of the onlooker's gaze. Unlike the Duke and Duchess of Urbino, the boy does not pose, but rather is pictured in a transitory moment of contemplation. One feels that in another second he will emerge from

his reverie and move on to some of the important duties assigned to him as the prior of San Giovanni dei Furlani. Again, as in the portrait of Clarice Strozzi, Titian has been able to subtly suggest the tensions that exist between youth and responsibility in these heirs of powerful families. The depiction of such complexities in the portraits of children simply did not exist before Titian.

Around 1530, he painted what might be called a "religious portrait," a *Mary Magdalene* [60], probably commissioned by Francesco Maria I della Rovere, Duke of Urbino, which is also new both in type and interpretation. Titian depicts the saint half-length, covered only by her long auburn hair. Placed close

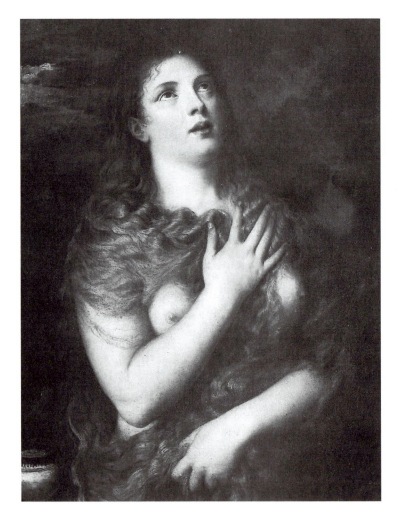

60. Titian, *Mary Magdalene,* Florence, Palazzo Pitti, Galleria Palatina

Vasari, who must have been struck by this depiction of the Magdalene, describes this as "a very unusual half-length picture of Saint Mary Magdalene with her hair disheveled." He must not have realized that the saint's hair functions as a sort of hairshirt, one of her most frequent attributes.

to the observer and occupying most of the picture's space, she is a considerable presence. The Magdalene is also startlingly fleshy. Using the viscous and pliable properties of the oil medium to create painted hair and skin with a degree of verisimilitude, subtlety, and sensuousness hitherto unseen, Titian has consciously and consistently emphasized the carnal nature of this sinner-saint. Pietro Aretino's statement that the artist's brush turned paint into living flesh once again comes to mind. It is, however, interesting to note how much more restrained are Titian's depictions of the Virgin and other female saints. His brush was a delicate instrument and he could temper its sensuousness whenever he wished.

Although the Magdalene is portrayed as a penitent, her spiritual nature is secondary to her voluptuous form. The erotic component of this picture is striking indeed, and it is likely that Titian derived the pose from an ancient Venus type—the Venus Pudica, which represents the goddess coyly covering herself. Given the carnal nature of Titian's *Mary Magdalene,* this association does not seem at all surprising. Such borrowing from the ancient world, and probably from a Roman statue Titian knew either first-hand or through drawings, is another example of his interest in the art of classical antiquity, which he saw as a vast quarry to be worked for motif and inspiration. Yet he never slavishly copied from ancient art; rather he transformed what he borrowed for his own artistic purposes.

This rather small (85 x 68 cm) painting of the Magdalene seems to have no precedents, except the courtesan portrait type, such as Titian's own *Flora* [45]. One wonders what the Magdalene's original function was, for without some contemporary documentation, this can only be guessed. The work could have been a small altarpiece or simply a devotional picture meant for private religious contemplation. But its high erotic charge must certainly have engendered other, nonspiritual thoughts in the mind of the onlooker.

Titian's ability to reinterpret subjects and endow them with unprecedented carnality is seen again in his so-called *Venus of Urbino* [61], one of his most famous works. This painting was bought from Titian in or around 1538 by an agent of the Duke

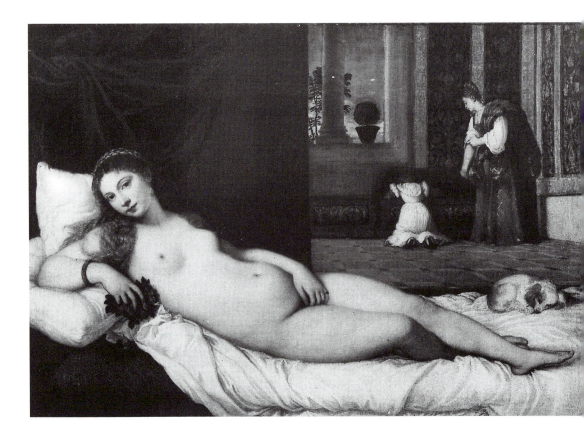

61. Titian, *Venus of Urbino*,
Florence, Galleria degli
Uffizi

Vasari saw this painting
in the ducal collection in
Urbino. He describes it as
"a young recumbent Venus
clothed in lovely fabrics and
flowers." *(See color plate 3)*

of Urbino, Guidobaldo II della Rovere, the son and successor of the very Francesco Maria I della Rovere whose portrait by Titian is discussed above [53]. Contemporary documents call the *Venus of Urbino donna nuda* (nude woman), and it is, in all likelihood, an idealized portrait of a Venetian courtesan that now masquerades under the more respectable title of *Venus,* an appellation that lends it a gloss of ancient myth and learning. Recently, some critics have suggested that the painting is an allegory of married love or fidelity, but this seems far-fetched, given the nature of the image.[11]

Clearly the *Venus of Urbino* depends on Giorgione's earlier *Sleeping Venus* [26]. In both, a nearly identically composed, recumbent figure fills much of the space with her large, volumetric nude body, although Titian's Venus is even more substantial than that of Giorgione. Titian has, however, changed the position of Venus' right hand, awakened her, and made her gaze toward the onlooker, who is, in turn, looking at her. These changes are considerable, for they animate the figure and create an entirely new and more intimate rapport between the spectator and the nude woman. Once again, as in his *Entombment* [43], Titian has been inspired by a prototype, which he has then substantially modified in composition and feeling.

He has, moreover, radically changed the scene by moving the figure indoors. The surrounding sylvan landscape of the *Sleeping Venus* has been replaced by the interior of a large, sumptuously appointed Renaissance palazzo–only a sliver of tree and clouds is viewed through the loggia at the back. Now located in a contemporary setting, the woman reclines on the pillows of an unmade bed. She awaits the attention of her maids in the background, one of whom holds a silken dress over her shoulder while the other searches in a *cassone* for other clothing.

It is, however, Venus' startling nudity rather than the clothing that is the focus of this painting. Stretched out before the onlooker, the body of the woman, whose head and torso are set off by the green drapery and dark wall behind, is a landmark of eroticism in Western art. Aware of the spectator upon whom she fixes her enigmatic gaze, she consciously and unashamedly presents her body for the delectation of the

onlooker. The nuanced network of brush strokes, the incre-
mental modulation of color, and the subtlest light all unite
to form a sense of living, breathing flesh. Here is one of the
most consciously voluptuous bodies in the entire history of
Western art. Enveloped by an atmosphere of luxury, and con-
structed with an astonishing sense of realism, Venus, from her
lustrous, auburn hair cascading down the shoulder to her
softly swelling abdomen, continues to hold the onlooker spell-
bound by her materiality and sensuality.

This ability to enthrall the onlooker is also found in Titian's
religious paintings of this period, and probably nowhere more
so than in the *Martyrdom of Saint Peter Martyr*, a work com-
pleted in 1530. Unfortunately, this large altarpiece (originally
some fifteen feet high and, like the Frari *Assumption*, painted on
panel) was destroyed by fire in 1867. Its loss is especially
unfortunate because it was one of Titian's most famous paint-
ings–Vasari called it his "greatest and best conceived." It
served, moreover, as an inspiration for many artists for several
centuries after its completion, and its role in the formation of
the Baroque style was considerable, as we shall see below.

The *Martyrdom* was painted for the altar of the
Confraternity of Saint Peter Martyr, in SS. Giovanni e Paolo,
perhaps as a result of a competition held between Titian and his
contemporary and rival Palma Vecchio, who was himself a
member of the confraternity.[12] Titian asked for only 100 ducats,
the same sum he was paid for the *Pesaro Altarpiece*. This was not
much money, and it is likely that he charged so little because he
wanted to execute a major painting for SS. Giovanni e Paolo,
the principal Dominican church of Venice. This done, he would
have executed commissions for the principal Venetian
churches of the two major mendicant orders–the Franciscan
Frari and the Dominican SS. Giovanni e Paolo. The attendant
publicity of these important commissions would have been
worth much more than money to Titian, who throughout his
long career proved himself to be a shrewd self-promoter. While
no photographs of the *Martyrdom of Saint Peter Martyr* were
taken before its destruction, it was extensively copied both in
paintings and engravings because of its great fame. Such copies
helped disseminate its composition to a wide audience of artists.

A good approximation of how the painting originally looked is furnished by an engraving of c. 1570 by Martin Rota (c. 1520–1583), an artist who worked in collaboration with Titian [62].[13] Throughout his working life, Titian was aware of the publicity that the circulation of prints in large numbers would bring him. At the start of his career, he had furnished designs for woodcuts, but by the 1560s, his interest had turned to engravings. In 1567 he applied to the Venetian senate for a fifteen-year copyright privilege for engravings after his work. As justification for his petition, he stated his fear of the piracy of his designs by unauthorized copyists, which occurred with increasing frequency as he became more famous. He wanted to both protect his own inventions and control their dissemination.[14]

In the document of 1567, Titian states that he wishes "to engrave and distribute [the prints] for the benefit and knowledge and use of painters and sculptors and other knowledge-

62. Martin Rota, *Martyrdom of Saint Peter Martyr,* Engraving after Titian

Titian's seventeenth-century biographer Carlo Ridolfi ends his long and laudatory description of this picture by saying, "Now in conclusion, this highly esteemed panel is deemed by every intelligent man to be among his [Titian's] finest efforts, and it is thought that Titian reached the most sublime height of art in this place. . ."

able persons." This distribution would, of course, be good for business, especially if Titian could supervise the quality and number of printed images. This he did with considerable care, employing as his principal engraver the talented Netherlandish artist Cornelis Cort (c. 1533/6–1578). Cort produced a number of superb prints after Titian's work, all made in collaboration with the painter during the engraver's two Venetian sojourns in 1555–1556 and 1571–1572.[15] Cort also made engravings after other Italian artists during a stay in Rome, where he later died, but his work with Titian is especially notable for its ability to capture the volume and light of the original paintings.

Martin Rota's print of the *Martyrdom of Saint Peter Martyr* was also probably made in Titian's shop, although it lacks the quality of Cort's work. The inscription, located on a tablet hung from a tree, clearly states that although engraved by Rota, the composition is Titian's. However, the print does not bear Titian's usual statement of copyright privilege. The fact that Rota's print was done at least twenty-eight years after the painting was completed demonstrates the lasting fame of this altarpiece.

Why was this painting so popular? This question can not be answered with documentary certitude, but it does seem likely that its stark, powerful drama and bold, activated figures and lighting were both innovative and influential. This can be sensed in Vasari's laudatory description of the painting in his "Life of Titian":

[He] painted the panel for the altar of Saint Peter Martyr in the church of SS. Giovanni and Paolo, making the figure of the holy martyr larger than life among enormous trees in a wood, where, having fallen to the ground, he is savagely assaulted by a solider who has wounded him in the head in such a way that his face, as he lies there half alive, shows the horror of death, while in the figure of another friar who is in flight the terror and fear of death can be recognized. In the air are two nude angels coming from a light in heaven which illuminates this unusually beautiful landscape as well as the entire work; this is the most accomplished and celebrated, the greatest and best conceived and executed of the works that Titian completed during his whole lifetime.[16]

The story itself is a violent one. Saint Peter Martyr was a thirteenth-century Dominican from the city of Verona. His

severe persecution of heretics caused them to finally murder him in a woods near Milan. As he died, Saint Peter forgave his killers and, with his own blood, wrote on the ground "I believe in God." The story had been depicted frequently before Titian's altarpiece, but in a very different way. If, for example, we look at a painting [63] of the same subject by the workshop of Giovanni Bellini, we see that the action stretches across the surface in an artificial friezelike pattern. Moreover, the killing and fleeing seem almost balletic, devoid of the real terror that Vasari so admired in Titian's work.

Titian's *Martyrdom of Saint Peter Martyr* is, conversely, full of movement both into and out of the painting's space. The violent, tense pose of the murderer, the dynamic, open posture of Saint Peter's companion, and the upward glance and gesture of the saint himself are amplified by the twisting, wind-blown trees, wafting clouds, and the hovering angels offering the palm of martyrdom to the saint below. Everything from the large, volumetric bodies (they were life-sized) to the landscape alive with movement and light adds to this new, forceful portrayal of a type of painted narrative hitherto unseen in Venice. Certainly Titian learned much about how to fashion such drama by

63. Workshop of Giovanni Bellini, *Martyrdom of Saint Peter Martyr,* London, National Gallery

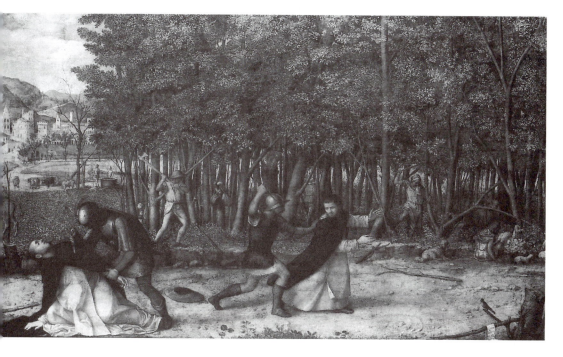

studying prints of Michelangelo's twisting, activated figures
from the Sistine Ceiling, but once again he has gone far beyond
his model in dramatic intensity and movement. It is for these
reasons that this painting was so inspiring to Baroque artists
searching for dynamism and theatricality in their paintings.

Titian's new and exciting depiction of drama was amplified
in other contemporary religious paintings by him. This was the
case in a now-destroyed *Annunciation* that, like the *Martyrdom
of Saint Peter Martyr,* is known only through a contemporary
engraving, done by Gian Jacopo Caraglio under Titian's super-
vision [64].[17] This *Annunciation,* which is overly neglected in
the studies on Titian, was commissioned by the nuns of Santa
Maria degli Angeli of Murano, a small island in the Venetian
lagoon. However, prior to 1537, it was refused by them
because they thought that Titian's price of 500 ducats was
too high–Titian had asked only 100 ducats for the *Saint
Peter Martyr* altarpiece! The commission for a replacement
Annunciation was subsequently given to Pordenone, Titian's

64. Gian Jacopo Caraglio,
Annunciation, Engraving
after Titian
 Gian Jacopo Caraglio
(1505–c. 1565) was born in
Verona and died in Cracow,
Poland. In Caraglio's engrav-
ing, two angels hold the
emblem of Charles V: two
columns with a scroll read-
ing PLVS VLTRA.

principal rival at the time.[18] Then, in 1537, perhaps at the poet Aretino's urging, Titian sent the painting to Charles V, the Holy Roman Emperor, as a gift for Empress Isabella. Charles must have valued the painting highly, because he gave the artist the considerable sum of 2,000 scudi. The *Annunciation* remained in Spain until the early nineteenth century, when it was probably destroyed during the French invasion.

This large altarpiece depicted a commonly painted subject with a long, venerable heritage in Venetian art. Versions of the Annunciation were painted by almost every important Venetian artist before Titian, and thus the weight of tradition, an important and often decisive factor in the mental apparatus of every Renaissance artist, must have influenced Titian as he considered the commission from the nuns of Santa Maria degli Angeli at Murano. Nevertheless, as in the *Pesaro* and *Saint Peter Martyr* altarpieces, he rethought the story and its meaning. Titian's rethinking resulted in the creation of a new vision of the Annunciation, a vision that the nuns might have found as unsettling as the price he asked for the painting.

In Titian's *Annunciation,* the graceful, almost balletic, physical and emotional character of previous paintings of the event, such as those by Giovanni Bellini [65], has been replaced by a whirlwind of writing action set within a space occupied by the same sort of monumental, proplike architecture found in the *Pesaro Altarpiece.* In fact, the major focus of the *Annunciation* is not the two figures of the angel Gabriel and the Virgin Mary below, but the burst of divine energy above their heads. The dove of the Holy Spirit, surrounded by an explosion of celestial light, flies through an opening in the rolling clouds between large, twisting angels. This luminescent glory, which must have been painted with remarkable subtlety and force, irradiates the Virgin with its sacred power. No artist before Titian had conceived of the Annunciation as a scene of such dynamic, divine energy. This is a cosmic view of the miraculous, supernatural incarnation of Christ. The meaning of the story is now conveyed by the power of heavenly light, the flying angels, and the dynamic clouds rather than solely by the two earthbound figures below. This remarkable conception of the Annunciation was soon to be imitated by Titian's follow-

65. Giovanni Bellini, *Annunciation*, Venice, Galleria dell'Accademia

These two panels from around 1500 were originally organ shutters, like those by Sebastiano del Piombo (fig. 27).

ers and, much later in his own life, by the artist himself [98], who would once more meditate on the meaning of the event. As in the *Pesaro* and *Saint Peter Martyr* altarpieces, the emphasis upon the energy of the miracle, with its agitated figures and sharp alternation of major areas of light and dark, anticipates some of the developments of Baroque painting in central Italy by a quarter of a century.

The dynamism present in the Murano *Annunciation* and the *Saint Peter Martyr* reappears in an important altarpiece commissioned in 1540. This painting, the *Crowning with Thorns* [66], was finished only in 1542, but it certainly did not require two solid years of labor. Rather, because commissions were starting to flood in from all parts of Italy at this time, the altarpiece had to be postponed until Titian could complete his outstanding orders. By the early 1540s, Titian must have already had a large workshop with a considerable number of apprentices and helpers to assist him with his many commissions. Nonetheless, the shop was so busy that even important customers had to wait in line, so to speak, for their paintings.

The *Crowning with Thorns* was a prestigious commission intended for the altar of the Cappella Corona (Chapel of the Holy Crown of Thorns) in the church of Santa Maria delle

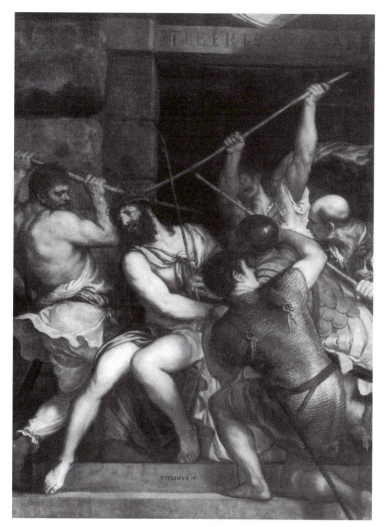

66. Titian, *Crowning with Thorns,* Paris, Musée du Louvre

Grazie in Milan. There it would be in the company of Leonardo's *Last Supper,* a work then, as now, universally acknowledged as an innovative masterpiece. In 1797, the *Crowning with Thorns,* along with many other famous Renaissance paintings, was stolen by Napoleon's invading troops and sent on to Paris, where it remains today.[19]

Like the *Martyrdom of Saint Peter Martyr* and the Murano *Annunciation* altarpieces, the *Crowning with Thorns* is replete with physical action of a degree not hitherto seen in Titian's paintings. Powerful but helpless, Christ is the fulcrum of the violent and cruel torment of his torturers, who twist the

crown of thorns into his head. Filled with the clash of sharp diagonal movements of bodies, individual limbs, and long poles, the very structure of the painting is itself dynamic and forceful. The work is also dramatic and stagelike, for the figures are set in the middle ground above three steps as though they were on a platform. Behind, they are framed by a massive façade constructed of huge, rusticated blocks as unyielding and harsh as Christ's pain.

In the niche above the doorway is a bust of Tiberius, the reigning Roman emperor at the time of Christ's Crucifixion. Just several years before painting the *Crowning with Thorns*, Titian had begun a series of now-lost portraits of eleven Roman emperors for Federico II Gonzaga, all destined for a room in the Palazzo Ducale in Mantua.[20] Titian based his Tiberius on a portrait of Nero he did for this room. Giulio Romano, the court artist of the Gonzagas, also furnished paintings for this space.

Giulio (c. 1495–1546) was Raphael's most talented and famous pupil. He had assisted in his teacher's late works and, after Raphael's death in 1520, had even completed some of them, using his master's designs.[21] In October of the following year, Giulio left Rome for Mantua. He was accompanied on this journey by Baldassare Castiglione, who had recommended him to the Gonzaga court. Giulio took up residence in Mantua and soon became the official painter, architect, stage designer, and general overseer of the court's many artistic projects. He was a highly productive and talented artist as well as a skillful impresario whose ingenious designs for painting and architecture were much in demand. His innovative paintings and his artistic pedigree as the pupil of Raphael impressed Titian. The two became friends and Titian painted Giulio's portrait, one of very few likenesses he did of fellow artists, who could usually not afford the services of such a famous and expensive portraitist.

Titian admired Giulio's vast frescoes in the Palazzo del Te, the pleasure palace that he designed and decorated for Federico II Gonzaga.[22] These novel and striking paintings–especially those in the Sala dei Giganti (so-called because of its colossal figures [67] of giants being attacked by Zeus)–must have been in Titian's memory when he began painting the

Crowning with Thorns. The contorted, compressed movements of its large, heavily muscled, highly expressive figures seem to be inspired directly by Giulio's forceful style in the Palazzo del Te frescoes. Distinguishing the work is a more summary, suggestive treatment of the figures and looser network of brush strokes, which may also be indebted to the extraordinary broad and bold handling of paint in Giulio's frescoes.

A recent cleaning of the *Crowning with Thorns* has revealed its full tonal and chromatic splendor. Although a violent and cruel painting, it is, paradoxically, one of the most beautifully colored and lit of Titian's works. Christ's pale skin and pinkish robes are the most fully illuminated in the painting–light is used as a metaphor for holiness. Around Christ, the tormentors, more swarthy than He, emerge from the surrounding darkness, but they are dressed in clothes of variegated and pleasing color. Notes of bright gold, green, olive, gray, brown, and an unforgettable blue, worn by the man just below the bust of Tiberius, stand out from the enveloping shadow. Here, as in all of Titian's work, color delineates form, but also creates large surface patterns that bring the object close up to the observer.

The years 1530–1543 witnessed Titian's rise to international fame. His portraits of Charles V created an unceasing

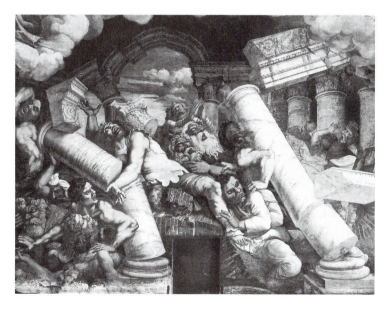

67. Giulio Romano, *Fall of the Giants* (detail), Mantua, Palazzo del Te

Vasari's marvelous description of the Sala dei Giganti remains unequaled. He concludes with, "Therefore let no one ever imagine seeing a work from the brush that is more horrible or frightening or more realistic than this one. And anyone who enters that room . . . can only fear that everything is toppling down upon him, especially when he sees all the gods in that heaven running this way and that in flight."

demand for portraits from nobles and patricians all over Europe. Such paintings were to become a significant part of Titian's production for the rest of his long life. During this period, as we have seen in the *Venus of Urbino,* he also began to reform many of his earlier ideas about mythological painting. Such rethinking is likewise evident in his religious work, especially in the lost *Annunciation* and *Martyrdom of Saint Peter Martyr* altarpieces and in the *Crowning with Thorns,* all of which depicted their subjects with a formal and emotional drama and dynamism hitherto unseen. By 1543, Titian was already a lauded and successful painter, but he had not yet worked for the wealthiest, most powerful patron in Italy, the pope. This opportunity was soon to arise.

NOTES

1. On the history of Renaissance portraiture, consult J. Pope-Hennessy, *The Portrait in the Renaissance,* Princeton, 1969, and L. Campbell, *Renaissance Portraits,* London, 1990.

2. A major work on Charles V is K. Brandi, *The Emperor Charles V,* trans. C. Wedgwood, London, 1968. For a survey of the influence of Titian's patronage and influence in Spain see F. Checa Cremados, *Tiziano y la monarquia hispanica,* Madrid, 1994.

3. Regarding the Gonzaga family and their patronage, there is the old, but still estimable work by J. Cartwright, *Isabella d'Este, Marchioness of Mantua,* 2 vols., London, 1903; as well as the more recent *Splendor of the Gonzagas,* ed. D. Chambers and J. Martineau, London, 1982 and S. Pagden, *Isabella d'Este, Fürstin und Mäzenatin der Renaissance,* Vienna, 1994.

4. On Federico Gonzaga as patron, see C. Hope, "Federico Gonzaga as Patron," *Splendor of the Gonzagas,* ed. D. Chambers and J. Martineau, London, 1982. See also A. Cole, *Virtue and Magnificence: Art of the Italian Renaissance Courts,* Englewood Cliffs, 1995.

5. The dukes of Urbino are described in C. Clough, *The Duchy of Urbino in the Renaissance,* London, 1981.

6. Piero's portraits of Federigo da Montefeltro and Battista Sforza are discussed in B. Cole, *Piero della Francesca: Tradition and Innovation in Renaissance Art,* New York, 1991: 127–137.

7. For an introduction to Castiglione's life and work see B. Castiglione, *The Book of the Courtier,* trans. G. Bull, Harmondsworth, 1967. For an old but valuable biography of Castiglione see J. Cartwright, *The Perfect Courtier: Baldassare Castiglione,* 2 vols., New York, 1927.

8. The drawing of a helmet is included in H. Wethey, *Titian and His Drawings,* Princeton, 1987: 16–17, 136–137; and in M. Chiari Moretto Wiel, *Titian. Corpus dei disegni,* Milan, 1989: 93.

9. The Aretino quote is from F. Valcanover et al., *Titian: Prince of Painters,* Venice, 1990: 220. For a description of the life of Pietro Aretino, see J.

Cleugh, *The Divine Aretino,* New York, 1966; C. Cairns, *Pietro Aretino and the Republic of Venice,* Florence, 1985. Aretino's letters on art constitute four volumes: see P. Aretino, *Lettere sull'arte,* ed. F. Pertile and E. Camasasca, 4 vols., Milan, 1957. On Titian and Aretino, see L. Freedman, *Titian's Portraits Through Aretino's Lens,* University Park, 1995.

10. On Ranuccio Farnese and Farnese patronage, consult C. Robertson, *Il Gran Cardinale: Alessandro Farnese, Patron of the Arts,* London, 1992.

11. The *Venus of Urbino* is the subject of an article by D. Rosand, "And So-and-So Reclining on Her Couch," *Titian 500: Studies in the History of Art,* 45, ed. J. Manca, Hanover, 1993: 101–119.

12. For the life of Palma Vecchio, see P. Ryland, *Palma Vecchio,* Cambridge, England, 1992.

13. Other works by Martin Rota can be found in M. Agnese Chiari Moretto Wiel, *Incisioni di Tiziano,* Venice, 1982.

14. Titian's engravings and woodcuts are surveyed in F. Mauroner, *Le incisioni di Tiziano,* Venice, 1941; D. Rosand, *Titian and the Venetian Woodcut,* Washington, 1976; M. Agnese Chiari Moretto Wiel, *Incisioni di Tiziano,* Venice, 1982; and D. Landau and P. Parshall, *The Renaissance Print, 1470–1550,* London, 1994.

15. M. Sellink, *Cornelis Cort: Accomplished Plate-Cutter from Hoorn in Holland,* Rotterdam, 1994.

16. G. Vasari, *The Lives of the Artists,* trans. J. and P. Bondanella, Oxford, 1991: 496.

17. On Gian Jacopo Caraglio, there is M. Agnese Chiari Moretto Wiel, *Incisioni di Tiziano,* Venice, 1982.

18. For Pordenone's original and powerful painting see C. Cohen, *The Art of Giovanni Antonio da Pordenone,* 2 vols., Cambridge, England, 1996.

19. Napoleon's theft of Italian art is described in C. Gould, *Trophy of Conquest: The Musée Napoleon and the Creation of the Louvre,* London, 1965.

20. For reproductions of these portraits, see H. Wethey, *The Paintings of Titian,* 3 vols., London, 1969–75, III: 43–47, 235–240.

21. F. Hartt, *Giulio Romano,* 2 vols., New Haven, 1958.

22. E. Verheyen, *The Palazzo del Te in Mantua,* Baltimore, 1977.

6

Titian:
Maturity

�֍

"The year [1543] that Pope Paul III went to Bologna and from there to Ferrara, Titian went to court and did the pope's portrait, which is a very beautiful work." This quote from Vasari's "Life of Titian" tells us that by 1543, the painter was working for the formidable Farnese pope, Paul III.[1] As we have seen, Titian had painted a portrait of Paul's grandson, Ranuccio Farnese [59], just the year before, but Paul's portrait was the first commission he had received from a pope. This was extremely important because it gave Titian access not only to Paul III, the patron of Michelangelo's Sistine *Last Judgment,* but also to the Curia in Rome, and consequently, to a host of potential new commissions.

Titian was at the papal courts from May to July in Ferrara, where he had already painted his mythologies [46, 48, 49], and in Bologna. It was in the latter city that he probably painted Paul III's portrait, a commission that is unusually well documented. Titian was quite aware of how significant this task was, and the painting remains one of his most remarkable performances both in its design and execution.

68. Raphael, *Julius II,* London, National Gallery

The large acorn finials of the chair refer to the pope's family name: Rovere, the Italian word for oak tree. A contemporary wrote that when this picture was first displayed, "all Rome had flocked to see him [Julius II] again, as if for a jubilee."

69. Titian, *Julius II,* Florence, Palazzo Pitti Galleria Palatina

The Duke of Urbino, Francesco Maria I della Rovere (fig. 53), owned this copy of Raphael's portrait of his famous della Rovere relative.

When planning this work, Titian paid special attention to some of the most recent papal portraits, in particular that of Julius II [68] by Raphael.[2] Julius, as Titian would have known, not only commissioned Michelangelo's Sistine Ceiling, but also employed Raphael to decorate various rooms in the Vatican, including the Stanza della Segnatura with its famous frescoes, *The School of Athens* and *Parnassus.* Raphael had been dead for twenty-three years, yet Titian must have felt a sense of admira-tion and rivalry with him, especially when painting the like-ness of a pope who, like Julius II, was a great patron of artists.[3]

Other artists had painted portraits of popes before Raphael, but these images had primarily been included within narra-tives. Raphael broke tradition by creating a fully independent likeness of the pope alone. Moreover, his portrait of Julius II instantly defined the papal portrait type for centuries to come. The pope is depicted seated in an armchair, a sign of his status, for at Renaissance courts only the most important personages sat, while those of lesser rank stood in attendance upon them. The pope's body is placed diagonal to the picture plane, creat-ing spatial movement into the painting while allowing the face

to be seen in three-quarter view. Raphael depicts the pope in a moment of introspection, unaware of the onlooker's presence. Such a view permits us to glimpse some of the human qualities of this living icon.

Raphael's painting was immediately famous. It was noted by Marino Sanuto, the Venetian diarist, when he saw it on the high altar of the Roman church of Santa Maria del Popolo in 1513. The portrait's composition must have been known in Venice soon afterward, either through painted copies or drawings. Thus, when he was asked to paint the portrait of Paul III in 1543, his mind must have turned at once to Raphael's celebrated painting. At an unknown date, perhaps when he was in Rome from 1545 to 1546, Titian himself made a copy [69] of the picture.

While much influenced by the pose and psychological tenor of Raphael's work, Titian painted a strikingly different picture [70]. Rejecting Raphael's rather precise, detailed depiction, he created his image of Paul III with color and light alone. Through this dazzling display of loose brushwork, Titian seemingly transformed canvas and paint into lustrous velvet, stiff linen, and living flesh. Color and light build form; line is absent. Many of the passages in the painting are created with the subtlest and most remarkable gradations of color and tonality.

Surprisingly, the range of color is severe, restricted to several hues: the white of the pleated rochette (the alb or tunic), the burgundy-colored *mozzetta* (the velvet cape), the velvet-covered chair of a slightly different hue, the gray of the beard, and the flesh tones. But even more subtle and marvelously variegated are the modeling and tonality of these colors, so that at first one is not aware of just how few hues are actually employed. Here Titian has given us a tour de force performance by demonstrating his remarkable skills as a colorist, not with a full spectrum of color, but with the absolute minimum number of hues.

Titian not only departed from Raphael's model in color, but in form as well. Paul III is closer to the spectator and occupies more of the picture's space than Julius II. Moreover, Titian has modified the compositional rhythms of Raphael's painting by creating a roughly triangular composition, with the pope's head

at its apex. He has also turned the figure more diagonally in space in order to achieve a greater sense of movement. All these changes make the presentation of the sitter more monumental, dynamic, and impressive.

The principal change is created by turning the pope's head so that it moves across his body to look toward the spectator. Titian has rejected Raphael's portrayal of the pope as contemplative in favor of a more active, participatory role. An aged head–Paul was seventy-five years old–juts toward us from the mountain of velvet and linen. The close-cropped, tonsured hair and the flowing, spadelike beard frame a face wizened but still full of reason and will. There is a latent power about Paul's face with its arresting, dark eyes, prominent nose, and thin lips set on top of the massive body. Especially expressive are the pope's hands, their long fingers seemingly so full of movement. One could not imagine a more appropriate likeness of this paragon of spiritual and worldly power.

This forceful portrayal of Paul III is equaled by another of Titian's portraits from about the same time (c. 1545), the likeness of Andrea Gritti (1454–1538), Doge of Venice from 1523 to 1538 [71]. Aside from its notable figurative and psychological aspects, this portrait provokes singular interest due to its excellent state of preservation. Unlike many of Titian's other works, the canvas has never been relined, a process that entails gluing a new piece of cloth behind the original canvas. Relining, often done when the canvas support has been damaged, changes the original appearance of the painting by altering its surface, sometimes in quite a major way. But not only has the *Doge Andrea Gritti* escaped relining, it has come down to us in a remarkably well-preserved state. Many of Titian's paintings have been relined, badly restored, damaged, or simply degraded by time. The *Doge Andrea Gritti* is, consequently, a touchstone that allows us to see what Titian's work looked like when it left his workshop. As such, its importance for the study of the artist cannot be overestimated.

The surface of the portrait of Andrea Gritti reveals Titian's brushwork in nearly its original state. Here, as in the portrait of Paul III, there is a dazzling array of loose, quick brush strokes. Titian's brush, sometimes fully loaded and often nearly

70. Titian, *Paul III*, Naples, Museo Nazionale di Capodimonte

Alessandro Farnese (1468–1549), who became Pope Paul III, was made cardinal in 1493. He rose to power during the reign of four remarkable Renaissance popes: Alexander VI, Julius II, Leo X, and Clement VII. Today Paul is best remembered for his patronage of Michelangelo's *Last Judgement* in the Sistine Chapel.

71. Titian, *Doge Andrea Gritti,* Washington, D.C., National Gallery of Art

Andrea Gritti, Doge of Venice from 1523 to 1538, was a skilled diplomat and soldier. A robust, imperious figure when made doge at sixty-eight years of age, he claimed never to have been sick a day in his life! *(See color plate 4)*

dry, flicks, scrubs, and darts across the surface. Everywhere, from the heavily impastoed gold buttons to the delicate, glowing glazes of the flesh tones, the brush magically creates different textures. Moreover, since the original canvas is almost perfectly preserved, one can detect how its rough tooth holds the paint, especially when Titian uses a dry brush, which reveals, rather than covers, the surface. The way the weave of the canvas (the tooth) works with the paint gives life and relief to the images. Because the weight, weave, and texture of the canvas determined its ability to hold paint in particular ways, Titian, like every other Venetian artist, chose his canvases with care. Early in his career, the surfaces of his paintings were much

more even and smooth [36]. But by the early 1540s, they were rougher and more varied in the amount of paint applied, and they revealed more of the tooth of the canvas. This is especially apparent in the *Doge Andrea Gritti,* which seems almost unfinished compared to Titian's earlier work, so sketchy are parts of the golden robe and its lining. In several areas, drips from Titian's brush were simply left where they fell on the canvas!

The vigor of the brushwork is equaled by the portrayal of Gritti's form and character. The doge, a skillful and effective diplomat and administrator, was a formidable personality with a commanding presence.[4] It is these attributes that Titian has re-created. To measure his originality here, one need only compare the *Doge Andrea Gritti* to its most distinguished ancestor, the portrait of Doge Leonardo Loredan [20], by Giovanni Bellini, a painting done perhaps while Titian was still Bellini's pupil.

Bellini's portrayal is accomplished, but more literal. We are given a lapidary image of the doge that reveals much about his appearance and status, but precious little about his character. Motionless and unblinking, Loredan seems almost sculptured, like a carved idol. Moreover, he is set behind, or perhaps on, a ledge which separates him from the onlooker. This distance and aloofness was exactly what Bellini intended.

However, when we turn from the *Doge Leonardo Loredan* to Titian's *Doge Andrea Gritti,* we move from one world to another. Unlike Loredan, Gritti is set close to the observer, much like Paul III. The bulk of his massive body, seen in three-quarter length, is topped by a scowling face looking at something off to our left. He seems to be momentarily distracted, but we sense that he will gather up his robes and move briskly out of the picture's space at any moment. The figure's arrested movement, the delineation of his aged but strong face, the network of robust brush strokes, and the volume of the figure create an image of physical and psychic power.

It has been suggested that the *Doge Andrea Gritti* was influenced by Michelangelo's statue of Moses [72]. But the portrait was painted before Titian went to Rome in 1545, so he could not have seen the statue, although he may have known it from

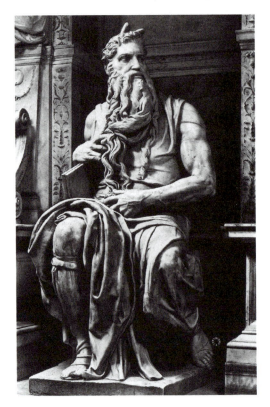

72. Michelangelo, *Moses,*
Rome, San Pietro in Vincoli

73. Titian, *Pietro Aretino,*
Florence, Palazzo Pitti,
Galleria Palatina
Although he called
himself "Secretary to the
World," Pietro Aretino
was in truth both an artful
flatterer and a skilled black-
mailer. His death in 1556
was caused by a fit of
apoplexy.

drawings or small-scale plaster copies. The more likely expla-
nation is that the similarities between the two images lie in
both artists' acute understanding of how form and surface
could be manipulated to create images of arrested power. Both
are superb portrayals of what contemporaries called *terribilità,*
a frightening and potentially destructive charge of power and
will. Furthermore, both are fascinating depictions of energetic
and commanding elderly men, the sort of figures Titian and
Michelangelo themselves were to become.

The mighty images of Andrea Gritti and Paul III mark a new
stage in Titian's evolution as a portraitist. This dynamic and
authoritative treatment of the sitter was not restricted to aged
popes and doges, but was also employed in depicting younger
men of lesser civic or spiritual rank and power. This can be
clearly seen in one of Titian's most famous portraits: that of his
friend and promoter, Pietro Aretino [73], whose name has
already figured several times in our account of Titian's career.

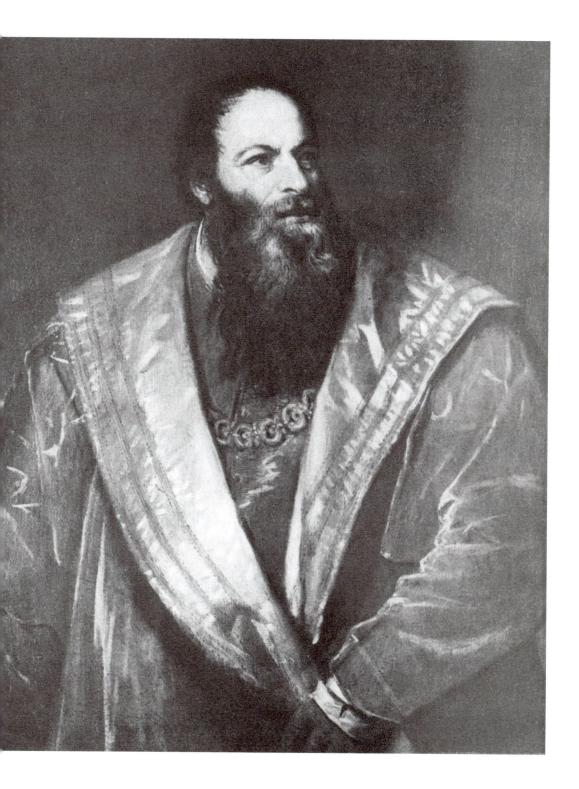

Aretino (1492–1556) took his name from his native city of
Arezzo in Tuscany, where as a youth he studied painting and
poetry.⁵ By 1517 he was in Rome, where his barbed lampoons
and sharp tongue made him many enemies. He left the city
tempetuously in 1525 after a series of sonnets he published to
accompany a set of erotic prints by Marcantonio Raimondi
incurred the wrath of the officials of the papal court.⁶ In 1526,
he moved to Venice, where he was to live and work for the
rest of his life. Protected by Andrea Gritti and other patricians,
Aretino became a Venetian celebrity and a friend of Titian and
other artists. He made his living, as he said, by "the sweat of
his pen." He amassed a considerable fortune from rich patrons
by alternatively publicly praising them or threatening to black-
mail them. However, Aretino remained loyal to Titian, who
rivaled him for fame after the 1540s. Perhaps this association
resulted from pure self-interest, but, whatever the reason, the
careers of painter and writer were intertwined for many years,
to the profit of both.

As in the portraits of Paul III and Andrea Gritti, Titian has
depicted Aretino close to the spectator, but now the bulk of
the body looms even larger, as the poet's massive shape fills
nearly all the picture's space. His fleshy face, framed by close-
cropped hair and a flowing, grizzled beard, looks out to our
right. Unlike Gritti or Paul III, he seems to be posing for the
painter, who has perfectly captured his aggressive, inflated
arrogance.

However, the centerpiece of this portrait is not Aretino
himself, but his attire. The mauve velvet coat with its gold silk
lining and the olive green velvet doublet are among the most
dazzling displays of Titian's brushwork. The play of reflected
light over the shiny silk is created by the application of a
nuanced network of glazes that form brilliant reflections on
the material. Each surface holds or reflects light in a unique
way: the soft reflections of the coat, the light-absorbing quali-
ties of the green velvet, the glow of the massive gold chain,
and the shine on the forehead are all treated differently.
Aretino has been magically reincarnated through Titian's
uncanny powers of observation, which he was able to transmit
through his brush.

The poet himself indeed felt this way. In several letters about this portrait, he commented on how it pulsed with life and embodied his spirit. He also called it a *terribile meraviglia* (a terrible marvel), an apt description of himself. But in one of these letters, that addressed to Cosimo I de' Medici, Duke of Florence, to whom he had sent the painting as a gift, Aretino had some harsh words about the portrait and his friend Titian. He said that if Titian had been paid more money, the satins, velvets, and brocades would have been finished better–Titian seems to have had a reputation for avarice. In another letter, this time to Titian himself, Aretino accused the painter of fur- nishing only a "sketch" instead of a finished portrait. This criti- cism is fascinating because it demonstrates how an accurate and articulate contemporary critic viewed one of Titian's mas- terpieces.[7] On the one hand, Aretino realized how lifelike the portrait was and how well it embodied and ennobled his char- acter. On the other hand, the daring application of paint, which re-creates the feeling and sense of the material world rather than minutely describing it, disturbed him, leading him to sug- gest that Titian had left the painting unfinished.

What Aretino failed to understand, despite his considerable aesthetic acumen, was that during the 1540s Titian was rein- venting the syntax of representation in oil painting. Con- sequently he was demarcating the boundaries in which the medium would be used up to the present day. Artists, including Giovanni Bellini and Sebastiano del Piombo, had already begun this process, but Titian's ability to make material take shape as much in the mind as on the surface of the canvas far surpassed that of his predecessors. In fact, he rejected the idea of high fin- ish in his paintings in favor of a surface that shows the mark of the artist's hand as it magically transubstantiates paint into the substance of the material world.

Titian finally visited Rome for the first and only time in 1545, the year in which he painted Aretino's portrait. The ancient city had been a destination for artists since the Middle Ages. More recently, its paintings, sculptures, and architecture by Michelangelo, Raphael, and Bramante had lured many Renaissance artists to the city. Titian, however, had refused to go, preferring instead to learn about the artistic events taking

place there through the medium of reproductive engravings and drawings, which had succeeded in keeping him remarkably well informed. As we have seen, he had already borrowed with considerable frequency from such graphic sources.

Already in his late fifties, Titian was lured to Rome by two irresistible factors: important papal commissions from Paul III and his family, the Farnese, and the possibility of a benefice for his son Pomponio. Of the two, it was probably the benefice, and the promise it held for the feckless Pomponio's financial support after Titian's death, which prompted the artist to make the long trip to Rome. He left Venice in September 1545.

He did not go straight to Rome but made stops in Ferrara, Pesaro, and Urbino. In Urbino he was fêted by Duke Guidobaldo, one of his admirers, who already owned the *Venus of Urbino* [61]. We know something of the artist's reception at Urbino from a letter Aretino addressed to the duke:

Titian bids me adore the Duke of Urbino whose princely kindness was never equalled by any sovereign, and he bids me do this in gratitude for the escort of seven riders, the payment of his journey, the company on the road, the caresses, honours, and presents, the hospitality of a palace which he was bid to treat as his own.[8]

Caresses, honors, presents, and the hospitality of a palace that Titian was to call home! These words form a vivid picture of Titian's status in the mid-1540s. He was, as his escort of seven riders from Urbino to Rome proves, treated like visiting nobility. In an age in which artists were excluded from elevated social status because they, like any other tradesman, worked with their hands, Titian's treatment was extraordinary and prophetic of a new image of the artist as creative, Promethean hero.

This adoration continued in Rome, where Titian was lodged in the Belvedere Palace and greeted by the pope and his family. Vasari was deputized as his guide to the contemporary and ancient treasures of the Holy City.[9] Aretino, who must have been bursting with curiosity, wrote to Titian asking his opinion of what he was seeing:

I long for your return that I may hear what you think of the antiques, and how far you consider them to surpass the works of Michelangelo. I want to know how far Buonarroti approaches or

surpasses Raphael as a painter; and wish to talk with you of Bramante's "Church of St. Peter" and the masterpieces of other architects and sculptors. Bear in mind the methods of each and of the famous painters, particularly that of Fra Bastiano [Sebastiano del Piombo] and Perino del Vaga; look at every intaglio of Bucino. Contrast the figures of Jacopo Sansovino with those of men who pretend to rival him, and remember not to lose yourself in contemplation of the *Last Judgment* at the Sistine, lest you should be kept all the winter from the company of Sansovino and myself.[10]

This letter is fascinating for its didactic tone and its listing of what Aretino thought Titian should not miss. Especially interesting is Aretino's admonition not to get lost in the examination of Michelangelo's *Last Judgment,* which had been completed only four years before. Although Titian did, in fact, see much in Rome, it did not markedly change his style or interpretation–he was already aware of much that had occurred there. He was, however, as Aretino suspected, impressed by the colossal *Last Judgment,* for echoes of it remained in his work for several years thereafter. Later the fickle Aretino was to harshly criticize the *Last Judgement* as lacking decorum.

Titian was called to Rome by the pope because of his fame as a portrait painter. It is not surprising, therefore, that his major commission in the Holy City was a large, important portrait: the *Paul III with His Two Grandsons, Ottavio and Alessandro Farnese* [74].[11] For this triple portrait Titian utilized the full-length format of the *Charles V* [50], upon which his reputation as a portrait painter had been founded, but his task was now complicated by the need to interrelate three figures.

He accomplished this by creating a silent dialogue between the seated pope and his two grandsons. The pope is addressed by the bowing Ottavio, while Cardinal Alessandro looks out at the spectator from a position behind Paul III. Once again, it is likely that Titian based his portrait on a painting by Raphael, *Leo X with His Two Nephews* [75], which depicts the pope seated and flanked by two standing figures. Yet in Titian's portrait, the rather straightforward depiction of Raphael's painting has been replaced by a complex intertwining of posture, gesture, and glance, which forges a subtle but not fully comprehensible physical and psychological relationship among the subjects.

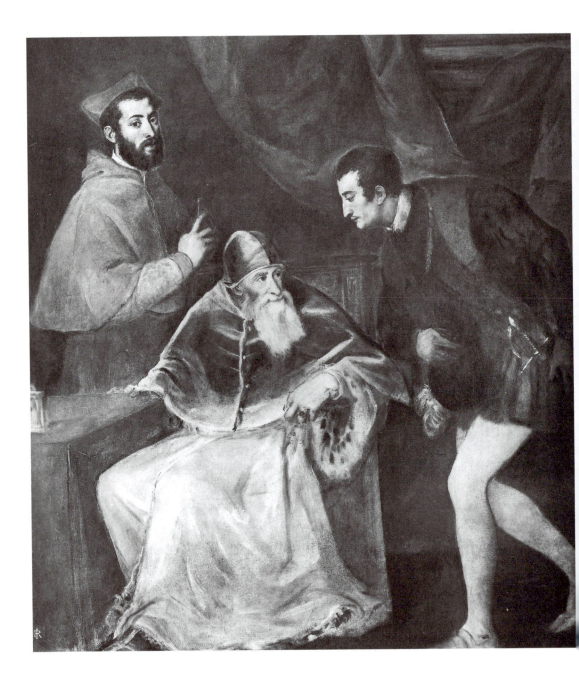

It has often been suggested that this relationship is one of mistrust and that Ottavio is fawning before a cunning, distrustful grandfather who realizes the falseness of his grandson's gesture. The fact that the picture remains incomplete (the figure of Paul III is unfinished and the background remains a sketch) is often adduced as proof that its portrayal of the three figures gave such offense that Titian was forced to abandon it. This theory seems at odds with Vasari's statement that the portrait was "all admirably executed to the great satisfaction of those lords [Alessandro and Ottavio]." Vasari was in a position to know because, as we have seen, he had acted as Titian's guide in Rome and was present during the painting of the portrait.

In the final analysis, it is impossible to ascertain exactly how Titian's portrait of Paul III and his grandsons was received, but the very fact that the relationship among the three figures provokes discussion and speculation is important. Portraits with multiple figures were not unknown before

74. Titian, *Paul III with His Two Grandsons, Ottavio and Alessandro Farnese,* Naples, Museo Nazionale di Capodimonte

The pope's two grandsons pictured here were considerable figures in their own right. Alessandro (1520–1589) was an important patron of art who completed the family's Roman palace, while Ottavio (1524–1568) married the illegitimate daughter of Charles V, thus forging an important dynastic alliance for the Farnese family.

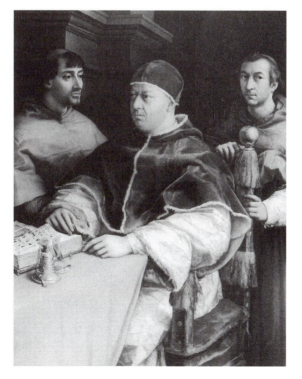

75. Raphael, *Leo X with His Two Nephews,* Florence, Galleria degli Uffizi

Behind Leo are Giulio de' Medici to his right, and Luigi Rossi to his left, both nephews of the pope. Giulio, the future Pope Clement VII, was an important patron of art like his uncle.

76. Titian, *Danaë,* Naples, Museo Nazionale di Capodimonte

This painting was recorded in the apartments of Cardinal Alessandro Farnese in 1581. It remained in Rome until the eighteenth century. During the Second World War, it was looted by German troops and recovered in an Austrian salt mine.

Titian's time, yet seldom, if ever, were they turned into narratives in which each figure is related to the other, not only by glance and gesture, but also by the role of each in the overall dramatic structure of the painting. Titian's uncanny ability to create physical form so expressive of individual character makes this painting, like many of his other portraits, not only a likeness, but also a story full of subtle meaning and drama. In the seventeenth century, under the influence of Titian and his Venetian followers, such narrative portraits were painted with some frequency and eventually became an important part of European portraiture.

During his stay in Rome between October 1545 and June 1546, Titian worked on other commissions for the Farnese family. One of these is a *Danaë* [76] painted for Cardinal Alessandro Farnese, whose likeness we have seen in the triple portrait. The *Danaë* is the subject of a fascinating anecdote in Vasari's *Lives.* Vasari brought Michelangelo to Titian's studio in the Belvedere Palace while he was painting the *Danaë.* Vasari tells us:

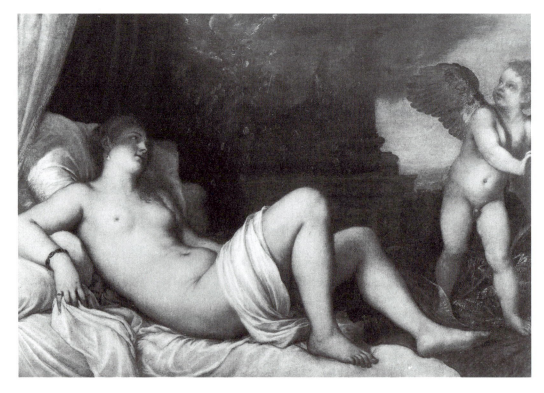

One day as Michelangelo and Vasari were going to see Titian in the Belvedere, they saw in a painting he had just completed a naked woman representing Danaë with Jupiter transformed into a golden shower on her lap, and as is done in the artisan's presence, they gave it high praise. After leaving Titian, and discussing his method, Buonarroti strongly commended him, declaring that he liked his colouring and style very much but that it was a pity artisans in Venice did not learn to draw well from the beginning and that Venetian painters did not have a better method of study.

"If Titian," he said, "had been assisted by art and design as greatly as he had been by Nature, especially in imitating live subjects, no artist could achieve more or paint better, for he possesses a splendid spirit and a most charming and lively style."

And in fact this is true, for anyone who has not drawn a great deal and studied selected works, both ancient and modern, cannot succeed through his own experience or improve the things he copies from life by giving them the grace and perfection that derive from a skill that goes beyond Nature, some of whose parts are normally not beautiful.[12]

Michelangelo's words, which appear to be faithfully reported, are of interest because they confirm that he and his biographer Vasari deplored the Venetian method of painting directly on the canvas without the intermediary step of making many paper sketches and finished drawings first. In the Florentine procedure championed by Vasari and Michelangelo, paintings were carefully worked up from many drawings through which the artists gradually refined both overall composition and figures. Michelangelo's claim that

[A]nyone who has not drawn a great deal and studied selected works, both ancient and modern, cannot succeed through his own experience or improve the things he copies from life by giving them the grace and perfection that derive from a skill that goes beyond Nature, some of whose parts are normally not beautiful,

elucidates what he thinks is the superior intellectual process of Florentine and other central Italian artists who improve on raw nature by refining and idealizing its imperfections, something that the Venetians, according to Michelangelo and Vasari, never did.

The difference between Florentine (and other central Italian) and Venetian painting has often been formulated along

similar lines. Scholars still discuss the dissimilarity of Florentine *disegno* and Venetian *colore*, but these distinctions are not the polarities that they may seem. In the first place, the Venetians did draw, and in truth, their draftsmanship was equal to even the finest Florentine works. However, their drawings were usually not on paper, although Venetian paper drawings do exist, but rather on the canvas itself.[13] Here the artists drew preliminary drawings with charcoal and with paintbrushes in order to formulate what they were about to paint. An x-ray of almost any Venetian painting of the sixteenth century will reveal that the artist worked empirically: He drew on the canvas and then corrected, modified, and redrew. Large areas of the painting might be substantially altered or even obliterated as he worked his way toward the final realization of the painting.

This method was at variance with the way in which the Florentines proceeded. After designing the overall composition and then resolving and refining its constituent parts through many drawings, they worked up a series of cartoons (detailed stencil-like drawings), which they then used to transfer the entire design to the surface to be painted. Thus, before the first stroke of the brush upon most Florentine pictures, the entire problem of design had been resolved fully.[14] In a sense, the actual painting was simply the application of color and texture to a carefully determined design. The "grace and perfection that derive from a skill that goes beyond Nature," which Michelangelo speaks of, is the result of the refining process of drawing to which all aspects of Florentine painting of the sixteenth century were subjected.

Thus, although drawing was a crucial part of the process of both Venetian and Florentine painting, the artists of the two schools employed drawing for different purposes. The Florentines used drawing to refine, correct, and idealize, while the Venetians used it as a means to realize their vision directly on the canvas. Both schools drew extensively; they just did so in quite different ways.

What Michelangelo praised in Titian's painting–his ability to imitate living subjects and his "splendid spirit"–demonstrates his understanding of the central element of the *Danaë*:

Titian's uncanny facility for turning paint into living, glowing flesh. This mastery, which continually astounded other contemporary observers, is at the center of the *Danaë*, whose corporeality is formed by a web of the most subtle, incremental variations of color and light. The seduction of the young woman by Jupiter, who has transformed himself into a shower of pulverized gold, occurs in an atmosphere that itself seems palpably charged with atomized particles of intermingled red, gold, white, and blue. Placed close to the spectator, her form sprawling over the picture's surface and literally overshadowed by the cloud of gold, Danaë is a formidable, sensuous figure set in an atmosphere of luxurious eroticism. This fleshy, materialistic vision is one of the high points of Titian's mature vision of mythology and his understanding of its often sexual nature. The corporeality, masterful handling of surface and paint, overall sense of grandeur, and originality of conception of the *Danaë* are also characteristics that distinguish his work through the 1540s and early 1550s.

Titian's style and interpretation have developed markedly since painting the *Venus of Urbino* only about eight years earlier. The forms are now larger, less detailed, and painted with a freer, more open brush stroke. The contrasts between light and dark are bolder and more synthetic—note how light plays over Danae's head and torso, creating volume and texture. Concomitantly, the sense of atmosphere is heightened and made even more palpable while the setting has been made less logical. No longer placed in a palace, as in the *Venus of Urbino*, the figure is now set before a huge column. She seems to be on a canopied bed in an indistinct outdoor location. Titian, unlike most of his central Italian contemporaries, was not interested in the logic of his settings, but in their sensory impact on the observer, an impact that he often increased by substituting suggestion for mere descriptive reality.

Two years after his return from Rome, Titian, aged about sixty, undertook an arduous winter journey across the Alps. Accompanied by his son and helper Orazio, his nephew Cesare Vecellio, and one of his students, the Netherlander Lambert Sustris, he left Venice in January 1548 for the southern German city of Augsburg.[15] Here he was to work once

more for Charles V, the Holy Roman Emperor who was resident in the imperial city, surrounded by his family and court. Ten months before Titian's arrival, Charles had defeated the Protestant forces at Mühlberg, capturing their leader, John Frederick of Saxony. Charles now sought Titian's services as court portraitist. He was to paint portraits of the emperor and the glittering court that had assembled for the Diet of Augsburg. This he did with dispatch. During his ten-month stay, Titian painted a series of portraits, now almost all lost, which must have been among his finest accomplishments of the type.

Fortunately several of these portraits have survived, including two of the emperor himself. Charles V was eager to commemorate the victory at Mühlberg and his role as defender of the Catholic faith and victor over the Protestants.[16] Consequently, Titian was commissioned to paint a large equestrian portrait depicting the emperor as leader of his victorious troops. Both artist and patron recognized that an image of a man on horseback had served as a symbol for power and command since the Roman era.

To prepare himself for this task, Titian, like all Renaissance artists, turned to the examples from the past. As he pondered the equestrian portraits he knew, he thought of Donatello's commanding bronze *Gattamelata* of 1453 [77].[17] This image of the mercenary soldier Erasmo da Narni stood in the piazza of the Santo in Padua, where Titian saw it repeatedly as he worked on his frescoes in the *scuola* of the Santo, located off the same square. In Venice, he probably also studied a work heavily influenced by the *Gattamelata,* Verrocchio's swaggering equestrian monument to the soldier of fortune Bartolomeo Colleoni, begun in 1481.[18] However, both of these statues commemorated mercenaries, warriors who were remembered for their toughness and audacity. Other, far nobler qualities were needed for Charles' portrait.

Titian's *Charles V at Mühlberg* [78] depicts not a mere mercenary, but a quasi-divine Catholic warrior who rides alone but resolute against the Protestants. The lowering sky and the dark forest from which he emerges create a sense of expectant drama. Charles and his nervous horse occupy center stage. Although the

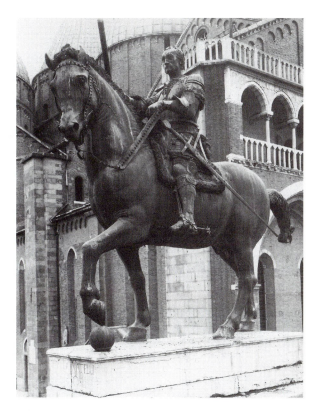

77. Donatello, *Gattamelata*, Padua, Piazza del Santo

Donatello's Gattamelata monument was influenced by the several Roman equestrian statues still extant during the Renaissance. The Gattamelata monument was the first large-scale equestrian statue to be produced during the Renaissance.

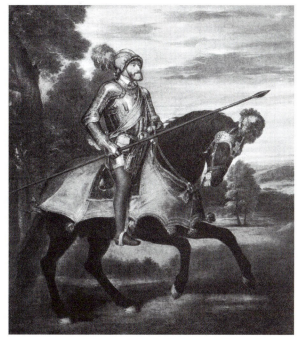

78. Titian, *Charles V at Mühlberg,* Madrid, Museo del Prado

A contemporary Venetian described Charles as a "small person, who stoops a little, with a small face and pointed beard." Little of this description is evident in Titian's ennobling painting. *(See color plate 5)*

emperor was ill and sallow during the battle, Titian has pictured
him as strong and steadfast. Much attention has been paid to his
armor, whose polished surfaces gleam in the sunlight, directing
our eyes to the rider. This is an accurate depiction of the armor,
still preserved in Madrid, which Charles wore at Mühlberg. We
know from documentation that Titian borrowed it while he was
painting the portrait, just as he had borrowed the armor of the
Duke of Urbino [53] for his likeness.

The dark horse with its red trappings is firmly controlled by
its rider; both animal and man seem to be a perfectly integrated
unit as they move across the surface of the painting toward the
battle that awaits them off to the right. The symbiotic relation-
ship between horse and rider seems to be borrowed partially
from Donatello's *Gattamelata,* a work that offered a near-
perfect solution to the problem of integrating the two forms.
However, in Titian's painting there is a solemnity and quietude
even in the face of danger that is much different from its pos-
turing, foreboding equestrian forerunners. In its calm resolute-
ness, the painting recalls Dürer's famous *Christian Rider* [79]

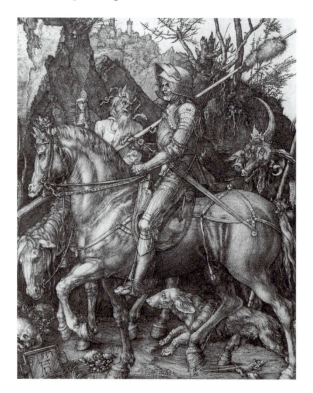

79. Albrecht Dürer,
Christian Rider
 Dürer (1471–1528)
lived and worked in Venice
twice: first in 1494 and
then again in 1505–1507.
His art was decidedly influ-
enced by what he saw
there, especially the work
of Giovanni Bellini.

engraving, in which another Christian warrior rides through a perilous landscape. It is quite possible that Titian knew this engraving by the German artist, who had lived and worked in Venice on two separate occasions.[19]

Yet *Charles V at Mühlberg* is more than just a record of valor; it is also a subtle depiction of place, time, and sensation. The description of and differentiation between the gleaming armor, the airy plume of the helmet, the hardness of the spear, and the glinting river in the distance are remarkable not so much for the exactitude of their depiction, but for their re-creation of the sense of that which they depict. This is partially achieved through color, which is as subtle as it is variegated. Notes of deep red and brown unify the surface while creating a dark penumbra against which Charles' armor and face glows. The entire picture is an extraordinary weaving of rich variegated color and complex interwoven shapes, all in the service of the creation of an icon of imperial power and religious righteousness. It is no wonder that when Charles's son, Philip II, King of Spain, wished to commemorate the victory at Lepanto (in which he did not actually participate), he commissioned another painting by Titian, to hang across from the authoritative portrait of his father.[20]

In Augsburg, Titian painted a second likeness of Charles, which is a polar opposite of the equestrian portrait. This picture (signed and dated 1548), known as *Charles V Seated* [80], depicts the Holy Roman Emperor, one of the most powerful rulers of the Western world, not astride a horse or enthroned, but seated in a simple arm chair. He is dressed in the plain dark clothes worn by the Spanish court. Only the massive column and large embroidered hanging behind him suggest his station, for there is no crown, scepter, or other royal trappings, only the Order of the Golden Fleece worn around his neck. The right half of the picture is occupied by an extensive landscape vista. In the *Charles V Seated,* it is the force of the ruler's personality alone that establishes his sovereignty.

Charles was suffering from gout at Mühlberg and must have had to keep off his feet as much as possible; nevertheless Titian could have portrayed him in any pose the emperor wished. That Charles chose to have himself depicted seated

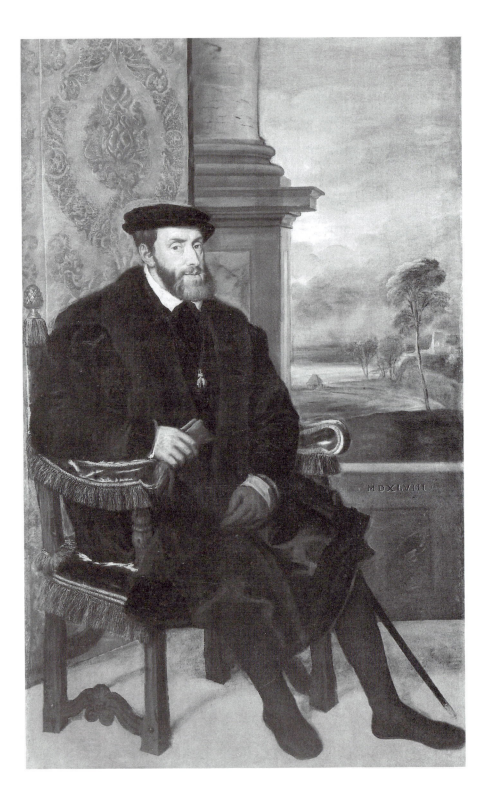

testifies to his faith in Titian's ability to make such a pose regal. He was not disappointed. Charles, through Titian's vision, emerges as a powerful, commanding presence, although looking much older than his forty-eight years. Charles is seated, but not static. His body is placed at an angle to the viewer, creating a sense of spatial movement. His sharp, quizzical face and upright form, rather like a coiled spring, demonstrate the potential for considerable action and power. Anticipating the Flemish painter Anthony Van Dyck, who was to learn much from him, Titian is able to make his sitter radiate intelligence, command, and the natural, if highly reserved, superiority often associated with aristocracy, without the conventional props of power.

Titian's ability to ennoble his sitters is also seen in a group portrait, *Members of the Vendramin Family Adoring the Relic of the True Cross* [81], the only surviving work of its kind by him. Although it repeats the shape and size of many altarpieces, this painting, finished around 1547, was not intended for a church, but rather for the Vendramins' Venetian palazzo, where it is first mentioned in an inventory of 1636. By 1641, the picture was in England in the collection of Anthony Van Dyck, who was then court painter to Charles I.[21]

Titian faced a number of difficult demands when he began this work for the Vendramins. He was asked to paint nine members of the patrician family adoring a relic of the True Cross given to the *scuola* of San Giovanni Evangelista by one of their ancestors, Andrea Vendramin. We have already seen Andrea's image in Gentile Bellini's *Miracle of the Relic of the True Cross Recovered from the Canal of San Lorenzo* [22]. It was the original Andrea's faith that ensured that only he could rescue the precious relic, which he had donated to the *scuola* in the fourteenth century. It is this very relic, so closely tied to the prestige and history of the family, that is contained in the crystal cross placed upon the altar in the painting.

Not all of the figures in the picture can be identified with absolute certainty, but it appears that the kneeling, gray-bearded man touching the altar is Andrea Vendramin (named after his famous ancestor). Standing to the spectator's left of Andrea is probably his brother Gabriele, the collector

80. Titian, *Charles V Seated*, Munich, Alte Pinakothek

During the sixteenth century, the seated pose was often reserved for papal portraits. It may be that Titian painted Charles V seated in order to evoke the notion of quasi-divinity and power associated with papal power, as employed in his own portraits of Pope Paul III.

whose important holdings included, as we have seen above, Giorgione's *Tempest*. The bearded youth standing behind Gabriele is almost certainly Leonardo Vendramin, Andrea's oldest son. On either side of the altar are depicted Andrea's other six sons (he also had six daughters!).

This commission seemingly offered little scope for the narrative complexity that Titian had constructed in his *Paul III with His Two Grandsons, Ottavio and Alessandro Farnese* [74], painted just a few years before. However, through his formidable narrative skills, he was able to turn what could have been a static, immobile scene into a compelling drama. Titian did this through the construction of both space and figure. He placed the spectator's viewpoint low, so that we seem to be looking up at the figures, who appear to tower dramatically over our heads. Titian organized these figures around the marble steps and altar, props that direct and channel the action (such organization dates back to the *Pesaro Altarpiece* [42]). The viewer is led into the picture by the steps, around and on top of which the Vendramins are disposed in a roughly triangular form. The lower center of the picture is open, as though reserved for us. The three central figures also direct our attention. Leonardo and Gabriele look toward the cross, an action that the latter's outstretched arm, gesturing toward the spectator, invites us to do as well. We are engaged directly by the kneeling Andrea, who touches the altar while looking toward us.

In a daring compositional move, Titian has set the relic, the focus of all reverence, not at the center, but to the far right of the painting. We are led toward the cross, which is flanked by wind-blown candles set against the cloud-strewn sky. Yet the primary focus of the painting is not the relic at all, but its fervent adoration, which in Titian's hands has become a dramatic, expressive event.

Titian has portrayed two generations of brothers, uncles, and nephews in adoration of the relic given by their famous ancestor. The emotional and physical nature of each Vendramin is highly individualized and finely drawn, but it is clear that they are all one family, united by blood and heritage. The older men seem deeply moved, aware of the gravity of the occasion, while some of the older children seek to imitate them

81. Titian, *Members of the Vendramin Family Adoring the Relics of the True Cross*, London, National Gallery

without a full understanding of exactly what is happening. The younger boys, especially those on the right, who cannot actually see the relic, are less attentive and more interested in one another than in the relic itself. Such childish disinterest helps to further humanize this serious narrative. What emerges from this painting is a dignified, subtle portrayal of an important Venetian family experiencing a moment of heartfelt piety. The history, status, faith, and character of the Vendramins are made both dramatic and engaging, and, above all, memorable.

The 1540s witnessed the gradual maturing of Titian's idiom. During this decade he finished some of his most masterful paintings: portraits of Paul III Farnese, prestigious commissions from other members of the pope's family, new portraits of the Holy Roman Emperor Charles V and the courtiers at Augsburg, the *Members of the Vendramin Family Adoring the Relic of the True Cross*, and other remarkable and innovative works. As the 1550s dawned, Titian found himself the most successful painter in Italy.

NOTES

1. Vasari's "Life of Titian," in G. Vasari, *The Lives of the Artists*, trans. J. and P. Bondanella, Oxford, 1991: 498.

2. See J. Pope-Hennessy, *The Portrait in the Renaissance*, Princeton, 1966, and J. Pope-Hennessy, *Raphael*, New York, 1970.

3. C. Shaw, *Julius II: The Warrior Pope*, Oxford, 1996.

4. On Doge Andrea Gritti, consult J. Norwich, *A History of Venice*, New York, 1989, and A. da Mosto, *I dogi di Venezia*, Florence, 1983.

5. J. Cleugh, *The Divine Aretino*, New York, 1966, and C. Cairns, *Pietro Aretino and the Republic of Venice*, Florence, 1985.

6. For the poems and erotic prints that caused such a furor, see P. Aretino et al., *I Modi: The Sixteen Pleasures*, trans. and ed. L. Lawner, Evanston, 1988.

7. A translation of Aretino's letter to Cosimo may be read in J. Crowe and G. Cavalcaselle, *The Life and Times of Titian*, 2 vols., London, 1881, II: 108.

8. Crowe and Cavalcaselle, II: 112.

9. For Vasari's fascinating account of Titian in Rome, see G. Vasari, *The Lives of the Artists*, trans. J. and P. Bondanella, Oxford, 1991: 500–501.

10. Aretino's letter is published in J. Crowe and G. Cavalcaselle, *The Life and Times of Titian*, 2 vols., London, 1881, II: 114.

11. More information about the portrait of Paul III and his grandsons is offered in R. Zapperi, *Tiziano, Paolo III e i suoi nipoti; nepostimo e ritratto di stato*, Turin, 1990.

12. For the relationship between Vasari, Titian, and Michelangelo, see G. Vasari, *The Lives of the Artists*, trans. J. and P. Bondanella, Oxford, 1991:

500–501. It is likely that Titian began *Danaë* almost a year earlier, cfr. C. Hope, "A Neglected Document about Titian's *Danaë* in Naples." Arte veneta xxxi: 188–189.

13. On Venetian drawings, there is the work by H. Tietze and E. Tietze-Conrat, *The Drawings of the Venetian Painters,* 2 vols., New York, 1970. For the differences between Florentine and Venetian drawings, see D. Rosand, *Painting in Cinquecento Venice,* New Haven, 1982.

14. On Florentine drawings, see B. Berenson, *The Drawings of the Florentine Painters,* 3 vols., Chicago, 1938.

15. The artist Lambert Sustris is discussed by A. Ballarin, "Profilo di Lamberto d'Amsterdam (Lamberto Sustris)," *Arte Veneta* XVII (1962): 61–68; and M. Lucco, "Lambert Sustris," *Dictionary of Art* XXX (London, 1996): 33–34.

16. For more on Charles V, see K. Brandi, *The Emperor Charles V,* trans. C. Wedgwood, London, 1968.

17. Donatello's *Gattamelata* is described in H. Janson, *The Sculpture of Donatello,* 2 vols., Princeton, 1957, and in J. Pope-Hennessy, *Donatello, Sculptor,* New York, 1993. For the equestrian statue in the Renaissance, see B. Cole, *Italian Art, 1250–1550: The Relation of Renaissance Art to Life and Society,* New York, 1987: 173ff.

18. Verrocchio's Colleoni statue is discussed by G. Passavant, *Verrocchio,* London, 1969, and C. Seymour, *The Sculpture of Verrocchio,* New York, 1971.

19. For Dürer's *Christian Rider,* see E. Panofsky, *Albrecht Dürer,* 2 vols., Princeton, 1948.

20. For a photograph of this painting, entitled *Philip II: Allegorical Portrait* or *Allegory of (the Victory of) Lepanto,* see H. Wethey, *The Paintings of Titian,* 3 vols., London, 1971, II: pl. 183.

21. The history of the Vendramin family portrait is elaborated in C. Gould, *National Gallery Catalogues: The Sixteenth-Century Italian Schools,* London, 1981: 284–287.

I was invited on the day of the calends of August to celebrate that sort of Bacchanalian feast which, I know not why, is called ferrare Agosto–though there was much disputing about this in the evening–in a pleasant garden belonging to Messer Tiziano Vecellio, an excellent painter as every one knows, and a person really fitted to season by his courtesies any distinguished entertainment. There were assembled with the said M. Tiziano, as like desires like, some of the most celebrated characters that are now in this city, and of ours chiefly M. Pietro Aretino, a new miracle of nature, and next to him as great an imitator of nature with the chisel as the master of the feast is with his pencil, Messer Jacopo Tatti, called il Sansovino, and M. Jacopo Nardi [a Florentine historian], and I; so that I made the fourth amidst so much wisdom. Here, before the tables were set out, because the sun, in spite of the shade, still made his heat much felt, we spent the time in looking at the lively figures in the excellent pictures, of which the house was full, and in discussing the real beauty and charm of the garden with singular pleasure and note of admiration of all of us. It is situated in the extreme part of Venice, upon the sea, and from it one sees the pretty little island of Murano, and other beautiful places. This part of the sea, as soon as the sun went down, swarmed with gondolas adorned with beautiful women, and resounded with varied harmony and music of voices and instruments, which till midnight accompanied our delightful supper.[3]

It is a prosperous and self-assured Titian that one sees in the self-portrait dating around 1550 [82], painted when the artist was in his sixties. This, in fact, might be the painting that Vasari saw in Titian's home in 1566, calling it "very beautiful and lifelike." Seated behind a cloth-covered table on which he has placed his right hand, Titian depicts himself as a wealthy Venetian, dressed in furs and linen. The massive golden chain that he wears prominently around his neck is the insignia of the Knights of the Golden Spur, conferred upon him by Charles V in 1533. All traces of Titian's profession as a painter have been rigorously suppressed. Painting was a manual occupation, and the use of one's hands still bore some of the stigma attached to any sort of physical labor. In fact, if we did not know that this was Titian, we would suppose we were looking at the portrait of a successful merchant or banker.

Around the middle of the sixteenth century, when Titian painted this self-portrait, several artists, including Titian and Michelangelo, were just beginning to exchange the traditional status of craftsman for that of artist, with all the powers of

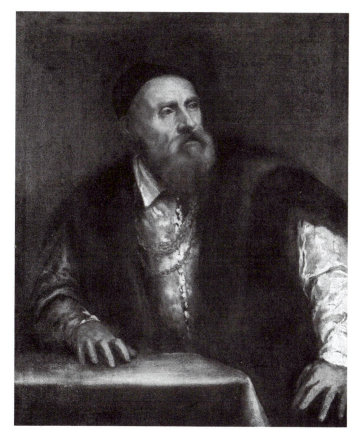

82. Titian, *Self-Portrait,*
Berlin, Gemäldegalerie,
Staatliche Museen

This painting was prob-
ably in Titian's studio at the
time of his death. Although
completed in its other parts,
the hands of the figure
remain unfinished. However,
if this is the portrait des-
cribed by Vasari who saw
it in Titian's studio, the
writer says that it was
"completed four years ago;"
perhaps Vasari was refer-
ring to another self-portrait.
(See color plate 6)

individuality and creativity that the word was then beginning
to acquire. Only one other self-portrait [83] by Titian survives,
and this one dates from very late in his life. In this picture he
represents himself with a brush, perhaps because by then he
felt secure enough about his reputation and his powers to
depict himself as he really was, an artist.[4]

But this was not yet the case in the earlier self-portrait,
where no reference to occupation is included. Moreover,
Titian has avoided the usual self-portrait pose, which derives
from the artist copying his face in a mirror. Instead, Titian
looks out past the spectator toward something located outside
the picture. It was, one must believe, his wish not to character-
ize himself as a painter that made him eschew the traditional
self-portrait pose and type.

The originality and force of Titian's self-portrait are striking.
The slight diagonal of his body, his visionary look outside the

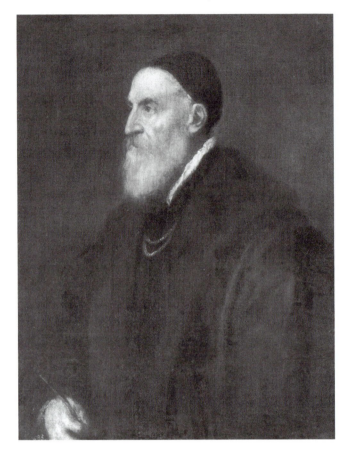

83. Titian, *Self-Portrait*, Madrid, Museo del Prado

This painting was once in the collection of Peter Paul Rubens. It was probably purchased from Rubens' estate by Philip IV, King of Spain.

picture's space, and the position of his arms and hands, which are unfinished, impart dynamism and energy to both the pose and the sitter. With its full gray beard, wonderfully rendered structure, and liquid eyes, the face is a tour de force of incisive characterization and idealization. The fur of the jacket and the cloth of the sleeve have been painted with a new boldness; their rendering is less nuanced than in many of the earlier works, and their surfaces are constructed with bolder transitions between the lights and darks, offering a new and more complex intermingling of color and lights. Here, the artist is in full command of his ever-increasing powers.

Much of Titian's career from the mid-1550s onward revolved around commissions from Philip II, his new and eager patron.[5] Philip's father, Charles V, abdicated in 1556, leaving the secular world for seclusion in a palace near the monastery of Yuste in

Spain. There he spent the last two years of his life in prayer and meditation. His successor to the Spanish throne and its vast empire was Philip, a ruler with a keen interest in art.

Titian's first portrait of Philip was begun in Milan in 1548 and shipped to him from Venice the following year. This painting, which is now lost, forms a fascinating historical foot-note illustrating just how important official portraits were in the Renaissance. It appears that in 1553, it was sent secretly by Philip's aunt, Mary of Hungary, to Mary Tudor of England during the wedding negotiations between the latter and Philip. Upon sending the portrait, Mary of Hungary commented:

[T]hat it was thought very like when executed three [sic] years before, but had been injured in the carriage from Augsburg to Brussels. Still, if seen in its proper light and at a fitting distance, Titian's pictures not bearing to be looked at too closely, it would enable the Queen, by adding three years to the Prince's age, to judge of his present appearance.[6]

Mary Tudor was well pleased with the likeness (a contem-porary observer commented that she was "greatly enamored" of it) and wrote that she would be delighted to see Philip in person. The portrait must have helped in the negotiations, for Philip and Mary were indeed married in England in 1554. Mary, however, died childless, and with her died the dream that England and Spain could become a single, united kingdom.

Titian's second portrait of Philip [84] was painted during the artist's stay in Augsburg between November 1550 and May 1551. He had again been called by Charles to work in the imper-ial city, where he stayed for seven months painting a series of important portraits. Certainly Charles and Philip had Titian's 1533 *Charles V* [50] in mind when this second portrait of Philip was commissioned, for not only is it of the same format and size, it also depicts the ruler full-length. This is not surprising. The *Charles V* had been such a success that it influenced the imperial portrait type in Spain, as well as in the rest of Europe, for cen-turies to come.[7] Moreover, a painting of the young Philip (he was twenty-four in 1550) in the same size and format Titian had used for his father many years before firmly established the importance of Philip as heir to the crown. Thus, this picture was not only a portrait, but a work of dynastic propaganda as well.

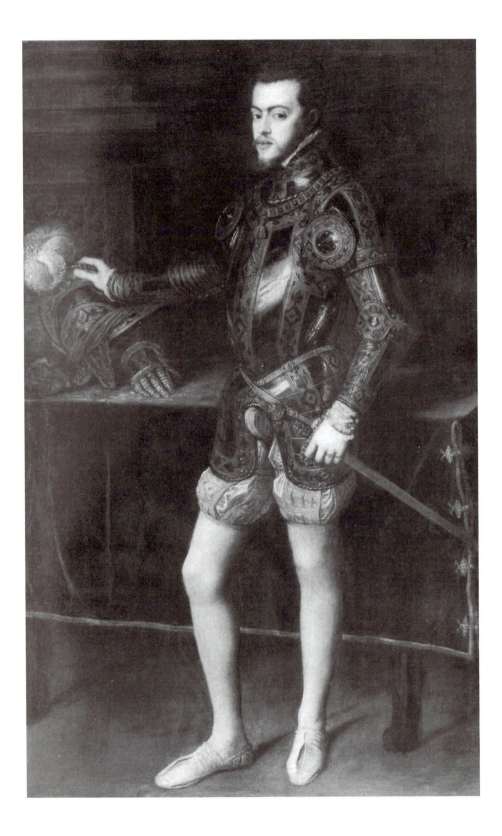

There are some notable differences between the two like-
nesses, however. Philip stands before a velvet-covered table.
Upon it rests the helm and gauntlets of the elaborate suit of
parade armor he is wearing in the portrait. He places one hand
on the helmet, while the other holds the hilt of the short
sword worn at his side. Special attention has been paid to the
armor, which, through Titian's magical touch, has become bur-
nished steel, alive with a myriad of subtle reflections, a feat
equaled only in the slightly earlier equestrian portrait of
Charles V. Behind the table rises the base and shaft of a large
column. This is a device used by Titian (as seen in the *Charles
V Seated*) and many subsequent portrait painters as well to
suggest the majesty of both the sitter and place.

Philip's status is established by the attributes of the column
and armor, but the spindly legs supporting the steel-bound
torso and the soft, heavy-lidded face with its sparse, downy
beard hardly convey a martial spirit. Philip seems tentative and
emotionally fragile when compared with the magisterial, confi-
dent image of his father, Charles V, painted by Titian some
two decades earlier. In fact, Philip was a complex figure.
Devoutly religious, sensuous, puritanical, reclusive, compul-
sive, and imperious, he defied easy classification.

Philip commented on this full-length portrait by Titian.
Writing to his aunt, Mary of Hungary, he remarked, "It is easy
to see the haste with which it has been made and if there were
time it would have been done over again."[8] This is a fascinating
statement because its note of displeasure indicates that Philip
was dissatisfied with the looseness of Titian's brilliant brush-
work and the daringly synthetic formal structure, which sug-
gest shapes and surfaces rather than carefully delineate them.
Philip, who considered himself a knowledgeable critic of art,
seems not to have fully understood the manner that so charac-
terized Titian's earliest self-portrait [82] and his own portrait.
Instead, he mistook his likeness for something done in haste,
which, had he time, he could have had corrected by requiring
Titian to bring it to a more traditional, polished state of finish.[9]

Philip's portrait was not the only painting Titian executed
during his second trip to Augsburg. While there, he was com-
missioned to paint the likeness of John Frederick of Saxony

84. Titian, *Philip II*, Madrid,
Museo del Prado

The helmet and
gauntlets on the table have
the same sort of monumen-
tal presence seen in the hel-
met and batons of the
*Francesco Maria I della
Rovere* (fig. 53).

[85], the leader of the Protestant forces defeated by Charles V at the battle of Mühlberg in 1547. John Frederick, although he lived a comfortable life at Augsburg, still remained a prisoner of the emperor. In captivity he had grown enormously fat and had difficulty moving, either on horse or on foot.

Titian's likeness of John Frederick is of considerable interest because it depends upon a contemporary German portrait type. Titian was never adverse to using models or, for that matter, even copying other works. We know, for example, that in several cases, including the portrait of Isabella of Portugal, the wife of Charles V, he used another artist's portrait as the basis for his own.[10] This was a common practice in Renaissance Italy and one which Titian would have accepted as right and natural.

85. Titian, *John Frederick of Saxony,* Vienna, Kunsthistorisches Museum
John Frederick of Saxony (1503–1554), leader of the Protestant forces, was captured by the troops of Charles V in May 1547.

The model for John Frederick's portrait seems to have been painted by Lucas Cranach (1472–1553), an important German court artist who was in the employ of John Frederick in Augsburg during Titian's second stay there.[11] Cranach, who was by then an old man, had painted Charles' portrait when the emperor was only eight years old. While in Augsburg, Charles sent for Cranach to ask him what he was like as a boy and received, not surprisingly, a flattering description. Titian and Cranach knew each other well enough in Augsburg for Cranach to paint a portrait of Titian, which is now lost. It is engaging to imagine Titian, the court painter of Charles V, the defender of the Catholic faith, sitting for Cranach, the court painter of the Protestant leaders of Germany.

Several of Cranach's portraits of John Frederick exist [86] and Titian's painting bears an unmistakable likeness to them. Cranach, working in the style of many contemporary German portraitists, presents the sitter close up, allowing the shape of his body to fill much of the painting's space. His hands clasped in front of him, John Frederick regards the sitter with a look that seems to hover between boredom and impatience.

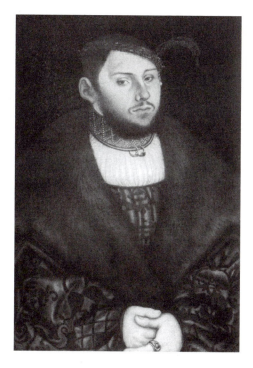

86. Lucas Cranach, *John Frederick of Saxony*, Weimar, Schlossmuseum

Lucas Cranach was born in southern Germany. He worked in Vienna before settling in Wittenberg, where he painted several portraits of Martin Luther. He was one of the most successful German court artists.

In Titian's hands, Cranach's prototype was reinvented. He enlarged the format to nearly three-quarters length and expanded its width. These changes transform John Frederick into a hulking presence whose massive body forms a space-filling triangle with its apex located in the sitter's corpulent face. The hands have been unfolded, made plumper, and used to help fragment the mass of the body.

Titian has also transformed Cranach's wiry, hard depiction into something much more fleshy and real. The material, sensual aspect of the sitter is heightened by Titian's remarkable mimetic skills. In his hands, John Frederick becomes a looming, somewhat disquieting presence rather than the static dynastic icon of Cranach's portrayal. This portrait is a brilliant demonstration of Titian's ability to take a likeness, either from a painting or from life, and transform it into something greater and more memorable than the original. These were precisely the skills that Titian's patrons admired and sought for their own portraits.

While at Augsburg, one of Titian's most important patrons commissioned not a likeness of himself, but of a heavenly vision. This was the picture alternately called the *Trinity, Gloria,* or *Last Judgment* [87], which Titian finished in Venice in October 1554 for Charles V. The artist mentions this picture in a letter he wrote to Charles in September 1554 in which he says:

I also send the picture of the *Trinity,* and, had it not been for the tribulation I have undergone [his ill health and the marriage of his daughter], I should have finished and sent it earlier, although in my wish to satisfy your C.M. [Catholic Majesty] I have not spared myself the pains of striking out two or three times the work of many days to bring it to perfection and satisfy myself, whereby more time was wasted than I usually take to do such things. But, I should hold myself fortunate if I give satisfaction, and beg your C.M. will accept my eager wish to be of service, my greatest ambition being to do a pleasure to your Majesty, whose all powerful hand I kiss with all the devotion and humility of heart.[12]

This passage is particularly interesting because Titian describes how he painted. Although he may have exaggerated to show Charles how hard he worked, his mention of "striking out two or three times the work of many days" as being an unusual practice indicates that such extensive repainting was not part of

87. Titian, *Trinity,* Madrid, Museo del Prado

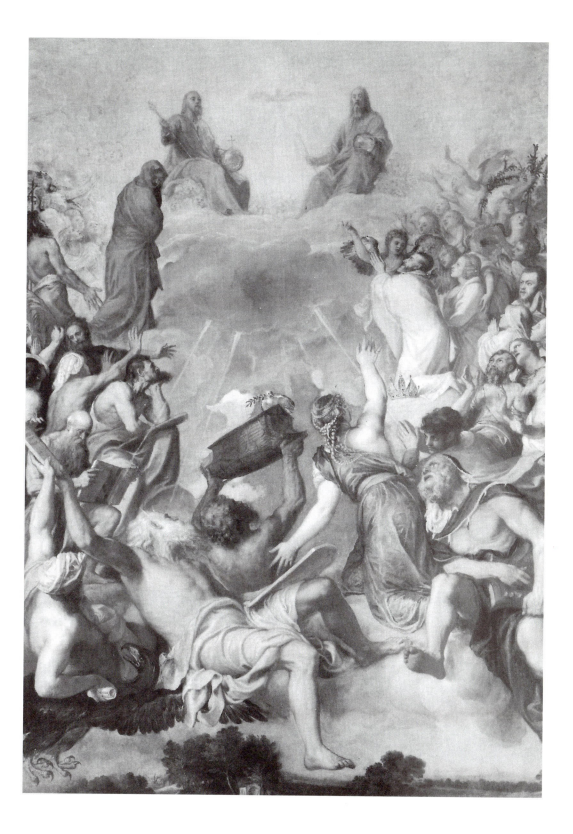

his regular painting process. X-rays of many of his paintings reveal that he made numerous, usually small changes as he worked, but this letter suggests that he must have made major alterations for the *Trinity,* involving large sections of the painting.

There exists a rare and fascinating description of Titian's painting methods given by his pupil and faithful follower Palma Giovane to Marco Boschini, a seventeenth-century historian of Venetian art:

Titian was truly the most excellent of all painters, since his brushes always gave birth to expressions of life. I [Boschini] was told by Palma Giovane . . . , who was himself fortunate enough to enjoy the learned instruction of Titian, that he used to sketch in his pictures with a great mass of colors, which served, as one might say, as a bed or base for the compositions which he then had to construct; and I too have seen some of these formed with bold strokes made with brushes laden with colours, sometimes of a pure red earth, which he used, so to speak, for a middle tone, and at other times of white lead; and with the same brush tinted with red, black and yellow he formed a highlight; and observing these principles he made the promise of an exceptional figure appear in four strokes. The most sophisticated connoisseurs found such sketches entirely satisfactory in themselves, and they were greatly in demand since they showed the way to anyone who wished to find the best route into the Ocean of Painting. Having constructed these precious foundations he used to turn his pictures to the wall and leave them there without looking at them, sometimes for several months. When he wanted to apply his brush again he would examine them with the utmost rigour, as if they were his mortal enemies, to see if he could find any faults; and if he discovered anything that did not fully conform to his intentions he would treat his picture like a good surgeon would his patient, reducing if necessary some swelling or excess of flesh, straightening an arm if the bone structure was not exactly right, and if a foot had been initially misplaced correcting it without thinking of the pain it might cost him, and so on. In this way, working on the figures and revising them, he brought them to the most perfect symmetry that the beauty of art and nature can reveal; and after he had done this, while the picture was drying he would turn his hand to another and work on it in the same way. Thus he gradually covered those quintessential forms with living flesh, bringing them by many stages to a state in which they lacked only the breath of life. He never painted a figure all at once and used to say that a man who improvises cannot compose learned or well-constructed verses. But the final stage of his last retouching involved his moderating here and there the brightest

highlights by rubbing them with his fingers, reducing the contrast with the middle tones and harmonizing one tone with another; at other times, using his finger he would place a dark stroke in a corner to strengthen it, or a smear of bright red, almost like a drop of blood, which would enliven some subtle refinement; and so he would proceed, bringing his living figures to a state of perfection. And as Palma himself informed me, it is true to say that in the last stages he painted more with his fingers than his brushes.[13]

This description provides us with several important insights. One is that "the most sophisticated connoisseurs" bought Titian's preliminary oil sketches. Before Titian's time, such sketches would have been considered only the first rough steps towards a finished painting and their value to patrons would have been minimal. However, in the early sixteenth century, there arose a new interest in the artist as creator and, consequently, in the various stages of the genesis of a work of art. Artistic process and development were now highly prized, and the preliminary drawings and oil sketches of artists such as Raphael, Michelangelo, and Titian were eagerly sought after by collectors.

The second important insight furnished by Palma concerns Titian's construction of the network of lights and darks in his paintings. Palma describes how Titian would sketch in his paintings with a bed of colors, using pure red earth or lead white as a middle tone. He would then build lighter or darker colors with a brush tinted with unmixed color. After sketching the paintings out in this manner, he would turn them toward the wall and return to them only after a considerable amount of time: up to several months, Palma states. Then Titian would examine the paintings carefully, "as if they were his mortal enemies," and correct and finish them, gradually covering "the quintessential forms with living flesh, bringing them by many stages to a state in which they lack only the breath of life."

Titian would then complete the painting, "reducing the contrasts with the middle tones," by rubbing the highlights into the darker tones. Occasionally he would add an enlivening and strengthening note of pure red or other dark color. Palma, who was in a position to know, tells us that late in his life Titian did this more with his fingers than with his brush.

When one looks at Titian's paintings, especially those from the 1550s onward, they give the impression of rapid, spontaneous execution; indeed, this is one of their most appealing aspects. But, as Palma's description proves, they were painted with considerable cogitation and labor, sometimes over a long period of time. Titian continually adjusted and readjusted his form and color to achieve precisely the effect he wanted. In short, his paintings, which often seem to have been executed in one furious session, are, instead, carefully calculated, highly calibrated works of art. Because of this procedure, the later paintings clearly show the hand of the artist at work. One sees Titian's mark and understands how the painting took shape; it is this revealed process of creation that makes them so fascinating.

Such a procedure was used in the *Trinity*, a picture particularly precious to Charles V. When in 1556 Charles abdicated the throne for a life of solitude and prayer, he took it with him to the monastery at Yuste. He had probably planned to do so when he commissioned it from Titian some two years earlier.

There is some confusion as to what the *Trinity* actually represents: Titian named it the *Trinity*, but in a codicil of Charles' will, it is called a *Last Judgment*. Since the early seventeenth century, it has often been called the *Gloria* (Heaven). In fact, Titian's title seems correct (he should have known what he was painting!), as it represents a multitude of holy and secular figures in adoration of the three elements of the Trinity. The scene is set in heaven and is in fact configured like a Last Judgment, but its real subject is the Trinity and its adoration.[14]

There are many recognizable figures among those adoring the Trinity. Personages from the Old Testament–David, Adam and Eve, Noah, Moses, and Ezekiel–appear with those from the New Testament–the Virgin and Saint John the Baptist. Members of the royal family are seen among the ranks of worshipers in the upper right. Dressed in shrouds as though risen from the dead and awaiting judgment are Charles V; his wife, Empress Isabella; and his son, Philip II. There are also other portraits of contemporaries, scattered through the crowd, but the identity of most have been lost. It has been claimed that the white-bearded figure seen at the extreme right edge of the

painting is a self-portrait of Titian, but it seems dubious that the portrait of an artist, no matter how exalted, would be allowed in such company.

The composition of the painting, with the Trinity at its summit and the swirling mass of bodies disposed in the space below, was surely influenced by Michelangelo's *Last Judgment*, which Titian had seen in Rome eight years earlier. On the whole, Titian's Roman stay had little effect on his art; as we have seen, he was already well informed about what was happening artistically in the city from a very early date. However, the effects of Michelangelo's gigantic painting were inescapable, as the huge, gesticulating figures of the *Trinity* demonstrate. Some of these monumental figures may also be indebted to the prophets and sibyls of the Sistine Ceiling, which Titian would have also viewed firsthand in Rome.

There are also echoes from Titian's earlier work in the *Trinity*, most clearly from the Frari *Assumption of the Virgin* [38]. The steep recession into space from the foreground to the distant background figures of the *Trinity* is reminiscent of that altarpiece, as are the billowing clouds, blazing angels, dappled illumination, and golden, heavenly light. Here and elsewhere throughout his career, Titian, like all Renaissance artists, borrowed from his own earlier compositions. Such borrowing allowed the artist to save time, thereby achieving the economy of means and effort sought by all efficient workshops of the era.

The *Trinity* was one of the last works Titian painted for Charles V, but there was no halting of royal commissions. When Titian painted Philip's portrait in Augsburg in 1551, the two men seem to have come to some sort of an agreement about further commissions. From that date until Titian's death twenty-five years later in 1576, a series of remarkable religious and mythological paintings was sent from Venice to Philip, who became Titian's most important client. In Augsburg, painter and prince probably agreed that Titian would send Philip his finest paintings.

In July 1558, Philip II commissioned an *Entombment of Christ* [88] from Titian to replace an earlier painting of the same subject, also by Titian, lost the year before in transit(!) between Trent and Flanders. Titian, as we have seen, had painted a

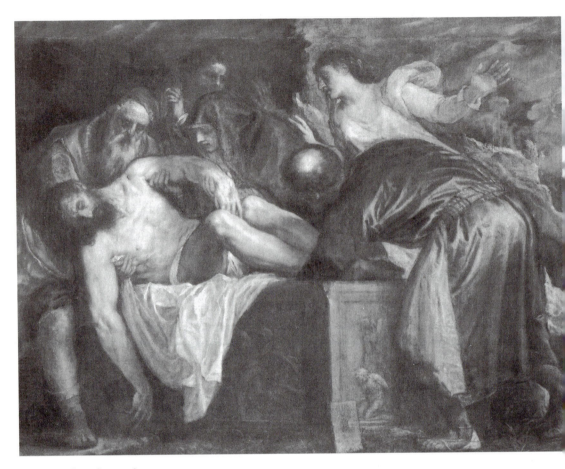

88. Titian, *Entombment of Christ,* Madrid, Museo del Prado

Commissioned in July 1558, this painting was shipped to Philip II from Venice in September 1559. It is unusual to be able to date Titian's work with such precision.

much earlier *Entombment* [43], probably for the Gonzaga of
Mantua, some three decades before. Although the two paint-
ings depict the same event, a comparison of them demonstrates
just how much Titian's visual and spiritual interpretation of
the subject had changed over the intervening year.

One of the most notable differences is in the scale of the fig-
ures and their relation to the painted space. In the earlier
Entombment–which depicts the carrying of Christ's body to the
tomb–the figures occupy, but do not dominate, the space.
Areas of sky and landscape are seen around them. In his sec-
ond version of the subject, in which Christ's body is being
lowered into the tomb, Titian has increased the scale and vol-
ume of the bodies: They now fill up most of the picture's
space, leaving only a glimpse of sky in the upper right-hand
corner. Moreover, they are very near the picture plane and
closer to the spectator, who is brought face to face with the
action.

The first version is dramatically lit and mysterious. It is the-
atrical in comparison to the second version: The shadow over
Christ's head, the mysterious penumbra surrounding the bod-
ies, and the facial expressions of the protagonists all seem
somewhat artificial compared to the later *Entombment*. The
older Titian was no longer interested in this sort of drama.
Instead, he depicts the body of Christ fully illuminated in the
1558 painting. Massive, but awkward in death, the body con-
fronts the spectator directly and inescapably, as does the tomb
into which it is being lowered by men grappling with its
weight and bulk. The graceful grouping of the earlier picture
has been replaced by a more chaotic and physical scene. Also
present is a sense of dynamism in the figures and in the storm-
tossed clouds often found in Titian's late paintings.

This sense of dynamism is partially created by the use of
color. In contrast to the earlier version of this subject, the
color is less localized here and more intricate in its composi-
tion. Warmer and more glowing, the color is brushed on in a
looser, less polished, and more exciting manner. Such a manner
anticipates the palette and brushwork of Titian's last paintings.

It has been claimed that the elderly, bearded figure support-
ing Christ's torso is a self-portrait and, in fact, it does bear a

resemblance to the self-portrait of c. 1550 [82], done some eight years before. Around the time of Titian's 1558 *Entombment,* Michelangelo carved his own image as a hooded old man hold-ing Christ in a marble *Pietà* [89], probably intended for his own tomb.[15] It can not be proved that Titian knew of this sculpture, but, given the rapidity with which images were exchanged within the artistic community during the Renaissance, he may well have been aware of it. Moreover, he was also to incorpo-rate his self-portrait in his own painted *Pietà* [104], which, like Michelangelo, he made for his own tomb.

On the tomb into which Christ is lowered are two reliefs painted to imitate Roman low-relief sculpture. These subjects–the Sacrifice of Isaac and Cain Slaying Abel–were considered to prefigure the sacrifice of Christ. It is the sacrificial nature of His death that so permeates Titian's *Entombment.*

Aside from sovereign religious paintings such as the *Entombment,* Titian completed a series of mythological paint-ings for Philip II during the 1550s. The subjects of these were all taken from Ovid's *Metamorphoses,* a book Philip owned and probably knew well.[16] Titian himself had already used this source when he was painting in the Camerino d'Alabastro in

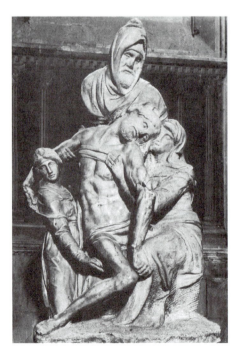

89. Michelangelo, *Pietà,* Florence, Museo dell'Opera del Duomo

Vasari claims that Michelangelo carved this work for his own tomb. Moreover, he says that the head of the old man (Nicodemus?) holding Christ is a self-portrait. Michelangelo became dis-satisfied with the still-unfin-ished group and smashed part of it with a hammer. The *Pietà* still bears the marks of this mutilation.

Ferrara. Arguably the most exceptional paintings of these stories from Ovid are three paintings, two of which Titian began around 1556 and finally sent to Philip three years later in 1559. These two, *Diana and Actaeon* [90] and *Diana and Callisto* [91], depict events in the life of the goddess Diana, the virgin huntress. They were to be joined by a third episode of the Diana story, the *Death of Actaeon* [92], which Titian mentions in a letter to Philip in 1559. This painting remained unfinished at the time of the artist's death in 1576.

Titian's *Diana and Actaeon* is based upon Ovid's description of how the young prince Actaeon stumbled into the woodland grotto sacred to Diana while he was hunting one day. At that unfortunate moment, the chaste goddess and her nymphs were there bathing. Enraged by the fact that a man had seen her

90. Titian, *Diana and Actaeon,* Edinburgh, National Gallery of Scotland

X-rays reveal that the large drape, which is such an important element in the composition, may not have been planned originally, but was added by Titian as the narrative was being painted —perhaps to enhance the sense of Diana's violated privacy.

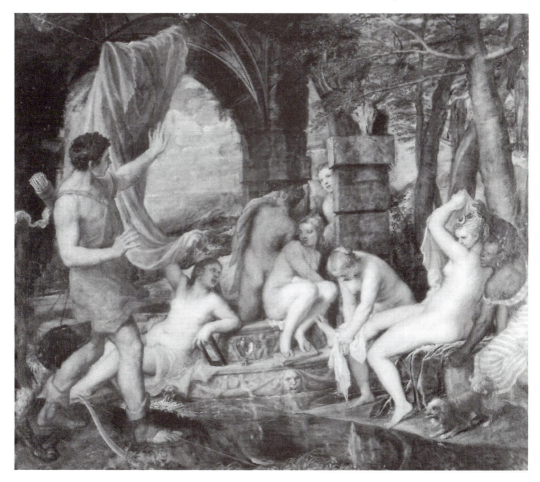

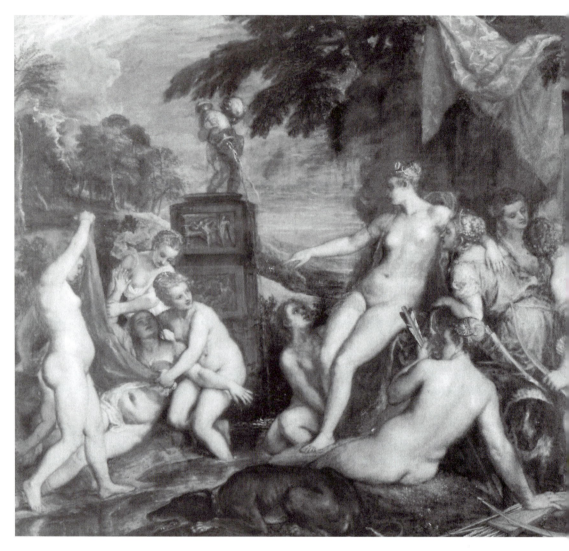

91. Titian, *Diana and Callisto*, Edinburgh,
National Gallery of Scotland

Diana told her companions to
undress and bathe in a stream. All
obeyed except the pregnant Callisto,
who was then stripped. Ovid (43 BC–
AD 17) writes that "she stood in terror,"
trying to hide her stomach. She was
then banished by Diana, who cried,
"This pool is holy, do not pollute it!"

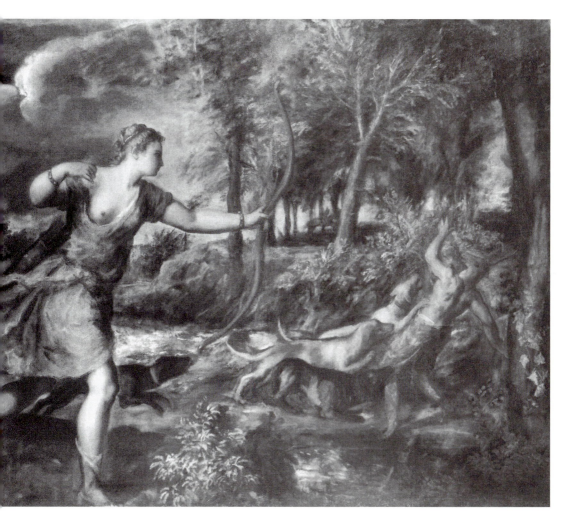

92. Titian, *Death of Actaeon*,
London, National Gallery

undressed, Diana looked about for a weapon to kill the intruder, but finding nothing at hand, she scooped up some water and threw it in his face, saying, "Tell people you have seen me, Diana, naked! Tell them if you can!" Immediately, Actaeon began to turn into a stag. Seized with fear, he ran from the goddess, but was pursued by his own hunting dogs and ultimately torn to pieces.

Like its companion piece the *Diana and Callisto*, the *Diana and Actaeon* is a large (190 x 207 cm) picture painted in Titian's most sumptuous manner. Glowing with color, its very atmosphere seems to be made of atomized gold and jewels. The major note of color is the shining flesh of Diana and her nymphs. But other hues–the blue of the garments of the nymph reclining in front of Actaeon, the wine-colored velvet upon which Diana sits, and the pinkish-red of the large drape, seemingly just pushed aside–combine with the flesh tones to form an overall sense of opulence. The strong local color of Titian's earlier works has been replaced by a more variegated, broken palette that scatters many more smaller areas of color and tone throughout the composition. This is the palette, that characterizes most of Titian's later paintings.

In the *Diana and Actaeon,* as in all his other canvases, Titian eschews deep background space. The large forms of the bodies, the trees, and the architecture are disposed friezelike across the surface of the painting, just beyond Actaeon. It is his figure in the near-left foreground that leads the viewer's eye back toward the nudes.

The play of the abstract pattern of interrelated forms spread across the surface in a band of finite, limited space was one of the major characteristics of Titian's work. The same holds true for the entire Venetian school of painting, from its Byzantine-influenced inception down to its demise in the early nineteenth century. Occasionally, as in the *Pesaro Altarpiece,* this rule is broken, but in general it is one of the most deeply held principles of Venetian painting.

The forms in the *Diana and Actaeon* tell the dramatic story astutely. Actaeon drops his bow and extends his hands in surprise as he realizes that he has accidentally stumbled upon Diana and her nymphs. The virgin goddess also reacts, masking

her face with her arm as she attempts to draw a cloth across her body; she fixes the hunter with a withering gaze as her maid rushes to cover her. These actions and reactions bracket the bathing nudes, whose fleshy bodies are tour de forces of Titian's mastery of figure drawing. The variety and complexity of poses–profile, three-quarter, frontal, and rear–must have delighted and amazed Titian's contemporary audience, just as they served as models for generations of artists. Never had Titian painted such complex monuments of volume and flesh so skillfully.

There is, however, an ominous message that transcends this lush display of form, skin, tone, and color. One knows that in a split second Diana will bend down, scoop water from the stream, and transform Actaeon into an imperiled stag. This action is already presaged by the two dogs: the hunter seen at Actaeon's heels and Diana's little dog, who yaps furiously at the hapless intruder.

Titian's earlier mythological paintings were, with few exceptions, celebrations of fantasy and sensuality, paeans to a long-lost Golden Age. But beginning in the 1550s, his interpretations of the ancient texts become more psychologically complex. There is a seriousness and gravity in the *Diana and Actaeon* that is absolutely appropriate to this distressing story. Here is a scene of human tragedy in which an innocent victim, Actaeon, is consigned to death by a cruel twist of fate outside his own understanding. As Ovid writes, "In the story / You will find Actaeon guiltless; put the blame / On luck, not crime; what crime is there in error?"

The *Death of Actaeon* is the subject of Titian's second meditation on the Diana and Actaeon story. This picture is probably the "Actaeon attacked by his dogs" that Titian mentions as "already begun" in a letter to Philip II of June 1559. Because there is no record of the work in any of the many inventories of the Spanish royal collections, it appears that the painting was never shipped to the king. It may, in fact, have been one of the several unfinished works remaining in Titian's studio at the time of his death in 1576.[17]

The death of Actaeon is not frequently portrayed, although it is fully described by Ovid, who lingers over its horrible

details. In his text, however, there is no mention of Diana shooting Actaeon with arrows (in fact she is absent from this episode) as the hunting dogs attack his pathetic half-stag, half-human form. One wonders if Titian included this action in the painting because he wanted to reflect further on the vengeful-ness of the goddess. In any case, the fact that he devoted an entire painting to the rarely depicted event demonstrates his fascination with the unfortunate Actaeon's lot. Whatever his reasons, he has created an unforgettable image of violence and horror, which will find counterparts in other works by the aging Titian.

One of the most striking characteristics of the *Death of Actaeon* is the summary nature of its form and fashioning. Figures, architecture, and landscape are realized with a mini-mum of detail as Titian's brush depicts the essence of that which is represented. Color is broken and scattered every-where. Instead of the large areas of localized color which Titian used in earlier works, hue is now separated and dis-persed throughout the painting in a myriad of small touches. Sometimes these fragmented passages of color seem almost stained rather than painted on with a brush.

There are, however, a number of areas in the foreground of the *Death of Actaeon* that seem so incomplete that the forms they are to meant to represent are unrecognizable, something never found in a completed painting by Titian. Moreover, many of the final finishing tonal touches and glazes are missing. In fact, this painting seems to correspond well with Palma's description of what one of Titian's works looked like before the artist returned to rethink and repaint it into its final form. Had the *Death of Actaeon* been completed, it would have looked very much like the two other Diana stories that were sent to Philip II, the *Diana and Actaeon* and the *Diana and Callisto*.

The *Diana and Callisto*, the third painting in Ovid's story of the virgin huntress Diana, a goddess for whom Titian probably had very little sympathy, depicts the plight of the unfortunate Callisto, one of Diana's nymphs. The beautiful Callisto had attracted the lecherous attention of Jupiter, who tricked her by appearing in the form of Diana and then raped her. Months later, Callisto's pregnancy was discovered while bathing with

the goddess and her other virgin nymphs, and she was turned into a bear by the vengeful Diana.

The large forms of the *Diana and Callisto* often mirror those of the *Diana and Actaeon* and, like the streams and landscapes that run through each, help tie the two paintings together. In each work, a frieze of heavy, volumetric figures extends across the picture's surface. Both paintings depict striding figures to the left and seated figures at the right. There are, however, major differences between the two paintings. In the *Diana and Actaeon*, the largest, most important figure is on the left, while in the *Diana and Callisto*, this role has been given to Diana, who is on the right. The foreground of the *Diana and Callisto* begins in the near-right, while in the *Diana and Actaeon* it starts in the near-left. In the *Diana and Actaeon*, the large swatch of drapery is on the left (x-rays reveal that Titian added it as a brilliant afterthought). In the *Diana and Callisto*, the drapery is located on the right. So, although there is a basic continuity of shape and space throughout both paintings, the major forms have been manipulated to make the paintings rough mirror images of each other. It is impossible to say if this spatial and formal arrangement indicates that they were to be hung side by side or across from each other. What is certain is that they were intended to be viewed as a pair.

The palette of the *Diana and Callisto* is the most variegated and sumptuous of the three Diana paintings. Much of the surface is given over to the glowing flesh tones of the abundant nudes, linked together through gesture and glance. The goddess and her nymphs are placed before a landscape brilliantly suggested by Titian's color. Although the panorama is composed of many elements–trees, hills, mountains, clouds–the visual effect is not achieved by the individual units of color that define the various shapes, but by the overall unity of rich, shimmering hue and tone. Certain parts of the picture, such as the cliff behind Diana or the base of the fountain, are brushed in with extraordinary freedom; their shape and texture form more in the imagination than they do in the eye. The distant mountains and sky above them are incandescent passages of cool blue and burnished gold. Recurring notes of broken hue are threaded through the composition so that there is an equi-

librium and harmony of color everywhere.

For the mature Titian (he was near seventy when he painted the Diana pictures), color was a major communicator of sensa- tion and emotion. In the *Diana and Callisto,* he has used color and tonality to produce a painting of singular sumptuousness and sensuality. But in the midst of all the glorious color and form, the essential tragedy of the story is omnipresent. A cre- puscular foreboding surrounds the protagonists and permeates the space. One always returns to the plight of the innocent Callisto who, like Actaeon, will suffer a cruel and undeserved fate in such a beautiful and shining world.

Questions of fate, and of the helplessness of innocent and trusting human beings who are entrapped by it, must have often been in the mind of the aging Titian. That he centered three paintings on the plight of Diana's victims suggests that, like several other remarkable artists who worked into extreme old age, he was preoccupied with the inability of men and women to fully control their destinies.[18] The capriciousness and cruelty of fate that haunted the elderly Titian, just as it did the old Rembrandt, increasingly formed the emotional core of his paintings. Unlike so many of his contemporaries who found the ancient myths merely amusing, Titian saw their tragic nature and increasingly depicted it.

One of these myths was the *Rape of Europa* [93], first referred to by Titian in the letter of June 1559 to Philip II. In this same letter, he also mentioned the still-unfinished *Death of Actaeon.* However, the completed *Rape of Europa* was not sent to Philip, who was now King of Spain, until 1562.

In a letter of April of that year, Titian wrote:

With the help of the divine Providence, I have at last finished the two pictures already commenced for your Catholic Majesty. One is the "Christ Praying in the Garden," the other the "Poesy of Europa Carried by the Bull," both of which I send. And I may say that these put the seal on all that your Majesty was pleased to order, and I was bound to deliver on various occasions. Though nothing now remains to be executed of what your Catholic Majesty required, and I had determined to take a rest for those years of my old age which it may please the Majesty of God to grant me; still, having dedicated such knowledge as I possess to your Majesty's service, when I hear–as I hope to do–that my pains have met with the approval of

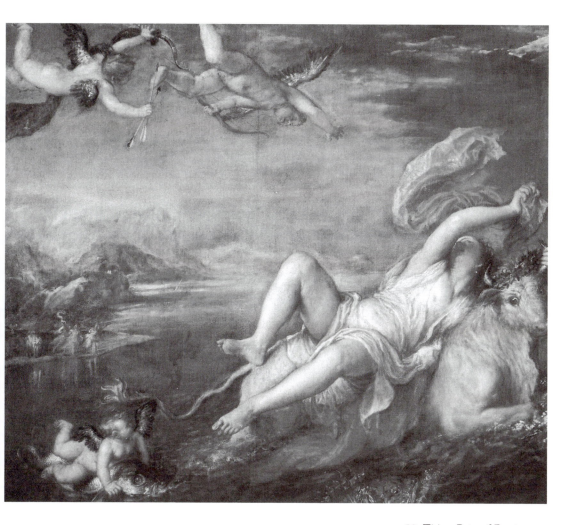

93. Titian, *Rape of Europa,* Boston, Isabella Stewart Gardner Museum

Ovid described the flight of the bull across the sea in great detail, including how Europa held tight to one horn while her flowing garments fluttered "in the breath of the sea-wind." Titian has carefully followed the text here.

your Majesty's judgment, I shall devote all that is left of my life to doing reverence to your Catholic Majesty with new pictures, taking care that my pencil shall bring them to that satisfactory state which I desire and the grandeur of so exalted a King demands.[19]

This letter does reveal that Titian and Philip had, in fact, made some sort of long-term agreement about what Titian was to paint. The delivery of the canvases mentioned in the letter marked the completion of Titian's work: "And I may say that these put the seal on all that your Majesty was pleased to order, and I was bound to deliver on various occasions."

However, Titian is clearly angling for new commissions in this letter, for he writes that he is waiting to hear Philip's opinion about the work he has just sent. If this proves to be favorable, Titian will "devote all that is left of my life to doing reverence to your Catholic Majesty with new pictures, taking care that my pencil shall bring them to that satisfactory state which I desire and the grandeur of so exalted a King demands." Clearly these royal commissions were the most important in Titian's later years and he had every reason to want them to continue after the delivery of the *Rape of Europa.*

The story of the *Rape of Europa,* like the Diana legend, comes from Ovid's *Metamorphoses.* It describes how Jupiter transformed himself into a comely and gentle snow-white bull to lure the unsuspecting Europa, the beautiful daughter of the King of Tyre, onto his back. He then leapt into the sea, carrying away the hapless maiden. Upon arriving ashore at Crete, Jupiter resumed his normal form, and then raped and impregnated Europa. Once again, Titian chose to paint a story portraying the fate of an innocent victim caught in disastrous circumstances completely beyond his or her control.

Titian has depicted the story in a manner that may be called eccentric. Europa and the bull occupy only the lower right corner of the canvas. The bull, his eye gleaming with excitement, plunges through the waves as Europa tries to hold on. Her grasp on the bull's horns is tenuous and she is falling off. Perhaps nowhere else in his painting of women has Titian painted such an intentionally awkward figure. As she is slipping off the bull, her legs and arms flailing about, her face turned back toward shore, Europa's bearing is a contradiction

of the comely pose always struck by glamorous women in the painting of Titian and his contemporaries. (It is interesting to note that the putto holding onto the fish is nearly a mirror image of Europa; Titian must have meant this little figure to form a visual parody of Europa and the bull.) Awkwardness is also one of the major characteristics of the *amoretti,* who seem to fall out of the sky rather than fly. Like Europa's, their limbs lash about and each is seen in an ungainly pose more humorous than dramatic.

Titian could have been spurred to paint in this way by the example of his rival Jacopo Tintoretto. Tintoretto (1518–1594), who may have spent a brief time in Titian's workshop, was a highly original painter whose many commissions posed a serious artistic challenge to the older master. The sweeping diagonals of the figures in the *Rape of Europa* are not unlike the active forms of many of Tintoretto's works [105] and, as in the latter's paintings, they create a particular excitement and dynamism.[20]

While it is possible that the figures in the *Rape of Europa* were inspired by Tintoretto, the rest of the painting is a splendid example of the aged Titian's singular mastery of form, color, and amplitude of depiction. In the wide background of sea, shore, mountains, and sky, Titian creates a memorable orchestration of shape and hue. There are no boundary lines to demarcate the various forms; rather it is color that creates profile, scale, and atmosphere. The sense of texture emanating from the panorama behind the foreground figures is remarkable; the deep, shimmering sea, the cold, snow-capped mountains rising in the haze of the distance, and the burning sky and fleeting clouds are breathtaking. As in the Diana paintings, all this is brushed in with hundreds of strokes to create large, carefully cogitated areas of flickering, broken color that, with the dynamic, massive figures of Europa and the bull, creates an immense, noble vision–a vision equal to the momentous, magical portrayal of divine lust and human tragedy forming the painting's subject.

To see how different, and much more profound, is Titian's interpretation of the Europa story, one need only compare it to a painting of the same subject by Paolo Veronese (c. 1528–1588), a talented younger contemporary. Painted some

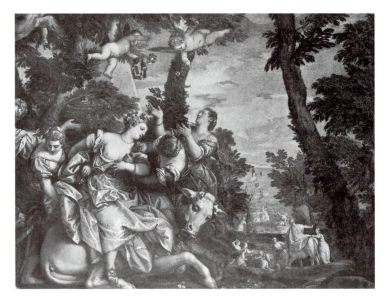

94. Veronese, *Rape of Europa,* Venice, Palazzo Ducale

Although it is now in the Palazzo Ducale of Venice, this painting was originally a private commission. Painted for Jacopo Contarini, it was left to the Venetian Republic by his heirs in the early eighteenth century.

ten years after Titian's, Veronese's *Rape of Europa* [94] presents a bucolic vision of the event.[21] Set in the foreground of a beautiful forest glade, Europa sits comfortably on a passive, rather sweet-looking bull. Attended by her servants who dress her and by the putti who fly overhead, she shows neither fear nor suspicion. In the middle ground, she sits astride the animal as it moves down toward the water. Finally, in the background, the now diminutive Europa is carried away across the sea by the bull almost out of the viewer's elements. Unlike Titian, Veronese has ignored the tragic and violent aspects of the story in favor of its more lyrical, if superficial, aspects. But it is not Veronese's interpretation of the legend that is unusual, but Titian's.

NOTES

1. There is no comprehensive study of Titian's workshop assistants, some of whom still remain anonymous. See R. Fisher, *Titian's Assistants during His Later Years,* New York, 1977, as well as B. Berenson, *Italian Pictures of the Renaissance: Venetian School,* 2 vols., London, 1957.

2. F. Saxl, "Titian and Pietro Aretino," *A Heritage of Images,* Harmondsworth, 1970: 71–87.

3. J. Crowe and G. Cavalcaselle, *The Life and Times of Titian,* 2 vols., London, 1881, II: 40.

4. For the late self-portrait, consult H. Wethey, *The Paintings of Titian,* 3 vols., London, 1969, II:114. This late self-portrait in Madrid is unusual in that

it presents the sitter in strict profile and is, I believe, unique in so doing. Given the problems involved in trying to paint oneself in profile, even with several mirrors, one wonders if this damaged portrait might be of Titian rather than by him. It could be by a talented pupil.

5. A recent work on Philip II is H. Kamen, *Philip of Spain,* New Haven, 1997. Consult also H. Trevor-Roper, *Princes and Artists: Patronage and Ideology in Four Habsburg Courts, 1517–1632,* New York, 1976.

6. For the text of the letter from Mary of Hungary, see J. Crowe and G. Cavalcaselle, *The Life and Times of Titian,* 2 vols., London, 1881, II: 209.

7. Spanish court painting in the age of Charles V and Philip II is dealt with in *Alonso Sanchez Coello y el retrato en la corte de Felipe II,* ed. S. Saaverda, Madrid, 1990.

8. Philip's quote is published in H. Wethey, *The Paintings of Titian,* 3 vols., London, 1971, II: 127.

9. Pietro Aretino made similar claims about his portrait by Titian; see Chapter 6 here.

10. The portrait of Isabella of Portugal is discussed by H. Wethey, *The Paintings of Titian,* 3 vols., London, 1971, III: 110–111.

11. M. Friedlander and J. Rosenberg, *The Paintings of Lucas Cranach,* Secacus, 1978.

12. J. Crowe and G. Cavalcaselle, *The Life and Times of Titian,* 2 vols., London, 1881, II: 231–232.

13. Marco Boschini's quote in translation is from C. Hope, *Titian,* New York, 1980: 163–164.

14. For a discussion of the subject of this painting, see H. Wethey, *The Paintings of Titian,* 3 vols., London, 1969, I: 35, 165–167.

15. Michelangelo's *Pietà* for his own tomb is described in C. de Tolnay, *Michelangelo,* vol. III, Princeton, 1960.

16. Ovid, *Metamorphoses,* trans. R. Humphries, Bloomington, 1955.

17. History of the *Death of Actaeon:* C. Gould, *National Gallery Catalogues: The Sixteenth-Century Italian Schools,* London, 1981: 292–297.

18. The subject of artists working in old age is dealt with by K. Clark, *The Artist Grows Old,* London, 1972.

19. J. Crowe and G. Cavalcaselle, *The Life and Times of Titian,* London, 1881, 2 vols., II: 319–320. In Italian, Titian calls the *Rape of Europa* a poesia– "*l'altra la poesia di Europa portata dal Toro.*" Mythological paintings are sometimes called *poesia* or, as Crow and Cavalcaselle translate it, "poesy." This term, which is also used for paintings without subjects, seems to suggest that both patron and artist viewed such works as a sort of painted poetry.

20. E. Newton, *Tintoretto,* Paulton, 1966.

21. R. Rearick, *The Art of Paolo Veronese,* Washington, 1989.

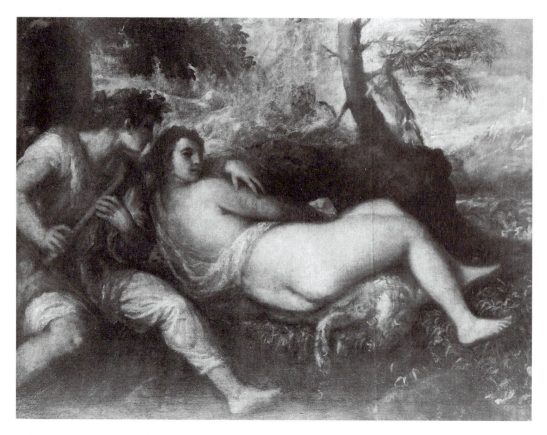

95. Titian, *Nymph and Shepherd,*
Vienna, Kunsthistorisches
Museum

Several subjects have been
suggested for this painting,
including Endymion and Diana,
Venus and Adonis, and
Oenone and Paris. None of
these have been universally
accepted and the exact identifi-
cation of the subject, if indeed
there is one, is still in question.

8

Titian:
The Late Works

꽃

The complex and profound depiction of the *Rape of Europa* is characteristic of Titian's late treatment of mythological stories. In one of his last pastoral mythologies, the enigmatic *Nymph and Shepherd* [95] of around 1565, he returns to a type of painting he had essayed in his youth. A comparison of this canvas with his much earlier *Three Ages of Man* [37] and the *Bacchanal of the Andrians* [46] demonstrates just how much his conception of mythology had changed and deepened over the decades of his long career. The bright, clear world of the earlier paintings has been replaced by a brooding, crepuscular atmosphere. No longer are the beautiful, luminous landscapes and shining bodies of his youthful paintings part of Titian's conception. Instead, the two large, sprawling figures of nymph and shepherd are set in a shadowy, indeterminate landscape only partially lit by the fiery sun on the horizon. Darker and more mysterious than any other previous landscape by Titian, the painting is composed of a myriad of broken colors applied with hundreds of small brush strokes.

The mystery of this painting is further deepened by the enigmatic relation between the two large and cumbersome figures. In contrast to his earlier paintings, where love, lust, fear, or surprise are clearly and often poignantly expressed, here the figures are physically close, but emotionally isolated and muted. One searches in vain for some clear meaning in this enigmatic and somehow tragic scene.

One of Titian's last works is also permeated by this sense of tragedy, tragedy realized with a range of formal and spiritual prowess remarkable even in the artist's late work. This picture, the *Flaying of Marsyas* [96] of c. 1570, is first recorded in 1655 in the collection of Thomas Howard, the Earl of Arundel, a famous and discerning collector who helped develop the taste for Titian's work in England. It is quite possible that the painting was purchased by Arundel or Aletheia, his equally astute wife, in Venice during one of their several trips to Italy.[1] In any case, for whom the *Flaying of Marsyas* was originally painted is unknown, as there is no surviving record of it during Titian's lifetime.

As with other mythological scenes by Titian, the literary source of the painting is found in Ovid's *Metamorphoses*.[2] Ovid describes how the satyr Marsyas found a flute that had been cursed by Minerva. Angered by Marsyas' pride in his ability to play the instrument, Apollo challenged him to a musical contest in which the winner could do anything he liked to the loser. Apollo, who played the lyre, was judged the winner by the muses, who were his companions and thus far from unprejudiced. The victorious Apollo then flayed Marsyas alive. As in the stories of Diana and the Rape of Europa, it is an innocent person's destiny to fall victim to cruel fortune. In the *Flaying of Marsyas*, Titian once more meditates on the arbitrary nature and cruelty of fate, a subject that seems to have become increasingly important to him as he grew older.

Titian's depiction of the fate of Marsyas is, simply put, horrifying. Marsyas is located squarely in the center of the picture, in the very forefront of the painting's space, where he cannot escape our attention. Suspended and trussed like a slaughtered animal, the satyr is flayed by two figures. One whose head is crowned with leaves uses his knife to peel the still-living flesh

96. Titian, *The Flaying of Marsyas*, Kremsier, National Gallery

Ovid's description of the flaying of Marsyas is particularly horrible. Marsyas, he writes, was "one great wound, with the blood flowing, the nerves exposed, veins with no cover of skin over the beating surface, lungs and entrails visible as they functioned." (*See color plate 7*)

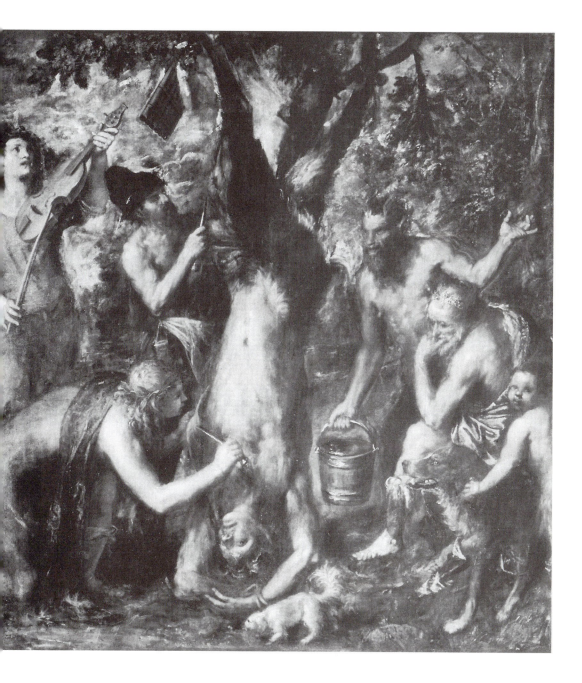

away from the body. The calm, workaday efficiency of this man and his companion is disturbingly pedestrian and banal in such a violent scene. Particularly distressing is the action of the small brown-and-white dog that innocently laps up the blood that has begun to pool under Marsyas' head.

Titian has grouped several other figures around Marsyas and the two executioners. The standing man playing the lyre, who must be Apollo, looks upward and away from the gruesome scene before him—one can only imagine the mournful wail of his music. On the other side of Marsyas, a satyr carrying a bucket freezes with horror as he witnesses the event. Another figure, an old crowned man, watches the scene as he calmly contemplates the fate of Marsyas. This figure resembles the aged Titian, whose likeness we know from a late self-portrait [83], but perhaps is meant to represent King Midas in this picture. From his contemplation and from the actions of the other figures as well arises a hushed, reverential atmosphere that is almost sacramental, as though the flaying were a sacrifice rather than an execution. In fact, some Renaissance humanists did see the Flaying of Marsyas as an allegory of the shedding of the sensual self, a rite of purification revealing the spiritual nature of man. Although the spiritual, sacrificial nature of the innocent victim must have been very much on Titian's mind as he conceived and then painted this magisterial work, it is highly unlikely that Titian had such an allegory in mind, for his intellect did not embrace such allegorical concepts easily. In fact, in its emotional tenor and in the amazing freedom in which it is executed, the *Flaying of Marsyas* is close in conception to Titian's late religious paintings.

Each of the figures forms a large pattern placed close to the picture plane. There is virtually no background in the painting, for even the clouds in the upper left corner form flat patterns. As in the works of Bellini, space is developed from the top to the bottom of the picture rather than back into it. The scene is conceived with a minimum of detail and with a maximum of volume, achieved by color and tone. Some of the objects, such as the torso and legs of the kneeling figure in the foreground, are realized as much in the mind of the viewer as they are seen by the eye. The minute, painstaking construction of form by

hundreds of small brush strokes is very like that of the *Death of Actaeon* or the *Rape of Europa,* but here the color is even more broken and scattered. The colors are also more somber and thus quite different from the sumptuous, glowing, gemlike hues of earlier works, such as the *Rape of Europa* or the Diana pictures. Like the other late works of Titian, the *Flaying of Marsyas* seems almost monochromatic at first sight because there are no large areas of local color. Closer analysis reveals that the surface of the painting is a myriad of greens, browns, blacks, and other appropriately somber hues, applied by brush, palette knife, rag, and fingers. Notes of red also appear throughout the picture: the clothes of the lyre player, the robe of the seated figure, the red ribbon hanging next to the pan pipes, and, of course, in the bloody body of Marsyas. Moreover, small touches of red are visible in the figures and throughout the landscape, giving the canvas a blood-spattered appearance that is disquieting indeed. The *Flaying of Marsyas,* like several other of Titian's most consequential late paintings, is impossible to describe in mere words. The depth of its anguish, cruelty, reverence, and sacrifice is of a visual and emo-tional order seldom encountered in the history of art. Ultimately one most fully understands the *Flaying of Marsyas* not with the intellect, but with the heart.

Considering the emotional impact of this painting, it is fasci-nating to learn that Titian's source of inspiration for this work was a relatively minor fresco of the Flaying of Marsyas by the Mannerist artist Giulio Romano in the Palazzo del Te, Mantua. Working from his own drawing after the fresco or from the still extant preliminary drawing by Giulio himself [97], Titian reutilized the basic elements of Giulio's composition and by so doing, made a rather pedestrian image profoundly moving.[3] That Titian drew both inspiration and motif from another artist's work, and a lesser one at that, should not be surprising. The Flaying of Marsyas was a rather uncommon subject and, like any other Renaissance artist, Titian did not simply invent something new; rather, he borrowed from what was at hand. However, what emerged from his protean brush made Giulio's work seem contrived and tame, for, as in many of the late mythological paintings by Titian, the subject became the vehicle

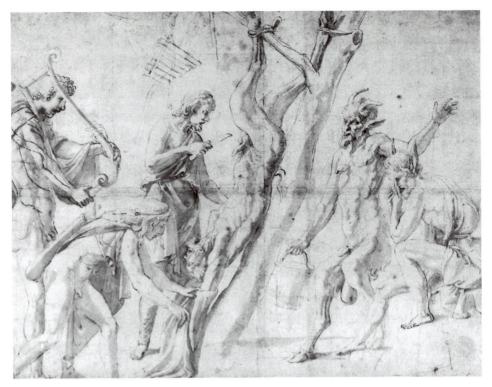

97. Giulio Romano, *Preliminary Drawing for Flaying of Marsyas Fresco, Palazzo del Te, Mantua*, Paris, Musée du Louvre

Giulio Romano was Raphael's principal assistant at the time of the latter's death in 1520. After Raphael's demise, Giulio finished several works commissioned to his teacher. In 1525, he moved to Mantua, where he became the court artist. His Mantuan masterpiece, the Palazzo Te, was designed and decorated for Federico II Gonzaga (fig. 52).

98. Titian, *Annunciation*, Venice, San Salvatore

for a hitherto unexplored range of emotional and physical states.

The trajectory of Titian's mythological paintings from the 1560s onward was closely paralleled by his religious works. These became increasingly personal visions of sacred drama. His altarpieces moved outside the boundaries and conventions of sixteenth-century Venetian painting (many of which he himself had established), becoming highly complex revelations of intense spirituality and power of the sort prefigured in the 1558 *Entombment of Christ*.

Such qualities are clearly seen in the *Annunciation* [98] painted by Titian for the Venetian church of San Salvatore probably around 1560. The donor of this painting, Antonio Cornovì della Vecchia, commissioned Titian to paint "the altarpiece of the Incarnation of our Lord," and it is indeed "Incarnation"–the transformation of the divine spirit into flesh–rather than the usual appellation of "Annunciation" that best describes what Titian actually painted.[4] As in the rejected altarpiece for the nuns of Santa Maria degli Angeli at Murano from the 1530s [64],

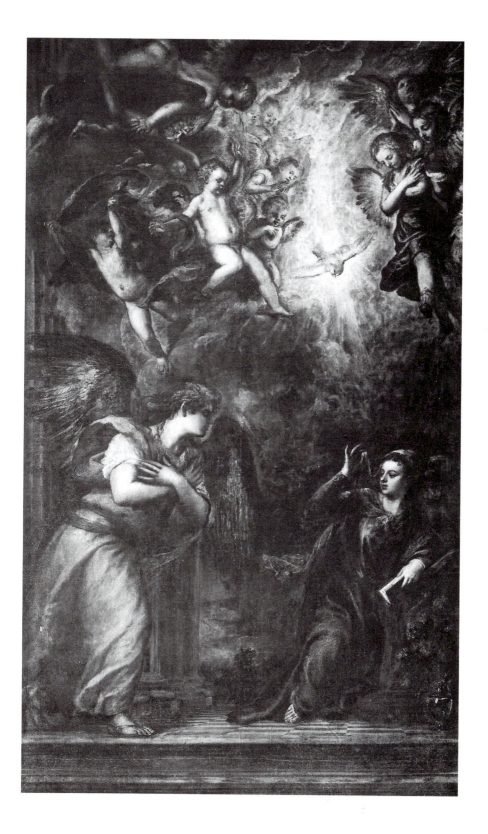

Titian spurned the conventional placid tradition associated with the subject. In his later *Annunciation,* he even further increased the dynamic, supernatural power of the conception of Christ. The very fabric of the San Salvatore *Annunciation* is a burst of light and life-giving energy. Through the tumultuous clouds and writhing angels, the skies are dramatically parted by a bolt of heavenly light propelling the Holy Spirit toward the Virgin. The large beautiful angel, who looks very much like the goddess Diana in the *Death of Actaeon* [92], seems almost a supernumerary, as much a passive witness to this supernatural event as the Virgin herself. In fact, x-rays reveal that Titian originally painted the angel with an outstretched arm, which he later moved to the current, more passive position.

The religious pictures of Titian's late style contain a smoky, turbulent, and blazing sky filled with the type of corporeal angels that appears in the San Salvatore *Annunciation.* Such imagery is especially apt in this painting because an inscription below the vase of flowers in front of Mary reads, "Fire that burns but does not consume." This passage from Exodus 3:2 refers to the Burning Bush of Moses, but here it symbolizes the virginity of Mary, which remained intact at the Incarnation. Indeed, there are Byzantine paintings of the Annunciation that actually depict Mary in the Burning Bush and it is possible that Titian was aware of such depictions. Interestingly enough, in a contemporary engraving of the paintings by Cornelius Cort, the flamelike flowers of the vase have been turned into flames (one wonders if this could have been Titian's original intent).[5]

The simple yet grandiose setting of the event–the gigantic colonnade at the left and the stagelike platform resting on two steps that keeps the spectator from intruding too closely on the event–is almost obscured by the torrent of supernatural energy, the perfect visual metaphor for the mystery of divine incarnation. The tremulous light emanating from a divine source irradiates and sanctifies the picture's space and its two sacred personages. The remainder of the scene, including the distant landscape, is cast into inky darkness.

Vasari saw this painting, along with the now-ruined high altarpiece by Titian, also in the church of San Salvatore, and

commented that "these late works, although some good things
can be seen in them, are not very highly regarded by him
[Titian] and do not possess the perfection of his other paint-
ings."[6] One wonders if this was simply modesty on Titian's
part or if Vasari, who often embellished the truth, fabricated
these comments. To Vasari, accustomed to the smooth, highly
resolved forms and surfaces of central Italian painting and to
the much more polished earlier works of Titian, these later
paintings must have come as both a surprise and, at first
glance, a disappointment. Like the *Nymph and Shepherd* and the
Flaying of Marsyas, the San Salvatore *Annunciation* seems, by
comparison to contemporary paintings by other artists, unfin-
ished. Its forms are suggested by quivering light and dark
rather than being described in detail, and the color is broken
and scattered throughout the painting in hundreds of small
touches. Indeed, writing about this painting, the sixteenth-
century critic Ludovico Dolce claimed, "the flesh trembles" and
"the lights fight and play with the shadows," and in the thick
paint one senses "the desperate greatness" of Titian.[7]

Vasari believed that in his late paintings, such as the
Annunciation, Titian had damaged his reputation: "he would
have done well in his last years not to have worked except as a
pastime to avoid damaging with less skillful works the reputa-
tion he earned in his best years before his natural gifts had
begun to decline." But this is Vasari speaking as a historian and
devoted disciple of Michelangelo. However, when he
describes other late paintings by Titian, Vasari the artist can-
not help himself from becoming rhapsodic:

But it is certainly true that his method of working in these last works
is very different from the one he employed as a young man. While
his early works are executed with a certain finesse and incredible
care, and are made to be seen both from close up and from a distance,
his last works are executed with such large and bold brush-strokes
and in such broad outlines that they cannot be seen from close up
but appear perfect from a distance. And this technique explains why
many, wishing to imitate Titian in this and to prove their expertise,
have produced clumsy pictures, and this comes about because
although many believe them to be executed without effort, the truth
is very different and these artisans are very much mistaken, for it is
obvious that his paintings are reworked and that he has gone back

over them with colours many times, making his effort evident. And this technique, carried out in this way, is full of good judgement, beautiful, and stupendous, because it makes the pictures not only seem alive but to have been executed with great skill concealing the labour.[8]

This is a fascinating, important passage, for it both describes Titian's late style precisely and reveals how astounding his last paintings must have been, even in the eyes of a contemporary as prejudiced against Venetian art as Vasari.

In Titian's studio Vasari saw an altarpiece of the Martyrdom of Saint Lawrence that had been ordered by King Philip of Spain. This was a free copy of an earlier *Martyrdom of Saint Lawrence* [99], still in its original location in the church of the Gesuiti in Venice. This first altarpiece has a rather complex history. It seems that it was commissioned from Titian in 1548 by Lorenzo Massolo for his chapel in the church, but its completion was much delayed and it was probably not finished until around 1560.[9]

The subject of this huge painting in the church of the Gesuiti (493 x 277 cm), which honors the namesake of the donor, San Lorenzo (Saint Lawrence), is frequently illustrated upon altarpieces, but Titian's interpretation of the event is, as we would expect, highly original. In a daring break with convention, he depicts the martyrdom of Saint Lawrence as a night scene. One sees emerging from the forbidding darkness the body of the saint, forced onto a grill above a bed of flaming wood as the sinister figures of his tormentors bend to their task of execution. The strong contrast between the lights and darks of this picture and the theatrical action that it creates are remarkably innovative, although they may owe their distant inspiration to Titian's observation of Raphael's *Liberation of Saint Peter* in the Vatican Stanze, a remarkably painted night scene. Titian's dramatic alternation between light and dark, the powerful physicality of the figures, and the deep, mysterious space of the painting extending into the vast background, with its classical idol and temple façade, foreshadow, by nearly a half century, Caravaggio's startling Roman paintings from the early 1600s. Many of Titian's works, from early maturity onward, served as sources of formal and interpretive inspira-

99. Titian, *Martyrdom of Saint Lawrence*, Venice, Gesuiti

In 1558, Garcia Hernandez, the Spanish Ambassador in Venice, informed Philip II that the monks of Santa Maria dei Crociferi (the church's original name) would be willing to part with their *Martyrdom of Saint Lawrence* for 200 scudi. Instead, Philip commissioned Titian to paint another altarpiece with the same subject.

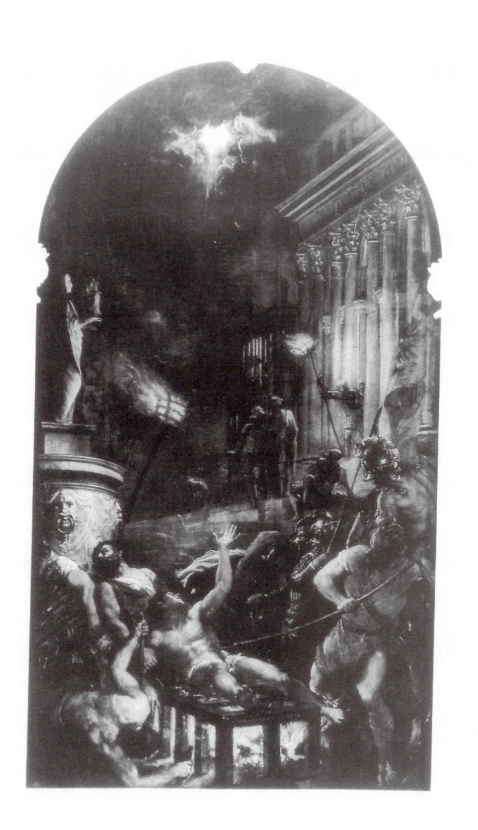

tion for the first generation of Baroque painters, who strove to free themselves from the restricting and convoluted conventions of their Mannerist teachers. Moreover, much of the painting style of the Venetian Renaissance, which itself was to influence radically the formation of the Baroque style throughout Europe, centered on many of Titian's compositional innovations and painting techniques.

Titian's use of these techniques in the *Martyrdom of Saint Lawrence* has created a scene of the highest spiritual, emotional, and physical drama. In the hands of Titian, the story has become a cosmic struggle between good and evil, darkness and light, and pagan idolatry and the godly salvation offered by Christianity. Often Saint Lawrence is pictured stoically accepting his fate: He is reputed to have said, "See, I am done enough on one side, now turn me over and cook the other." Titian transforms the traditional, rather mundane approach into something fundamentally different. His saint is a powerful, struggling physical presence who has to be forced upon the gridiron. In fact, the entire foreground of the painting is occupied by straining, muscular men who bend to their various gruesome tasks. The weaving together of all these figures through the twisting bodies and outstretched limbs is reminiscent of the Diana mythologies [90, 91, 92]. The figure who pins down the shoulders of Saint Lawrence is borrowed, with substantial modification, from Raphael's *Entombment* [44], completed in 1507 and itself heavily influenced by Michelangelo. Titian must have recalled the frieze of beautifully interwoven, struggling bodies of this famous work when he first began the *Martyrdom of Saint Lawrence,* and was inspired by both the figure of Christ and the man who labors to support His torso.

In Titian's painting, the tormentors are illuminated by the flames that burn the saint's body. There are also several other sources of light penetrating the gloom of the background, including the blazing torch partially illuminating the standing idol, and the diffuse light emanating from the colonnade of the temple. These flickering flames, which cast a weird, shifting light upon the scene, are reflected in the polished armor of the soldier who stands to the right in the painting. The mysterious penumbra and the stark contrast between light and dark are

characteristic of the late Titian in general, as are the flames, embers, and smoke that so energize this painting.

There is yet another light source within this picture: the divine emanation that breaks through the clouds and darkness high above the earthly scene. Here the sky opens as a divine glory appears to Saint Lawrence, who looks and gestures toward it. The darkness is shattered and a sign, unseen to all except the martyr, offers hope of salvation and heavenly reward. In a scene of physical struggle and torment, this light piercing the darkness is a beacon of hope for both saint and observer alike.

Vasari was so impressed by the illumination of the *Martyrdom of Saint Lawrence* that he wrote a perceptive and admiring description of it in his "Life of Titian":

And because Titian has imagined a scene at night, he has two servants holding two torches in their hands which illuminate the places where the light of the fire, burning brightly and intensely under the grate, does not reach. And besides these details, he has imagined a flash of lightning coming down from the heavens and cutting through the clouds to overcome the light from the fire and the torches, shining above the saint and the other main figures; and besides these three sources of light, the people that he has depicted in the distance in the windows of the apartment building are surrounded by the light from their lanterns and candles, and the whole picture is, in short, executed with admirable skill, ingenuity, and good judgement.[10]

The physical struggle and torment of the *Martyrdom of Saint Lawrence* are also seen in Titian's late *Crowning with Thorns* [100], seemingly begun around 1570. Carlo Ridolfi, the author of an important seventeenth-century biography of Titian, tells us that this painting was left unfinished at Titian's death. Titian's profligate son Pomponio, who, Ridolfi writes, "reduced his worthy father's patrimony to nothing," sold the painting to the Venetian artist Jacopo Tintoretto, one of Titian's foremost younger rivals and most fervent admirers.[11]

The other works left to Pomponio at the time of Titian's death included unfinished works, preparatory oil sketches, and *modelli*. These *modelli* (models), which served as records of already completed paintings, some probably done many years before, were used to make copies and variants of those earlier

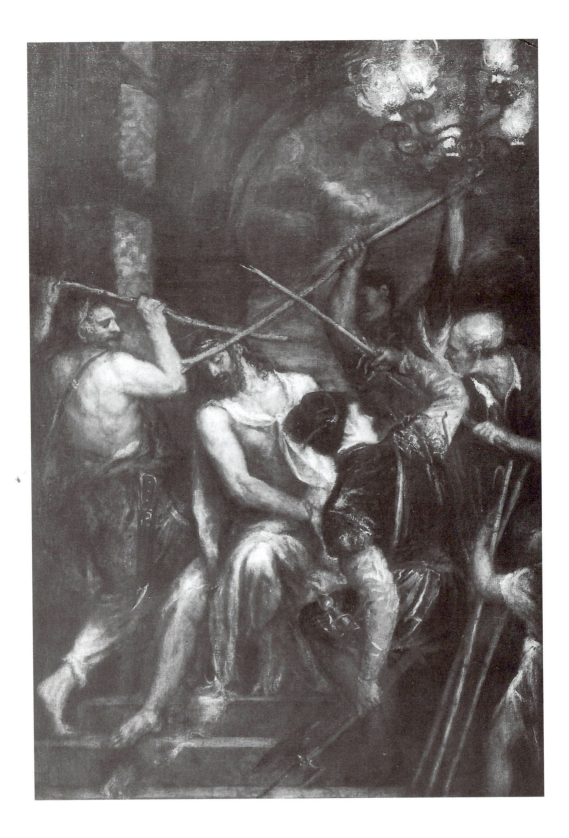

works when new orders for them arrived at Titian's work-
shop. Some of these *modelli* and oil sketches from Titian's stu-
dio passed into the hands of the Barberigo family when they
bought his house and its contents from Pomponio. The
Barberigo collection remained nearly intact until the middle of
the nineteenth century, when much of it was sold to the Czar
of Russia.

One of these paintings from the Barberigo collection is a
portrait of Philip II of Spain [101], depicted three-quarter
length and seated. This seems not to be a *modello*, but rather a
preparatory oil sketch that would have been used to create the
finished portrait.[12] Such sketches would have remained in the
workshop and then, like the *modelli*, been used to execute

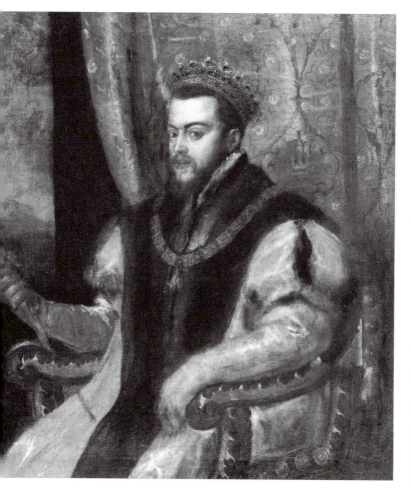

100. Titian, *Crowning with Thorns*, Munich, Alte Pinakothek

Pomponio, Titian's dis-
solute son, sold this painting
to Tintoretto. Pomponio
was born in 1524. His
mother Cecilia, who was
probably not married to
Titian at the time, was the
daughter of a barber from
Cadore, a hamlet close to
Titian's birthplace.
Pomponio outlived all his
siblings and thus inherited
Titian's estate, including the
contents of his studio.

101. Titian, *Philip II of Spain*,
Cincinnati, Art Museum

Titian met Philip II
twice: first in Milan in 1548
and then again in Augsburg
in 1550–1551. Because this
sketch seems painted from
life, it would have to have
been done on one of these
two occasions. The crown
is a later addition.

orders on request. The face, the most important part of the portrait, is quite finished and resolved. The rest of the painting is unfinished and was intended to serve only as a guide to creating Philip's final spatial position, the shape of the chair, and the cut of the clothes. Such sketches were probably produced for every portrait painted in Titian's workshop. Some of them may have been sketched in paint from life, with the painter rapidly capturing the faces of busy patrons who could spend only a short time sitting for their portraits. These sketches were not only necessary for making the original portrait, but were also crucial for the production of copies, in which there was often much participation by Titian's apprentices. These assistants would find such sketches invaluable guides for their share in the portraits.

The *Crowning with Thorns* is too large to be either a *modello* or a sketch, but is it, as Ridolfi states, unfinished?[13] Certainly some of the faces and the background do seem just blocked in, but this is a difficult question to answer with certainty when one considers Titian's works from the 1560s and 1570s. Some paintings that were delivered to their patrons, and therefore certainly completed during these years, reveal a relatively high degree of finish. For instance, the portrait of Jacopo Strada [102] of 1568 has an overall uniform degree of finish that, while painted more freely than portraits from earlier decades, is, nevertheless, undeniably complete. The portrait comes much closer to displaying the conventional degree of finish for a Renaissance painting than the *Crowning with Thorns*. This may be because a portrait had to attain a certain level of detail to minimally fulfill its function as a recognizable, acceptable depiction of a sitter. There were, in other words, certain topological conventions that had to be honored.

However, there are some late non-portraits, such as the *Tarquin and Lucretia* [103], painted between 1568 and 1571 and sent to Philip II, which are also more refined than many of the paintings from the same decades.[14] Titian realized that works for certain patrons, such as Philip II, were expected to appear finished in the conventional sense. Other paintings may have been destined for collectors who appreciated the suggestive, evocative nature of his late paintings, like the *Nymph and*

102. Titian, *Jacopo Strada*, Vienna, Kunsthistorisches Museum

Jacopo Strada (c. 1515–1588) was an antiquarian, linguist, scholar, and courtier. In his portrait he is surrounded by coins, antique statues, and books, all symbols of his erudition. According to the art dealer Niccolò Stoppio, Titian had called Strada, "the most solemn ignoramus that can be found."

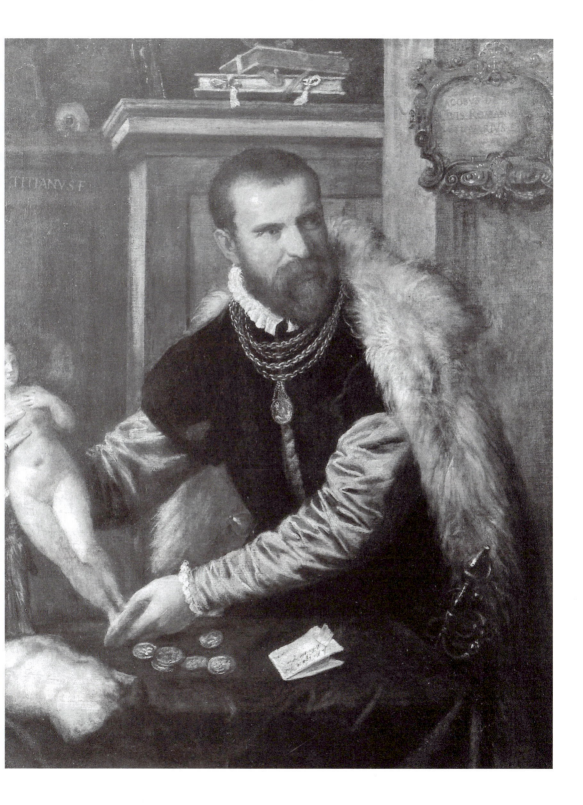

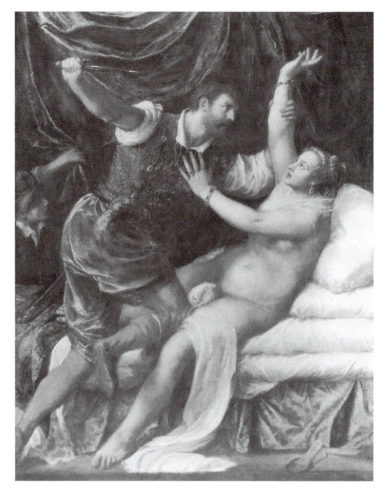

103. Titian, *Tarquin and Lucretia*, Cambridge, Fitzwilliam Museum

Shepherd, which more openly exposed the workings of Titian's mind and hands. For example, we know from Palma Giovane that there was a demand for works such as Titian's oil sketches that revealed artistic process: "The most sophisticated connoisseurs found such sketches entirely satisfactory in themselves, and they were greatly in demand since they showed the way to anyone who wished to find the best route into the Ocean of Painting."

Hope and salvation, as expressed in the *Martyrdom of Saint Lawrence,* are also themes of Titian's last work, the monumental *Pietà* [104] painted for the chapel of Christ in the church of the Frari, the location of his first triumphs in Venice. Titian

wished to be buried in this chapel and probably offered the altarpiece to the friars of the church in exchange for this privilege. His wish was fulfilled when the plague, and not old age, took him in August 1576. However, the *Pietà* remained unfinished and was seemingly inherited by his pupil Palma Giovane.[15]

Evidence for Palma's participation in the painting is found in Ridolfi's *Life of Titian*:

He [Titian] had also begun a panel painting of the dead Savior resting upon the breast of His sorrowful Mother for whom Saint Jerome serves as a support and the Magdalene weeping with open arms; Titian designed this for the Chapel of Christ in the Church of the Frari, a commission obtained from those fathers [the Franciscans] with the agreement to place the painting there, but drawing out the

104. Titian, *Pietà*, Venice, Galleria dell'Accademia
(See color plate 8)

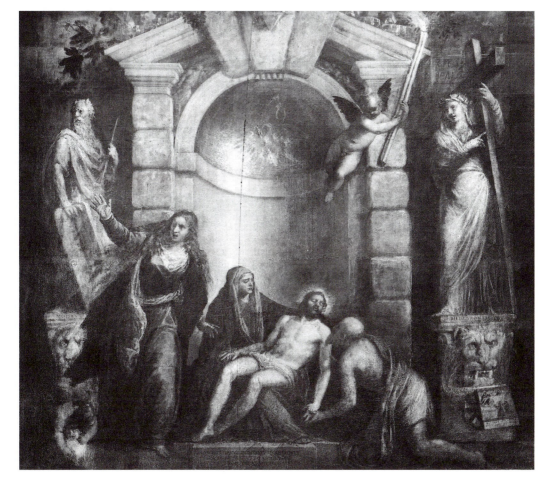

work, or, as some people declare, because the fathers did not wish to lose the ancient devotion to the Crucifix that can be seen there in that chapel, Titian did not complete the work, and after his death it came into the hands of Palma, who finished it, with the addition of several angels and this humble inscription:

> What Titian left unfinished,
> Palma reverently completed
> and dedicated the work to God.[16]

Recent conservation indicates that the large painting is constructed of seven pieces.[17] The central section of the Virgin and Christ is painted on a reutilized canvas that x-rays reveal was originally painted with an entombment of Christ. Each of the other six canvases is of varying weave and texture, suggesting that Titian used what he had at hand in his workshop, either because he was in a hurry or because he kept unexpectedly expanding the picture as he went along, or perhaps both. Such spontaneous modification is, of course, quite characteristic of Titian and Venetian painting in general.

Palma treated the unfinished painting with much respect. His participation consists solely of adding some final glazes, meant to cover the seams between the various pieces of canvas, and the flying angel, which, as we can see from x-rays, was painted over Titian's very different sketch of the same figure. Palma seems to have finished the pediment, which seems overly linear when compared to the fluidity of brush stroke and imagery of the rest of the painting. It does not appear that Palma made any further additions to the picture, thus leaving it in its unfinished state. There is no doubt that the overall finish of the *Pietà* and its degree of detail would have been considerably greater had Titian lived to bring it to completion.

Size and scale play a considerable role in the *Pietà*'s powerful effect upon the spectator. This is a monumental painting with nearly life-sized figures. Throughout the second half of the sixteenth century, Venetian painters often painted huge canvases, so their figures are frequently life-sized, or even greater. Such similarity in size creates a strong rapport between figure and spectator. The size of the paintings also allows the painters to work on a scale that demands large, bold compositional and

technical planning and execution. Part of the power of Titian's
Pietà arises precisely from these factors; it is not only a configu-
ration of powerfully reasoned and brilliantly delineated forms,
but, through its size and scale alone, the painting is an
inescapable, commanding physical presence.

With its image of the dead Christ and liturgical associa-
tions, the Pietà is an appropriate sepulchral image and as such
was frequently chosen for burial chapels. We have already
seen how Michelangelo carved a *Pietà* intended for his own
tomb. But, as is often the case with Titian's late works, the tra-
ditional imagery has undergone substantial and highly original
modification.

Kneeling before the Madonna and Christ in the *Pietà* is a
figure of uncertain identity. Although often called Saint
Jerome, the old man has no attributes that clearly identify him.
He bears a physical resemblance to several Saint Jeromes by
Titian, all of which closely resemble Titian's late self-portrait
now in Madrid [83]. It is perfectly credible to suggest that the
kneeling figure, who assumes a pose often struck by donors in
Venetian painting, has no specific saintly identity; rather, he
is a supplicant, a witness, a donor whom Titian, through self-
portraiture, has identified with himself. Such an identification
would be unsurprising, indeed even appropriate, considering
the fact that the painting was destined for Titian's own burial
place.

The identification of the distraught woman with the flow-
ing hair is less problematic. Though lacking specific attributes,
she is surely Mary Magdalene, a saint who appears in earlier
painted Pietàs in Venice, almost always as a passive witness to
Christ's death. Titian must have included her here to furnish
the dramatic gestures of grief traditionally associated with her
image, most often in paintings of Christ's Crucifixion, where
she is usually one of the most expressive mourners.[18]

Mary Magdalene is, physically and emotionally, the oppo-
site of the kneeling figure, showing devotion rather than grief.
There is, however, another dichotomy between the figures:
The old man seems to be contemplating a timeless image, an
icon, and not a historical event. In the Renaissance, representa-
tions of the Pietà were indeed removed from any specific tem-

poral associations. They were pictorial symbols of the timeless grief and loss resulting from Christ's sacrifice. But at the same time they were images of hope for mankind's salvation through Christ's death and resurrection, and thus most appropriate for sepulchral imagery. In both cases, they were meant to be contemplated as icons and reminders of the deeper meanings of the biblical event. By adding Mary Magdalene and the kneeling man, Titian has given the image a new and specific historicity and emotional charge.

A novel temporal context is also created by the giant niche flanked by rusticated piers and covered by a pediment bearing burning lamps. The form of the niche and its piers evokes contemporary Venetian architecture by Palladio and Serlio, but the entire structure is, in a sense, an old man's homage to his teacher. Titian remembered the monumental arches that formed the space in a number of works by Giovanni Bellini, such as the *San Giobbe Altarpiece* [9]. Their placement and form must have been in his mind when he designed the *Pietà* for his own tomb. Even the glowing mosaic with its pelican, a symbol of resurrection, seems to owe its origin to the remarkable mosaics of Bellini's painted niches.

Flanking the niche in Titian's *Pietà* are two large statues. To the left is Moses holding the Ten Commandments. As lawgiver and liberator of the Jews, Moses was seen as the Old Testament forerunner of Christ, and it is this role his image assumes in the *Pietà*. To the right of the niche is the Hellespontic Sibyl who prophesied Christ's death and resurrection, and is thus wearing a crown of thorns and holding a large cross. These two statues, which seem more like ghostly apparitions than stone sculptures, are the ancient prophets of Christ and, as such, add one more element of temporality to the image. Thus, in Titian's hands, the *Pietà* assumes various historical, devotional, and emotional associations woven into a complex, many-layered fabric of spiritual, liturgical, and personal meaning. In its richness of symbol, figure, composition, and association, the *Pietà* occupies a position of singular profundity in Titian's work.

The complexities of imagery in the *Pietà* are created through the alchemy of Titian's late style. Everywhere the figures seem

to emerge out of the penumbra. As in the *Nymph and Shepherd* [95] and the *Martyrdom of Saint Lawrence* [99], an air of mystery enshrouds both space and object. There is, as in all of Titian's very late paintings, a remarkable subtlety and variety of light and tonality, ranging from still, inky blackness, through quivering half-lights, to the radiant brilliance of the rays surrounding Christ's head. A shifting, tremulous illumination animates the painting, making its figures exist in a supernatural world of absolute credibility.

Titian's analysis of form, color, and light in the *Pietà* is the culmination of some sixty years of painting; it is also outside the boundaries of any convention of Renaissance art. The figures, which now take shape as much in the imagination as in the eye, are reductive and expressive. Only the essential elements are described, and these consist of a mosaic of broken colors laid in with hundreds of highly variegated brush marks. There is a synthesis and analysis of structure through paint that is brilliantly simple and endlessly evocative. Orthodox ideas of beauty, finish, and form are abandoned in favor of a new syntax of painting. The marks of Titian's hand are everywhere apparent as the paint magically and expressively becomes what it depicts while remaining mere material.

In the work of the late Titian, as in the work of the late Rembrandt, there is a marvelous tension between that which is represented and that which represents it. Paint is transformed into flesh, cloth, or light without losing its essential nature. In the *Pietà* as in other works by the aged Titian, a passage reads both as heavily impastoed and brushed oil paint, and, for example, a nose or sleeve. The evidence of creative process is everywhere as the onlooker discovers how Titian's mind, hand, and brush worked to create moving illusions out of humble materials. The act of genesis revealed by the surface of the *Pietà* and Titian's other late paintings, was appreciated by some of Titian's contemporaries, including Vasari, who was increasingly fascinated by creativity, process, and artistic personality.

During his long and highly productive career, Titian redirected the course of Venetian painting and through his vast body of work exercised a major influence on European art for

centuries. Building upon the broad and firm foundation of Giovanni Bellini, he developed highly original ways of conceiving and illustrating the various subjects he was called upon to paint. His religious and mythological narratives and portraits are nothing less than turning points in the history of art.

While still working within the venerable tradition he inherited from his Venetian predecessors, Titian reconfigured the altarpiece: first tentatively in the great Frari *Assumption of the Virgin* and then more radically in the *Pesaro Altarpiece* for the same location. In both he used space and form to make the altarpiece more expressive and dynamic. But he was never an iconoclast. He respected and revered the past and often borrowed from it. Even in his earliest dated works, the frescoes for the Scuola of Saint Anthony in Padua, he respects the conventional configuration of this sort of decoration while modifying it substantially.

After the two Frari altarpieces, Titian established himself as the foremost painter in Venice, a position that would be challenged by several artists of great talent, but never relinquished. Yet, he was never content to rest on his laurels. Although his production of altarpieces was sometimes slowed by the incessant demand for other types of commission, he nevertheless produced a long succession of masterpieces of religious painting. The destroyed *Saint Peter Martyr,* the most famous of these altarpieces, embodied an increased dynamism and drama that inspired generations of artists and was influential in the formation of the Baroque style of painting. The later altarpieces are equally dramatic, although darker and more meditative in their interpretation of religious drama. Works such as the *Annunciation* [98] and the *Crowning with Thorns* [100] are new visions of venerable themes painted in the astounding late manner of the artist. Through them and his other late altarpieces, Titian interprets sacred narrative with a new and more urgent sense of the tragedy, both human and divine, of Christ's sacrifice, an interpretation that reaches its apex in the awesome bleakness of the *Pietà,* the artist's last painting.

Although Titian first made his mark in Venice by producing a series of stunning altarpieces, it was his work in portraiture that ensured his immortality as an artist. His encounter with

Charles V and the resulting connection with the Hapsburg court propelled him to the ranks of international fame and fortune. Although his very early portraits are quite expressive of the nature of his sitters, he soon developed the ability to paint men and women of rank not as they were, but as they wished to be. Without pictorial rhetoric, obvious props, or pomp, he was able to depict his sitters' important status, and to endow them with the nobility and grandeur of this status, even when they were not very noble or grand. The early portraits of Charles V and members of the courts of Urbino and Mantua created an unceasing demand for an artist who had these rare talents; nowhere else in the Italian peninsula could such precious and useful artistic gifts be found. Soon Titian was painting the likeness of the pope, the king of Spain, doges of Venice, and other personages of status throughout Europe.

Nothing like this sort of international fame had ever been conferred on an artist before. Titian was, in fact, one of the first artists to rise from the rank of manual craftsman to an elevated position in Renaissance society. Wealthy, famous, employed by the most powerful patrons of the time, the friend of important poets and writers, he moved decisively away from the traditional occupational, economic, and social status that characterized most earlier artists. Although his work still issued from a conventional workshop where apprentices and helpers labored in traditional ways, his image as an inspired "creator" was new. He helped set the stage for the concept of the modern "artist" and, along with Raphael and Michelangelo, became a prototype of our notion of the artist as a personage of considerable importance in his or her own right.

Titian's portraits from all the decades of his long career were the most important conveyers of his influence. These portraits, the staple of his workshop, were admired by contemporary painters who sought to imitate their innate sense of nobility, power, and dignity—qualities that Titian, more than any previous artist, brought to the art of portraiture. These fellow artists also marveled at Titian's ability to endow his canvases with a brilliant and convincing materiality that made whatever he painted, including religious and mythological subjects, exist with a new palpability and realism. In all his works

he defined the art of oil painting; his technical and formal uses of the medium established the fundamental conventions for painting in oil right up to the present day. It is no wonder then that when Titian's great ultramontane followers, headed by Peter Paul Rubens and Rembrandt, came into contact with his portraits, they were first dazzled and then inspired by what they saw. Through his followers, especially Rubens and Van Dyck, Titian's portraits, more than any other painting type by him, were to have a monumental influence on the conception and depiction of power and privilege for centuries to come all over the Western world.

The influence of Titian's mythological paintings had an almost equal importance for the subsequent history of art. Before him, the vision of mythology was confined mainly to the depiction of figures of gods and goddesses who represented, but did not embody, the gorgeous world of myth found in Ovid and other ancient authors, and in the remains of classical antiquity itself. Titian transformed all this. Starting with his earliest major mythologies, done for Ferrara, and proceeding to those done in the twilight of his life, he presents the viewer with a living, breathing world of gods and goddesses. Through his manipulation of paint to create atmosphere and environment, we enter a mythical but highly believable place very different from our world, a sort of magical evocation of our most elemental hopes and dreams and, sometimes, nightmares. Nothing like this had ever been seen before, and it is not an overstatement to say that Titian's concept of mythology became, through his many followers, the lens through which we still see that subject.

Titian's accomplishments were formidable. They involved nothing less than the transformation of the artistic world that he inherited. But it would be wrong to see him as an artistic rebel in the modern sense of the word. His changes in medium, type, and interpretation came slowly and were always built with great respect for what had come before. Many of the attributes that one sees in his early works—the construction of the figure, the sensuousness, the luxurious landscape, the handling of oil paint, and many other aspects—are found in his late work as well, although much modified. His painting developed

gradually with nuance, and while it was very different at the end of his life from where he had started, it was not radically so. The grandeur, scope, and magnificence, especially of the human spirit, were inherent in everything he did from beginning to end.

Venetian painting of the sixteenth century was dominated by Titian. His work set the high standard to which his contemporaries aspired. Of these, there were several of significant talent and imagination who were, in their own way, nearly as impressive and original as Titian himself. These artists, while fundamentally indebted to the towering older figure, nonetheless managed to create works of considerable innovation and influence. Titian's paintings sparked a chain reaction that shaped much of Western painting. This phenomenon, as we shall now see, is what makes his work so vitally important for our visual heritage.

NOTES

1. For more on Thomas Howard, consult D. Howarth, *Lord Arundel and His Circle*, New Haven, 1985, and G. Parry, *The Golden Age Restor'd: The Culture of the Stuart Court*, Manchester, 1981.

2. Ovid, *Metamorphoses*, trans. R. Humphries, Bloomington, 1955, VI: 382–400.

3. F. Hartt, *Giulio Romano*, 2 vols., New Haven, 1958.

4. For the commission of the San Salvatore *Annunciation*, see *Titian: Prince of Painters*, Venice, 1990: 318–320.

5. The Cort engraving is discussed in M. Sellink, *Cornelis Cort: Accomplished Plate-Cutter from Hoorn in Holland*, Rotterdam, 1994.

6. G. Vasari, *The Lives of the Artists*, trans. J. and P. Bondanella, Oxford, 1991: 502.

7. Ludovico Dolce's quote is cited from *Titian: Prince of Painters*, Venice, 1990: 320.

8. G. Vasari, *The Lives of the Artists*, trans. J. and P. Bondanella, Oxford, 1991: 503–504.

9. The history of the Gesuiti *Martyrdom of Saint Lawrence* is described in *Titian: Prince of Painters*, Venice, 1990: 308–312.

10. G. Vasari, *The Lives of the Artists*, trans. J. and P. Bondanella, Oxford, 1991: 504–505.

11. The Ridolfi quote was published in the recent translation of C. Ridolfi, *The Life of Titian by Carlo Ridolfi*, ed. J. and P. Bondanella, B. Cole, and J. Shiffman, University Park, 1996: 134.

12. For an article about the oil sketch of Philip II, see M. Rogers, Jr., and L. Mayer, "Titian's Modello of Philip II," *The Cincinnati Art Museum Bulletin* 12/4: 5–10.

13. C. Ridolfi, *The Life of Titian by Carlo Ridolfi,* ed. J. and P. Bondanella, B. Cole, J. Shiffman, University Park, 1996: 134.

14. Documentation on the *Tarquin and Lucretia* is provided in H. Wethey, *The Paintings of Titian,* 3 vols., London, 1971, III: 180–181.

15. On the early history of the *Pietà,* see C. Hope, "A New Document About Titian's *Pietà,* Sight and Insight," (ed. J. Onians), London, 1964: 153–163.

16. This quote is cited from C. Ridolfi, *The Life of Titian by Carlo Ridolfi,* ed. J. and P. Bondanella, B. Cole, J. Shiffman, University Park, 1996: 133–134.

17. On the conservation of the *Pietà,* consult *Titian: Prince of Painters,* Venice, 1990: 128–129. Observation with the naked eye easily reveals how much thicker the paint is on the central section of the Virgin and Christ, which was painted over a preexisting painting of a man's head.

18. For a possible antique origin of this figure, see F. Saxl, "Titian and Pietro Aretino," *A Heritage of Images,* London, 1970: 86; figs. 114–116.

9

Titian's Heirs

❧

For most of the sixteenth century–from his first works around 1510 to his death sixty-six years later–Titian was the presiding genius of Venetian painting. His large, busy shop trained scores of painters who came to study with him, some of them from as far away as the Low Countries. It is interesting to observe that none of these men, with perhaps the exception of Palma Giovane, ever achieved major status or much fame. Perhaps this was because they could not emerge from Titian's overwhelming influence and were thus unable to form their own recognizable idioms. There were also many artists who, while not part of his shop, were in Titian's artistic orbit. Most often these painters were never able to fully grasp the complexity of his style. Instead, their work is frequently an imitation of merely a few salient aspects of his painting.[1]

There were, however, a few of Titian's younger Venetian contemporaries who, while strongly influenced by him, were able to establish important, independent careers and, in fact, were to rival the old master for major commissions on occasion. Moreover, because Titian was so busy with important

foreign commissions, these artists were often given work in Venice that might otherwise have gone to him or his workshop. The most notable of these painters were Jacopo Tintoretto and Paolo Veronese.

Jacopo Robusti, called Tintoretto (1519–1594), who, like Titian, enjoyed a long and productive career, was a forceful, eccentric painter of major talent.[2] In his 1642 *Life of Tintoretto*, Ridolfi claims that Tintoretto began his studies in Titian's shop but was dismissed by the master after only several days:

> Not many days later Titian, returning home, entered the room where the students were, and on seeing some papers at the bottom of a bench with certain figures drawn on them, asked who had done them. Jacopo, who had made them, fearing to have done them incorrectly, timidly said they were his. But Titian foresaw that from these beginnings the boy might become a man of great merit. Scarcely had he climbed the stairs and laid aside his mantle than he impatiently called his pupil Girolamo (thus does the worm of jealousy affect the human heart) and ordered him to send Jacopo from the house as soon as possible. And so, without knowing why, Tintoretto was left without a master.[3]

This story may indeed be true, especially in the light of the small degree of artistic independence exhibited by Titian's many students, including Girolamo da Dente, the pupil mentioned by Ridolfi. Titian, shrewd businessman that he was, may have felt that he had no need to train painters who would eventually challenge his artistic hegemony. Moreover, both in his art and his life, Tintoretto exhibited an independent and aggressive spirit that probably challenged and worried Titian.

We do not know who taught Tintoretto and, indeed, there has been some speculation that he was an autodidact. However, it seems impossible that a self-taught artist could obtain such a high level of artistic and technical skill on his own, to say nothing of the necessary commercial connections needed to acquire important commissions in Renaissance Venice. Nonetheless, Tintoretto's art is so novel and independent that it is almost believable that he had no master other than himself.

Vasari, in his "Life" of the now forgotten Venetian painter Battista Franco, devotes several pages to Tintoretto.

Vasari's description of Tintoretto's art is one of the most inci-
sive appraisals of that painter's style:

In the city of Venice ... there lived, as he still does, a painter called
Jacopo Tintoretto, who has delighted in all the arts and particularly
in playing various musical instruments, beside being agreeable in his
every action, but in the matter of painting swift, resolute, fantastic,
and extravagant, and the most extraordinary brain the art of paint-
ing has ever produced, as may be seen from all his works and from
the fantastic compositions of his scenes, executed by him in a fash-
ion of his own and contrary to the use of other painters. Indeed, he
has surpassed even the limits of extravagance with the new and fan-
ciful inventions and the strange vagaries of his intellect, working
haphazard and without design, as if to prove that art is but a jest.
This master at times has left as finished works sketches still so
rough that the brush-strokes may be seen, done more by chance and
vehemence than with judgment and design.[4]

Even in his first important works around 1545, Tintoretto
reveals an understanding and appreciation of Titian's paintings
without ever slavishly copying them. When he was asked to
paint a *Presentation of the Virgin* [105] for the church of the
Madonna dell'Orto in Venice in 1552, he thought immediately
of Titian's famous canvas of the subject finished fourteen years

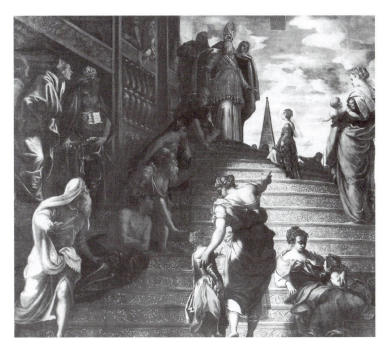

105. Tintoretto, *Presentation
of the Virgin*, Venice,
Madonna dell'Orto
 The church of the
Madonna dell'Orto contains
the *Presentation of the Virgin*
and several other large
important paintings by
Tintoretto. A chapel in
the church houses his final
resting place.

106. Titian, *Presentation of the Virgin,* Venice, Galleria dell'Accademia

This large painting, documented between 1534 and 1538, was commissioned for the Venetian Confraternity of Charity. Titian's seventeenth-century biographer Carlo Ridolfi gives a rather curious but perceptive criticism of the sprawling work: "And even though, all in all, this work lacks a conciseness that art requires, because Titian was a careful observer of nature, he nonetheless gave his figures a certain natural propriety that lends to them every kind of beauty."

before, in 1538. This painting was for a Venetian *scuola*. Like the frescoes Titian did for the Scuola of Saint Anthony of Padua, it revolutionized this type of painting while preserving many of its traditional elements, such as the panoramic view and the large crowds containing portraits of members of the confraternity. Titian's *Presentation of the Virgin* [106] is a grand, sweeping vision framed by classical architecture and constructed around a stage-set flight of stairs ascended by the Virgin, whose body is the nexus of the composition.

From this and other paintings by Titian, Tintoretto learned how to use architecture as a fulcrum for drama. But he turns Titian's well-ordered universe on its head in his own *Presentation of the Virgin.* The action now moves steeply up the stairs, from bottom to top instead of calmly across the picture. The action is still defined by architecture, but the angular flight of stairs crowded with spectral onlookers markedly heightens the drama. The towering high priest and the Virgin are borrowed from Titian's composition, but their relation has been changed: The priest now looms above the little Virgin, who is dramatically outlined against the sky. The welcoming, ritual-

istic atmosphere of Titian's painting has been replaced by mystery and tension. Yet however different in meaning Tintoretto's painting is, the construction of figures, the sky-scape, and much of the coloring would have been impossible without his study and adaptation of Titian's work.

Nonetheless, many of Tintoretto's paintings are so novel that they seem to bear only a tenuous relation with those of his Venetian contemporaries, Titian included. As Vasari so aptly put it, they are "executed by him in a fashion of his own and contrary to the use of other painters." This is especially true of a series of large canvases by Tintoretto done over decades for the meeting hall of the Scuola di San Rocco in Venice.[5] The latest of them, dating from the 1570s and 1580s, are notable for their daring, often revolutionary treatment of traditional subjects, as can be seen, for example, in the *Resurrection of Christ* [107]. This subject was painted by Titian early in his career [39], and although Tintoretto may have known this work and been impressed by the force with which Christ bursts from the tomb, he has painted a radically differ-ent, highly original version of the subject. An exceptional sense of energy is created by the sharp diagonal orientation of the space, again something that the artist could have learned from studying Titian's works, such as the *Pesaro Altarpiece* [42]. However, in Tintoretto's painting, Christ, traditionally placed close to the spectator, is now in the upper middle ground, just above two large angels flying in sharply foreshortened poses. The muscular body of Christ also reveals Tintoretto's study of the work of Michelangelo, an artist he admired and imitated by copying small plaster reproductions of Michelangelo's sculp-tures.

Although influenced by Titian's works, the illumination and color of Tintoretto's paintings are even more dramatic, if theatrical, in their sharp contrasts, which prefigure the striking chiaroscuro of Caravaggio and his followers in the early six-teenth century. Moreover, the freedom and vigor of brush-work—some parts of Tintoretto's paintings look like oil sketches—surpass even that of the late Titian. The power, eccentricity, and extraordinary invention of works like the *Resurrection of Christ* mark Tintoretto as one of the major

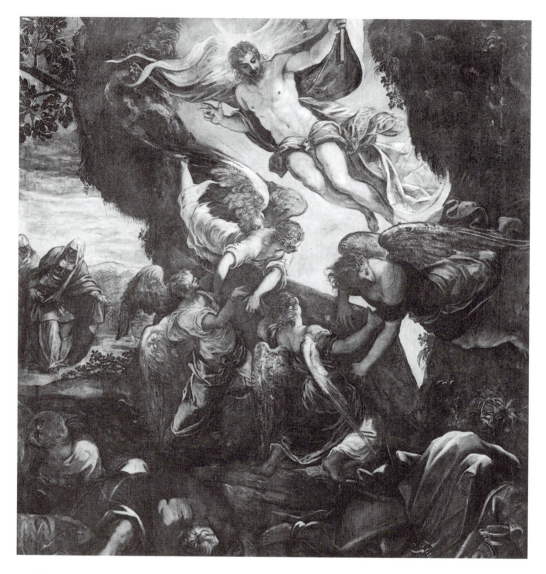

107. Tintoretto, *Resurrection of Christ,* Venice, Scuola di San Rocco

The Scuola Grade di San Rocco (Saint Roch) was one of the most important confraternities of Venice. Tintoretto, who was a brother of the Scuola, spent twenty-five years decorating it with a series of large canvases.

forces in Venetian painting, but none of his achievements could have been accomplished without his early absorption of Titian's style.

Paolo Caliari, called Veronese (1528–1588), was another major artist deeply indebted to Titian, although of a calmer and less iconoclastic spirit than Tintoretto.[6] As his name implies, he was a native of the northern Italian city of Verona, where he was trained. His first contacts with Venice do not come about until the late 1540s, and his earliest major commission in

108. Veronese, *Holy Family with Saints Catherine and Anthony Abbot,* Venice, San Francesco della Vigna

This altarpiece was painted for the Giustinan Chapel in Santa Maria della Vigna erected by the brothers Lorenzo and Antonio Giustinan.

the city dates only from 1551, when he was twenty-three years old. This painting, the altarpiece *Holy Family with Saints Catherine and Anthony Abbot* [108] for the Venetian church of San Francesco della Vigna, reveals the influence Titian had already exerted on Veronese, who probably had seen examples of his work in Verona and other northern Italian cities.

Veronese's *Holy Family with Saints Catherine and Anthony Abbot* was apparently done in his native city and sent to Venice. However, it is deeply indebted to Titian's *Pesaro Altarpiece*, finished some thirty years before. For Veronese and his contemporaries, the *Pesaro Altarpiece* must have been a lodestar of Titian's style and interpretation.

The stage-set space in Veronese's painting is composed of three levels. From top to bottom, they are the row of columns set before a very Titian-like sky; the high platform upon which the holy family is placed; and the space below the platform, occupied by Saints Catherine and Anthony Abbot, together with an amusing pig, Anthony's attribute. The layering of the space and its diagonal orientation are, of course, straight out of Titian's *Pesaro Altarpiece*, although they have undergone some substantial modification.

Veronese has trimmed Titian's painting on all sides by shortening the columns, reducing the lateral extension of space, and compacting the figures. The drama is thus more centralized, more focused on the holy family, but far less dramatic and sweeping in scope. Unlike Tintoretto, who one feels often tried to outdo Titian's drama, Veronese uses Titian's space and figure type in his own early works to create an elegance quite alien to Titian. Veronese seeks a sheer beauty of form and color that never interested Titian at any stage of his career.

This can be well seen in Veronese's *Resurrection of Christ* [109], painted around 1570. Although the painting is ultimately reflective of Titian's famous *Resurrection of Christ* [39], which Veronese may have seen in Brescia, it represents an almost complete rethinking of the subject. In contrast to Tintoretto's nearly contemporary version of the story [107], also based on Titian's painting, Veronese does not concentrate on the sacred energy of the event. Instead of bursting forth from his tomb, Veronese's Christ seems to levitate in midair. His body is now

109. Veronese, *Resurrection of Christ*, Dresden, Staatliche Gemäldegalerie

smaller and must compete for the spectator's attention with the gesticulating soldiers, whose figures and poses are strongly indebted to Titian's types. As in his adaptation of Titian's *Pesaro Altarpiece,* Veronese lessens the drama and grandeur of the subject in favor of harmony and beauty.

The drama is also diffused by the brilliant color chording of Veronese's palette. As in the 1551 *Holy Family with Saints Catherine and Anthony Abbot,* we are dazzled by the remarkably original construction of hue. For Veronese, color can be almost an independent formal element, detached from the narrative. One can see it in his paintings as abstract pattern or, conversely, as the substance that creates shimmering robes, soft flesh, and glistening armor, displaying a skill that often equals that of Titian.

Both Tintoretto and Veronese were strongly indebted to Titian, but their interpretation of his work was not the same. Tintoretto was moved by the grandeur and sweep of Titian's drama, and, in his own eccentric and highly original, occasionally bombastic, way, he tried to amplify it. Veronese, on the other hand, was swayed by Titian's use of compositional elements, figure types, and color. Eschewing the high drama of Tintoretto, Veronese crafted highly sophisticated, urbane, gracious paintings of considerable beauty, although he does demonstrate a keen appreciation of the tragedy of the aged Titian's work in the pious and moving scenes of his late religious painting. For the generations of artists who followed them, Tintoretto's and Veronese's paintings were sometimes the first avenues of approach to Titian. Although more accessible than Titian's, their works contained, nevertheless, inventions and interpretive aspects that were theirs alone.

The Venetian school of painting continued for nearly two centuries after the death of Titian. Its last great representative was Giovanni Battista Tiepolo (1696–1770).[7] Born in Venice, Tiepolo began as a prodigy and developed into an exceptional artist whose accomplishments in oil painting and fresco decoration made him the most famous Venetian artist after Titian. And, like that earlier Venetian, he worked for many of the courts of Europe, traveling as far afield as Germany and Spain.

Although he painted in the eighteenth century, Tiepolo
has rightly been called the last Venetian Renaissance artist,
for his work exhibits not only a deep knowledge and under-
standing of the history of sixteenth-century Venetian painting,
but also the formal attributes associated with the school since
the early Renaissance. Tiepolo's paintings are noteworthy for the
large patternlike arrangement of their forms held close to
the picture plane, their brilliant coloring that both creates form
and acts as an independent decorative element, their virtuoso
application of paint, and their appealing and undoctrinaire treat-
ment of religious and secular subjects, all characteristics of
Titian and his sixteenth-century followers.

In the late 1730s Tiepolo painted a *Crowning with Thorns*
[110] as one wing of a triptych for the Venetian church of San
Alvise. One immediately sees that this painting depends on
Titian's *Crowning with Thorns* [66], painted nearly two cen-
turies before. Tiepolo must have seen Titian's painting in its
original location in Milan. From it he took the viewpoint from
below, the flight of stairs, the rugged architectural framework,
and the bust of the emperor. He was also able to capture some
of the remarkably rendered pain and brutality of Titian's inter-
pretation of the subject.

However, Tiepolo made a number of fundamental
changes to his prototype. Two hundred years of painting stood
between him and Titian, and one can see in Tiepolo's *Crowning
with Thorns* influences of several other Venetian painters,
including Tintoretto, but above all others, Veronese. Tiepolo's
own highly individualistic style and explication of religious
drama are apparent as well. He reversed Titian's Christ,
rotated the composition, changed the colors, elongated the fig-
ures, and slackened the tight formal and emotional structure of
his model. Like many Venetian painters, he was able to utilize
Titian's work as a template while creating something very dif-
ferent and original. But Tiepolo lived in the Indian summer of
Venetian painting. After him, the living, constantly mutating,
centuries-old organism of the city's painting came to an end.
Suddenly there ceased to exist any painting that could be char-
acterized as specifically Venetian. And less than two decades
after his death in 1770, the oldest republic in Europe ceased to

110. Tiepolo, *Crowning with Thorns,* Venice, San Alvise

Tiepolo's career was vast in scale and scope. He painted for churches, private palaces, governmental buildings, country villas, and, during his final years, in the royal palace in Madrid, where he died.

exist itself, as Venice succumbed first to French and then to Austrian rule.

Although the influence of Titian in Venice went no further than the late eighteenth century, the work of other, non-Venetian artists made Titian's painting a part of the mainstream of European art. Soon after his death, the work of these artists helped broaden the dissemination of his paintings. This process first took place in northern Italy.

In the last decades of the sixteenth century a number of painters from that area rose to prominence in the Italian peninsula. These influential artists, who created the stylistic movement known as the Baroque, were influenced by the paintings of Raphael and Michelangelo done in Rome during the early sixteenth century. But they were also highly indebted to Titian and his followers, whose works they had seen both in Venice and in and around their native cities. In fact, Titian was the reigning artistic genius of their youth and early maturity, and they could not but be influenced by his works.[8]

One of these painters was Annibale Carracci (1560–1609).[9] Although born and trained in Bologna, he was conversant with art in Venice, which he visited in 1585. He traveled to Rome in 1595 to execute a series of frescoes in the Palazzo Farnese; these brought a new sense of structure, order, and vigor to painting in Rome. Along with Caravaggio (1571–1610), another artist indebted to Titian, he helped initiate the Baroque style in that city.

Shortly before he left Bologna for Rome (where he died), Annibale painted a *Venus Adorned by the Graces* [111], a mythological story taken from the *Odyssey*. While this work displays influence from a number of painters, its basic stylistic and interpretive tenets come from Titian. The atmospheric setting with its subtle, dappled play of light; the large, corpulent bodies of Venus and her attendants; the facial types; and the suggestive, feathery landscape with its dramatic sky are all his inventions. Moreover, the sensuous, materialistic nature of Carracci's depiction, so fitting for the subject, finds its origin in Titian's early mythologies, such as the series he did for Ferrara nearly three-quarters of a century earlier. Of course not all of Titian's influence seen in Annibale's painting came directly from

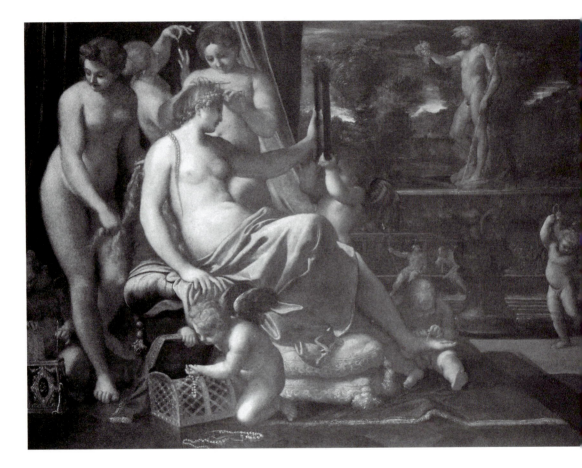

111. Annibale Carracci, *Venus
Adorned by the Graces,* Washington,
D.C., National Gallery of Art

The Carracci workshop consisted
of Annibale, his brother Agostino
(1555–1602), and their cousin
Ludovico (1555–1619). Together
they developed a school in Bologna
which became a major force in Italian
Baroque painting. Annibale's frescoes
in the Palazzo Farnese (begun 1597)
were enormously influential in the
history of sixteenth-century
European art.

Titian's own works; much of it was filtered through his follow-ers and contemporaries–Veronese, for example. Nonetheless, the fundamental conception of Carracci's *Venus Adorned by the Graces* would have been impossible without Titian.

Titian's greatest and most understanding seventeenth-century admirer was, interestingly enough, not an Italian, but the Fleming Peter Paul Rubens (1577–1640).[10] It was Rubens, more than Annibale Carracci or any of his Italian or French contemporaries, including the influential French painter Poussin, who was responsible for maintaining Titian's influence throughout Europe. Born in 1577, just ten months after Titian's death, Rubens first came into contact with the Venetian's art in Antwerp through prints by Cornelius Cort after works by Titian. These he copied in order to master Titian's figural inven-tions, which he then made part of the foundation of his idiom.

In 1600 Rubens left Antwerp for Italy, where he stayed for eight years.[11] Not surprisingly, his first destination was Venice. To this young foreigner from beyond the Alps, the city with its paintings by Bellini, Giorgione, Titian, Tintoretto, and Veronese must have seemed a new and wondrous world.

Rubens, however, was soon to leave Venice for Mantua, where he found employment with Duke Vincenzo Gonzaga. The Gonzaga collection was then rich with works of Titian and many other notable Italian artists. In 1627 a great group of Gonzaga paintings, including many by Titian, was sold to Charles I of England by Duke Vincenzo's son Duke Francesco, an act that Rubens commented on bitterly, saying, "The Duke of Mantua should have died some months earlier before selling his collection to the English."

In 1603, Rubens was sent to Spain. He accompanied a caravan of gifts from the Duke of Mantua, including many paintings, destined for the Spanish king, Philip III, and his most important courtiers. During this visit, he was able to view the works by Titian in the royal collection. They "stunned me by their quality and quantity," he wrote.[12] This admiration of Titian was already noted by Rubens' contemporaries, one of whom aptly remarked, "how wonderfully has the light of Rubens' mind taken fire through its contact with Titian's brush." It was, in fact, Rubens' contemplation of this series of masterpieces by

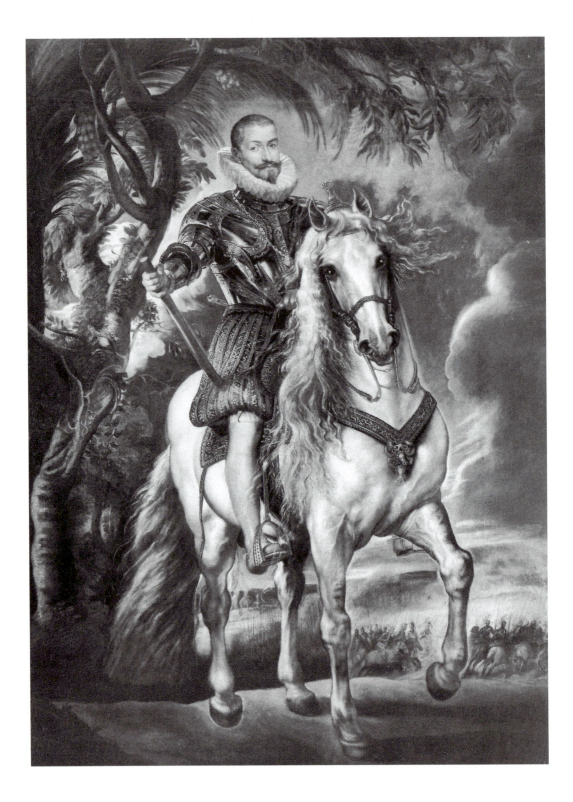

Titian that helped set the course of his painting for the rest of his life.

Rubens' own talent as a painter, and as a young but highly skillful courtier, found favor in Spain. While there in 1603–1604, Rubens was commissioned by the Duke of Lerma, the real power behind the Spanish throne, to paint an equestrian portrait [112] for him. By the early seventeenth century, Titian's equestrian portrait *Charles V at Mühlberg* [78] had become a dynastic and artistic icon, and both the duke and Rubens wanted to capture some of its power by emulating it. The result was a striking and highly original variant of Titian's famous painting.

Rubens' admiration for Titian is seen in the general disposition of the horse and its rider, which depends on the *Charles V*, as do the tree, atmosphere, sky, and landscape. In the portrait of Lerma, however, a depiction of a pitched battle has been added to the middle ground. This scene of combat was probably inspired by a large battle fresco which Titian had painted in the Doges' Palace in Venice. By the time Rubens arrived in Venice, the fresco had been destroyed, but at least one of Rubens's drawings reveals that he knew copies of Titian's work.

Although he clearly idolized Titian and based his *Duke of Lerma* on the *Charles V,* Rubens invented almost as much as he borrowed. He has turned the horse toward the picture plane, giving both it and its rider a new and more dynamic orientation toward the spectator: Both animal and man now fix the onlooker with their gaze. The distant, dignified, sideways progression of the rider across space in the *Charles V* has been forsaken here in favor of more immediate, action-filled drama. In the *Duke of Lerma,* the sharper contrasts of dark and light, the twisting tree, the scudding clouds, and the flying mane and tail of the horse introduce a note of immediacy alien to the *Charles V,* but entirely characteristic of Rubens' interpretation and modification of Titian's idiom.

In 1628–1629 Rubens returned to Spain once again, this time as a diplomat to help negotiate a peace treaty between Spain and England. He was forced to wait in Madrid for more than seven months while negotiations continued, but he made

112. Peter Paul Rubens, *Duke of Lerma*, Madrid, Museo del Prado

Francisco Gomez de Sandoval y Royas (1553–1625) was created Duke of Lerma by Philip III. Lerma was a trusted confidant of the king.

good use of this time by copying *all* the paintings by Titian in the royal collection, according to Francisco Pacheco, the father-in-law and teacher of Diego Velázquez. In one sense this is surprising and highly unusual; Rubens was already fifty-one and a mature and successful painter and diplomat. Why, at this stage of his career, would he still need to copy so many works by a single master? The answer, of course, lies in his unceasing admiration of Titian and the principles of his art. Rubens' copying was both an exercise in learning and a late homage to an artist whom he had worshiped from his youth. After Rubens' death, the inventory of his considerable estate listed the copies after Titian made in Spain, along with a number of paintings by Titian himself, further evidence of just how much that artist meant to Rubens.[13]

Titian and Rubens were influential in the development of the art of Anthony Van Dyck (1599–1641), another artist who carried on the Venetian tradition through northern Europe and into England.[14] He was born in Antwerp, where he soon distinguished himself as a prodigy–he was producing accomplished paintings by the time he was fourteen! He spent two years in Rubens' workshop, but by the time he arrived there, he was already a masterful painter, so he was probably as much a collaborator for Rubens as a pupil. In 1620, he lived for several months in England working for the king, James I (Rubens was to follow in 1629). Then, like Rubens before him, he traveled to Italy, that mecca of art for northern painters. There he spent the years 1621–1627 working for various aristocratic patrons, mainly in Genoa. Although he already knew much about Italian art through his association with Rubens, the years he spent in Italy were formative for his style because while he was there, he, like Rubens before him, became an assiduous student of Venetian art in general and Titian in particular. Van Dyck's sketchbook and drawings from this period are filled with copies of Titian's work, which he studied for compositions, motifs, and his own edification and inspiration. From Titian, again like Rubens, he learned to use oil paint to perfect scenes of material and atmospheric splendor.

While in Genoa, Van Dyck painted portraits of the children of the patrician Cattaneo family. These paintings depend

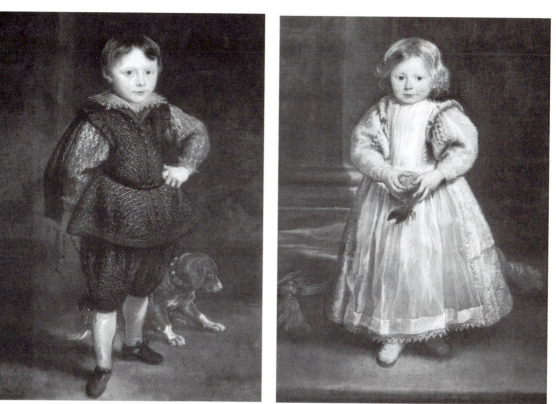

heavily on prototypes by Titian, such as the *Clarice Strozzi* of
1542 [58]. Van Dyck's *Filippo and Clelia Cattaneo* of 1623 [113,
114] represent both of the small sitters full-length, situated in a
room adorned by a majestic column. The setting and expensive
clothes of the two children signal their social position. The
boy's pose, his command over his dog, and the self-confident
way in which he regards the spectator are all indebted to
Titian's portraits of the nobility. As in those paintings, the boy
is endowed with a natural, commanding presence, much like
that of an adult, despite the fact that he is only four years old.
However, as in Titian's *Clarice Strozzi*, Van Dyck's portraits of
these children, especially the girl, also reveal their childlike
nature. Shyness, innocence, and vulnerability radiate from these
enchanting portraits, painted with a brilliant technique that
both derives from and rivals Titian's. Despite their wealth and
status, the two little beings are seen not as small adults, but as
real children.

113. Anthony Van Dyck,
Filippo Cattaneo,
Washington, D.C., National
Gallery of Art

114. Anthony Van Dyck,
Clelia Cattaneo, Washington,
D.C., National Gallery of
Art

In 1628 Van Dyck moved back to Antwerp from Italy, but departed again after just several years, this time for England, where, from 1632 until his death in 1641, he worked for King Charles I and his group of courtiers. Both Rubens and Van Dyck were knighted by the king.[15] Van Dyck's considerable success in England was due in great part to the Italianate nature of his art. Charles and many members of his sophisticated court were passionate admirers and collectors of Venetian paintings, those by Titian above all. For the king and his court, Titian's paintings represented apogees in the history of art. His portraits embodied a natural nobility and grace admired by an English aristocracy who aspired to just those virtues. Moreover, Titian was the ultimate court painter, whose clients included not only dukes, doges, popes, and kings, but also the Holy Roman Emperor, Charles V, a ruler much esteemed in highborn English circles.

In the 1630s and early 1640s, the idea of divine kingship was under attack in England. Charles I continually reaffirmed his divine right to rule in the face of strong opposition from Parliament, a course that led ultimately to the English Civil War and to his own beheading in 1649. For Charles and his circle, Titian's art, and the painting of his great follower Van Dyck, embodied both the grand style and the ideal of rulership. However, the king's patronage of the Catholic Van Dyck and his collection of Italian art helped incite his anti-papal Protestant enemies in England and hastened his downfall.

Van Dyck's image of nobility is nowhere better seen than in his portraits of the king. The artist painted several large, important equestrian portraits of Charles that are greatly indebted to Titian. However, in *Charles I in the Hunting Field* of 1635 [115], the king is dismounted and placed not in the center of the painting, as in the *Charles V at Mühlberg,* but rather daringly off to the left. He dominates the space by his noble character, and not by his physical presence or position, as does Charles V in Titian's painting. Charles I is dressed in simple hunting clothes, which give little indication of his rank, rather than in ceremonial robes or armor. Nonetheless, his elegant pose and intelligent, fine face are the perfect embodiments of the commanding royal image that finds its origins in Titian's work, as do

115. Anthony Van Dyck, *Charles I in the Hunting Field,* Paris, Musée du Louvre

Van Dyck's portraits of the king, queen, and the members of the royal court exerted a paramount and formative influence on the development of English portraiture. This influence continued unabated throughout the eighteenth century.

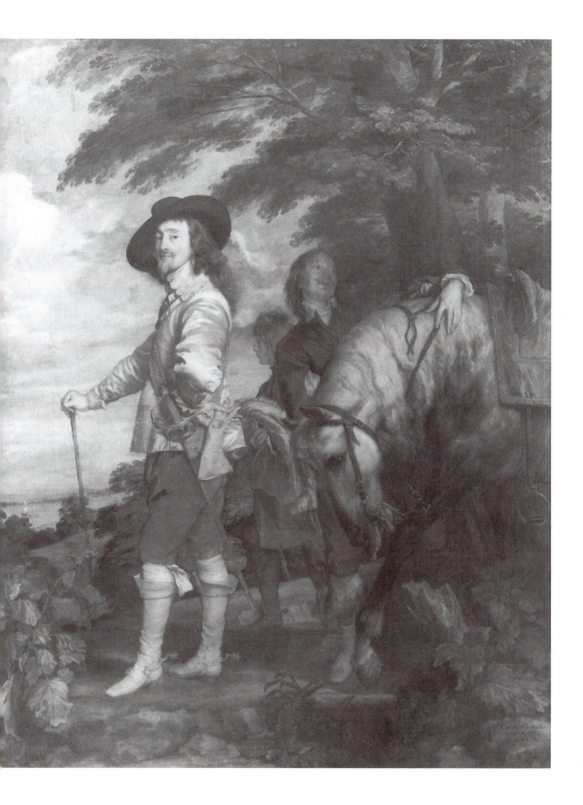

the cloud-filled sky, feathery trees, and dappled lighting. Moreover, the dazzling brushwork, which constructs the material surface with a richness of highly modulated, variegated colors, reveals just how much Van Dyck learned from his long and intensive study of Titian. As with Rubens, the foundations of Van Dyck's style and interpretation derive from Titian. Yet, as we have seen in Van Dyck's *Charles I in the Hunting Field* and in the *Duke of Lerma* by Rubens, neither of these artists was a slavish follower. Instead, they felt free to use Titian's art as inspiration and springboard for their own highly inventive paintings.

Rembrandt (1606–1669), a Dutch contemporary of Van Dyck and Rubens, was one of Titian's most perceptive followers. Although Rembrandt never traveled to Italy and consequently saw fewer of Titian's canvases in the original than did Rubens and Van Dyck, knowledge of Titian's art was still a decisive factor in his painting.[16] In Amsterdam, where he settled in 1631, Rembrandt was able to see Italian paintings and engravings in private collections and for sale in auction houses. Moreover, he owned prints by Mantegna and engravings after Italian artists, including Raphael and Titian. Rembrandt, however, remains the only artist of his stature never to have visited Italy.

He was born and trained in the Dutch town of Leiden, where he established himself as an independent master by 1625. Around 1631, he moved to cosmopolitan Amsterdam, where he met with considerable success painting portraits and religious paintings. While knowledge of Titian, especially his handling of paint to create illusion and his depiction of figures, was influential in many of Rembrandt's works done in Amsterdam, it was in Rembrandt's portraits that Titian's influence was most strongly displayed. Titian's early *Portrait of a Man,* from around 1512 [36], was sold at auction in Amsterdam in 1639. Rembrandt was so deeply impressed by this painting that in the following year he modeled his *Self-Portrait* [116] on it–he may have thought that Titian's painting was a self-portrait as well. Rembrandt copies the ledge, the protruding right arm cloaked in its magnificent sleeve, and the axial twist of the body. However, he turns his own body more parallel to the picture plane, thus modifying and reducing the

116. Rembrandt, *Self-Portrait,* London, National Gallery

Rembrandt saw both Titian's early *Portrait of a Man* (fig. 36) and the *Portrait of Castiglione* by Raphael in Amsterdam. Both were being offered for sale by the dealer Alfonso Lopez in 1639.

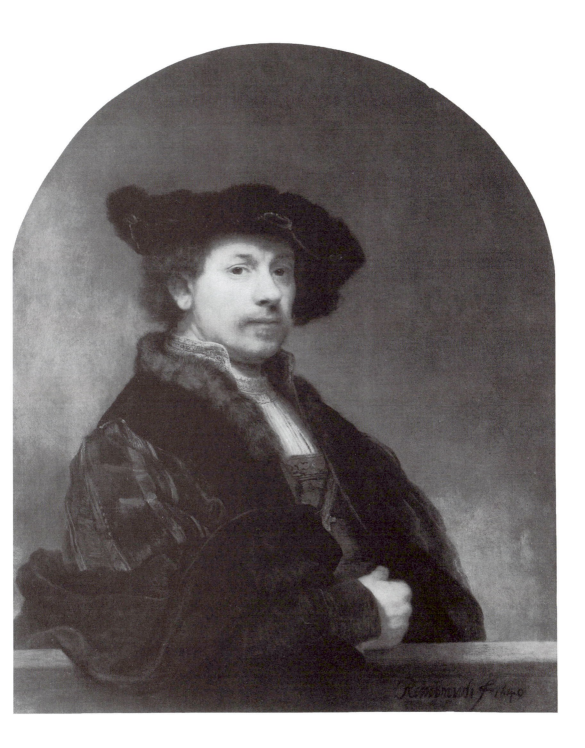

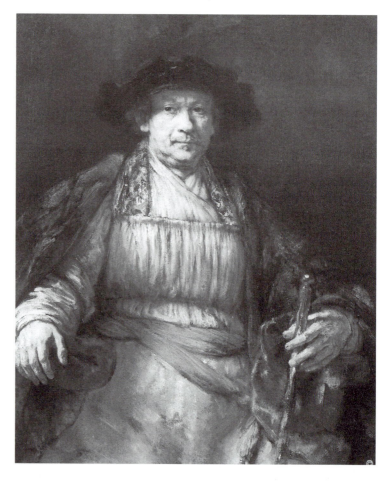

117. Rembrandt, *Self-Portrait*, New York, The Frick Collection

dramatic angle of the sleeve and twist of the head in Titian's painting. He also adds a large, floppy hat, an element he probably borrowed from Raphael's *Portrait of Castiglione,* also in Amsterdam at the time.

Although Rembrandt is indebted to Titian's painting, his self-portrait is a fiercely independent work. He modifies it so that his face is the major focus of attention. It is in the conception of this face that the major differences between Titian and Rembrandt are most evident. The handsome face of Titian's portrait conveys a sense of haughtiness and is fairly expressive in character for a Titian portrait. However, in comparison to Rembrandt's frank and unflattering depiction of his own face, Titian's sitter seems idealized and remote. Rembrandt painted more than sixty remarkable self-portraits,

through which he continually studied his changing face and character. Most of them are as rigorously self-analytical, probing, and candid as the 1640 self-portrait. In this respect, it and the other self-portraits by Rembrandt are poles apart from the much more idealized and removed portraits of Titian, including his self-portrait dating about 1550 [82].

This is true even in one of Rembrandt's most regal self-portraits, the famous *Self-Portrait* of 1658 [117]. This painting's relation to Titian has been wisely described by Kenneth Clark:

And in several of Rembrandt's greatest portraits we feel the Venetian spirit permeating the whole design although we cannot point to the individual Titian or Tintoretto on which they are based. In the superb self-portrait painted in the year of his bankruptcy–a philosopher king indifferent to misfortune–not only is the grandiose, frontal pose derived from Titian, but the pleated shirt is a part of Venetian sixteenth-century dress, which Rembrandt has put on, partly because he felt like dressing up, and partly because it gave him a strong horizontal line.

But in spite of similarities of design, the basis of Rembrandt's portraiture was very different from that of Titian. It may seem far-fetched to speak of Catholic and Protestant portraiture, but it is a fact that Titian's strongly Catholic approach to all experience, his hearty acceptance of doctrine and hierarchy, is perceptible in his attitude toward his sitters, and even in his sense of form. He saw each sitter as a type to be enhanced till it reached its perfect state, rather as our bodies will be (the theologians tell us) on the Day of Judgement. Rembrandt, who was essentially a Protestant, saw each sitter as an individual human soul whose weaknesses and imperfections must not be disguised, because they are the raw material of grace. It was this pre-occupation with the individual which led him to study his own face so relentlessly.[17]

The formal syntax, technique, and illusionism of the *Self-Portrait* of 1658 depend on portraits by Titian and his followers. But the magnificence of Venetian color, brush stroke, and princely image is at odds with Rembrandt's aging face, marked by its bulbous nose and sagging jowls. Titian's portraits always elevate and ennoble his sitters; they never let the observer probe much beneath the surface of appearance and social station. Rembrandt's do just the opposite. They tell much more about individual character, inviting us to dwell on

the nature of the sitter as a unique human being whose character and life experiences are visible in the face, regardless of rank or status.

After Rembrandt, Titian's influence continued unabated. In a book of this scope it would be impossible to even begin to trace this continuing influence, but paintings by two artists, one from the eighteenth and another from the nineteenth century, may reveal something about Titian's enduring sway.

Scores of artists absorbed Titian's style during the eighteenth century, either through direct contact with his canvases or secondhand through works by other painters. It was through the latter means that Antoine Watteau (1684–1721), arguably the greatest artist of eighteenth-century France, encountered Titian's art. Born in Valenciennes, a Flemish town recently made part of France, Watteau arrived in Paris in 1702. Five years later he was working with Claude Audran, keeper of the Luxembourg Palace, the location of the famous *Life of Marie de Médicis* series by Peter Paul Rubens. Watteau was given access to these famous works, which are among Rubens' most accom-

118. Watteau, *Departure from the Isle of Cythera,* Paris, Musée du Louvre

In his *Journal*, Eugène Delacroix writes of a visit he made to the home of a Parisian collector. Commenting on a painting by Watteau (now in the Wallace Collection, London), he says, "This is a magnificent Watteau. I was struck by that admirable art of painting. Flanders and Venice meet in it. . . ."

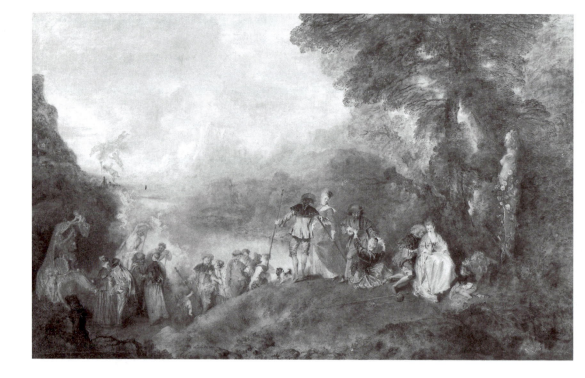

plished and exuberant. Each of these huge paintings is suffused with Venetian influence from Titian and his followers. Watteau's early experience with Rubens and his study of the Venetian works then in Paris formed the foundation of his style.

One of Watteau's first masterpieces was the painting that he did as his Reception Piece for the French Academy, to which he had been admitted in 1712. Completed only five years later, it is the *Departure from the Isle of Cythera* [118]. The birthplace of Venus, Cythera was a fabled isle sacred to lovers, and their departure from this enchanted place back to the reality of life was a melancholy subject ideally suited to Watteau, an artist who excelled in the depiction of delicately shaded human emotion, especially love.

Watteau's large canvas depicts a wide and deep landscape occupied in the middle ground by knots of lovers, dressed in the beautifully silken fashion of the early eighteenth century. These men and women are just making their way down the hill toward a golden barge waiting to take them back to shore. To the right is a shrine to Venus draped in flowers, before which a man and women seemingly speak of their love for each other, oblivious of all else. Farther to the left, the pilgrims to Cythera are seen getting to their feet, standing, and then beginning the walk to the boat. Several, however, cast longing glances backward, remembering their idyll of love and pleasure. Above and around the boat and among the pilgrims are cupids, mythological emissaries of love.

This sort of subject and its physical and emotional possibilities had already been explored by Rubens in many paintings, some of which Watteau certainly knew. However, the ultimate source is found in Titian's mythological works, beginning with the *Bacchanal of the Andrians* [46] of c. 1518. Watteau might also have known the famous *Fête champêtre* by the young Titian, then in the collection of Louis XIV, but such firsthand acquaintance was not necessary. The sort of hedonistic dreamland of the *Departure from the Isle of Cythera* was first conceptualized and depicted by Titian, and then adopted by Rubens, who effectively transmitted it to Watteau. The barely defined, atmospheric landscape with its distant mountains all

but dissolved in mist is dependent on Titian's *Rape of Europa* [94], via Rubens (who copied it in Spain), as are the feathery trees, luminous water, general sense of atomized light and color, and the glazing technique.

But while not forgetting his distinguished artistic heritage, Watteau has changed the tenor of the subject from a sensualistic revel to a more complex interplay of transitory human emotions traced with sorrow and regret. In contrast to Titian and Rubens, on whose foundation Watteau built, his narrative is less robust and more tinged with the complexities of love and its loss. Nonetheless it is a respectful, even adoring ode to those two artists.

Throughout the nineteenth century, Titian remained a lodestar for painters. Yet one of them, Édouard Manet (1832–1883),[18] formulated a strikingly new and fundamentally different attitude toward Titian. Manet was a wealthy, socially prominent, and conservative-minded Parisian who became a reluctant rebel against many of the artistic conventions of his

119. Manet, *Olympia,* Paris, Musée d'Orsay

Manet's attitude toward his *Olympia* is summed up in a remark he made to a friend: "It seems as if I have to do a nude. All right, I will give them a nude!

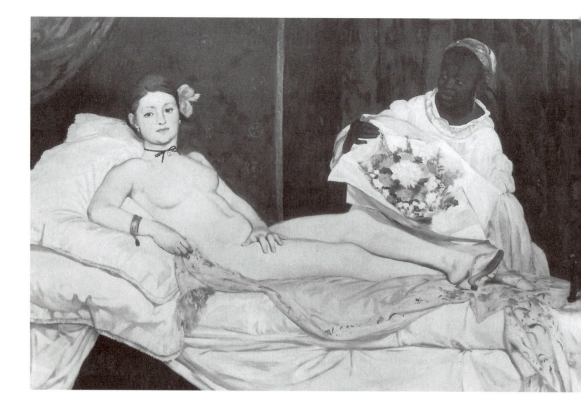

day, and, more importantly, the past that he loved. He had spent much time looking at Venetian pictures in Paris and throughout Europe, including Italy. While in Florence in 1853 he made a copy of Titian's *Venus of Urbino* [61], by then recognized as the primogenitor of the recumbent female nude in Western painting.

Ten years later Manet painted his *Olympia* [119] of 1863. This painting stood the Paris art world on its head, so much so that it had to be protected by armed guards when it was first officially exhibited. Today, in our age of constantly shocking art, it is hard to understand this furor, yet at its heart lies the conscious subversion by Manet of what had been until that time an icon of painting and taste.

Manet did several astonishing things. Although it is probable that Titian's Venus is a courtesan, her form and face are idealized. She is set in a palace, with drapery and wall hangings imparting a sense of wealth and luxury to which the woman seems to belong naturally. By contrast Manet's Olympia, although obviously derived from Titian's Venus, is startlingly real and mundane. Wearing slippers, a bracelet, and a necklace, Manet's Olympia is attended by a maid who brings her a bouquet of flowers. She looks directly at the spectator unfeelingly. Manet has abandoned the idealized distance between the woman and the viewer, and by so doing has revolutionized and actualized the meaning of the female nude, one of the most popular and venerable subjects in Western art. Even the sleeping dog in Titian's *Venus of Urbino* has been changed; it is now replaced by an arched, hissing alley cat, the perfect visual symbol of Manet's attitude.

While based on Titian's model, which Manet revered, *Olympia* undermines its meaning. Manet has broken the long succession of respect and imitation of Titian, forged in the Venetian's own lifetime and then added to by a succession of distinguished artists, including Rubens, Van Dyck, Rembrandt, and Watteau. It is no wonder that his Olympia was called a "female gorilla" and so virulently derided!

But Manet did more. He painted the *Olympia* in a summary planar form with abrupt transitions between light and dark; to the viewing public, used to beautiful palettes and subtle

gradations of light, the painting looked more like a crude sketch than a finished picture. Many of Manet's contemporaries thought it was ugly and coarse in subject and style. Ultimately, the *Olympia* was more than a painting; it was a slap in the face of what a painting of a nude woman, starting with Titian, had become. And, for better or worse, this subversion of type and tradition planted the fundamentally iconoclastic roots of modern art. The long golden chain, whose first link had been forged by Titian, had been broken forever.

NOTES

1. For a pictorial survey of the works of several of Titian's imitators, see B. Berenson, *Italian Pictures of the Renaissance: Venetian School,* 2 vols., London, 1957. See also S. Freedberg, *Painting in Italy, 1500–1600,* New Haven, 1993: 708.

2. E. Newton, *Tintoretto,* Paulton, 1966, as well as S. Freedberg, *Painting in Italy, 1500–1600,* New Haven, 1993.

3. This quote is cited from C. Ridolfi, *The Life of Tintoretto and of His Children Domenico and Marietta,* trans. C. and R. Enggass, University Park, 1984: 15.

4. This quote is taken from G. Vasari, *Lives of the Painters, Sculptors, and Architects,* trans. G. de Vere, 2 vols., New York, 1996, II: 498–515.

5. F. Valcanover, *Jacopo Tintoretto and the Scuola Grande of San Rocco,* Venice, 1983, and G. Romanelli, *Tintoretto: La Scuola grande di San Rocco,* Milan, 1994.

6. R. Rearick, *The Art of Paolo Veronese,* Washington, 1989, as well as S. Freedberg, *Painting in Italy, 1500–1600,* New Haven, 1993.

7. For Tiepolo see M. Levey, *Giambattista Tiepolo: His Life and Art,* London, 1968.

8. For the origins of the Italian Baroque see S. Freedberg, *Circa 1600: A Revolution of Style in Italian Painting,* Cambridge, Mass., 1983.

9. D. Posner, *Annibale Carracci,* 2 vols., London, 1971, and *The Age of Correggio and the Carracci,* Washington, 1986.

10. J. Burkhardt, *Rubens,* Vienna, 1937, and C. White, *Rubens and His World,* London, 1968.

11. For material regarding Rubens in Italy, consult M. Jaffe, *Rubens and Italy,* London, 1977.

12. The Rubens quote is from R. Magurn, *The Letters of Peter Paul Rubens,* Cambridge, Mass., 1955: 33.

13. Rubens' collection is discussed at length in J. Muller, *Rubens: The Artist as Collector,* Princeton, 1989.

14. C. Brown, *Van Dyck,* Oxford, 1982.

15. On the subject of Van Dyck in England, see O. Millar, *Van Dyck in England,* London, 1982.

16. K. Clark, *Rembrandt and the Italian Renaissance,* New York, 1966, as well as his *An Introduction to Rembrandt,* New York, 1978.

17. K. Clark, *Rembrandt and the Italian Renaissance,* New York, 1966: 130.

18. For Manet see T. Reff, *Manet, Olympia,* New York, 1977; F. Cachin, *Manet,* New York, 1991; B. Brombert, *Édouard Manet: Rebel in a Frock Coat,* Chicago, 1996.

Selected Bibliography

The following is a brief list of books in English, many of which contain extensive bibliographies devoted to specialized areas of Renaissance history and art.

RENAISSANCE HISTORY

Italy

J. Burckhardt, *Civilization of the Renaissance in Italy*, New York, 1958. (Although first published in 1860, this much-debated book remains the classic definition of the Renaissance.)

P. Burke, *Culture and Society in Renaissance Italy, 1420–1540*, London, 1972. (A broad historical synthesis, especially good on patronage.)

J. Hale, ed., *A Concise Encyclopedia of the Italian Renaissance*, New York, 1981. (Helpful short entries on a wide range of Renaissance topics.)

Venice

F. Lane, *Venice: A Maritime Republic*, Baltimore, 1973. (Important scholarly study.)

O. Logan, *Culture and Society in Venice, 1470–1790*, New York, 1972. (Much fascinating material about artists and the collecting and patronage of painting.)

G. Lorenzetti, *Venice and Its Lagoon*, Rome, 1961. (The fullest and most detailed guidebook to Venice. Extremely difficult to consult because of its strange organization, but worth the effort.)

M. McCarthy, *Venice Observed,* London, 1956. (A brilliant and evocative por-trait of the city.)

J. Morris, *The World of Venice,* New York, 1960. (An urbane and beautifully written essay on the city.)

J. Norwich, *A History of Venice,* New York, 1989. (Enthralling and accessible history of the whole scope of Venetian history. The first book to read on the subject.)

RENAISSANCE ART

B. Berenson, *Italian Pictures of the Renaissance,* 7 vols., London, 1958–68. (Pioneering works of attribution of all the Italian schools of painting; illustrated with hundreds of plates.)

B. Cole, *Italian Art, 1250–1550: The Relation of Renaissance Art to Life and Society,* New York, 1987. (A study of the function and location of Renaissance art in the society of its time.)

B. Cole, *The Renaissance Artist at Work,* New York, 1983. (The world of the Renaissance artist's workshop.)

S. Freedberg, *Painting in Italy, 1500–1600,* New Haven, 1975. (The magisterial study of Renaissance painting.)

F. Hartt, *History of Renaissance Art,* New York, 1987. (Perceptive and personal view, with many illustrations.)

P. Humfrey, *Painting in Renaissance Venice,* London, 1995. (Useful survey, with appendix of artists' biographies.)

N. Huse and W. Wolters, *The Art of Renaissance Venice,* Chicago, 1990. (Comprehensive survey of Venetian painting, sculpture, and architec-ture.)

F. Mather, *Venetian Painters,* London, 1937. (Beautifully written and full of sage and acute observations; this book is now, regrettably, almost com-pletely forgotten.)

TITIAN

J. Crowe and G. Cavalcaselle, *The Life and Times of Titian,* 2 vols., London, 1881. (Essential. One of the most remarkable monographs in the litera-ture of art history. Indispensable for an understanding of Titian.)

C. Hope, *Titian,* New York, 1980. (Iconoclastic and thought-provoking essay on the artist.)

C. Ridolfi, *The Life of Titian,* ed. J. and P. Bondanella, B. Cole, J. Shiffman, University Park, 1996. (After Vasari, the most important early source for the artist's life and work.)

G. Vasari, *The Lives of the Artists,* trans. J. and P. Bondanella, Oxford, 1991. (Vasari's firsthand account of Titian and his art is the starting point for all writers on the artist.)

H. Wethey, *The Paintings of Titian,* 3 vols., London, 1969–1975. (The funda-mental catalogue of Titian's painting.)

Index